NEW YORK NOIR

CRIME PHOTOS FROM THE DAILY NEWS ARCHIVE

NEW YORK NOIR

CRIME PHOTOS FROM THE DAILY NEWS ARCHIVE

William Hannigan

Introduction by Luc Sante

RIZZOLI
NEW YORK

First published in the United States
of America in 1999 by
Rizzoli International Publications, Inc.
300 Park Avenue South
New York, New York 10010

ISBN 0-8478-2172-2
LC 99-70709

Edited by Christopher Lyon
Designed by Kathleen Oginski &
 Greg Van Alstyne
Printed in Italy

The New York Daily News Photo Archive is
the largest searchable online database of photo-
graphs in the world. Consisting of current
color photographs as well as historic images
edited from more than six million prints and
negatives, the Daily News Photo Archive is the
most comprehensive visual resource for the
history of twentieth-century New York. It
may be accessed on the World Wide Web at
http://www.dailynewspix.com.

Acknowledgments

This book is dedicated to all of the photogra-
phers who helped make the News, over the last
eighty years, "New York's Picture Newspaper."

It is also dedicated to the Hannigan family
and c.j.b.

This book could not have been completed
without the editorial assistance of James
Wellford.

Further assistance came from Jacques
Menasche, Claus Guglberger, and Leah Singer.

Thanks are also owed to Jacques, and to
Aurora Wallace, for patient and insightful cri-
tiques. For their support and encouragement,
appreciation is extended to Eric Meskauskas,
Director of Photography at the News, the News
Library staff, Billy Martin, Jason Prohaska,
James Wellford, and most of all Joe Regal,
without whom this book would never have
come to light.

CONTENTS

INTRODUCTION 7
Luc Sante

NEWS NOIR ... 15
William Hannigan

PLATES ... 23

SYNOPSES .. 151

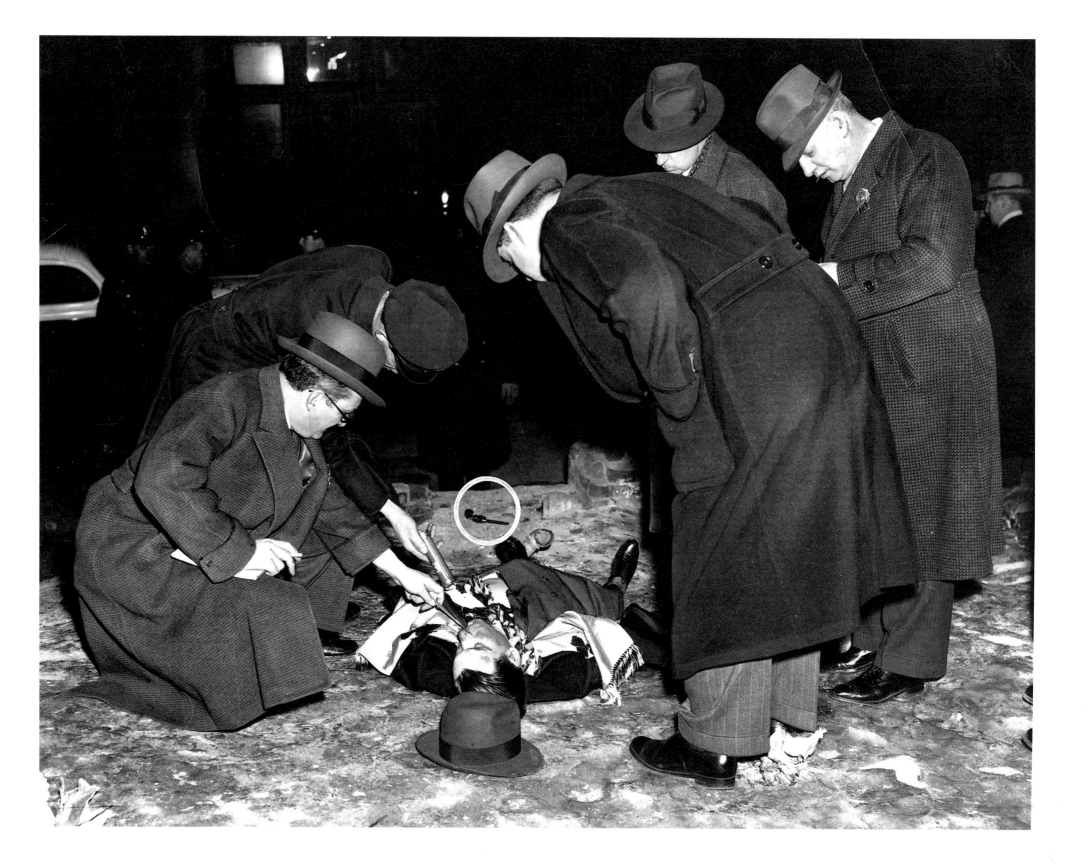

INTRODUCTION

Luc Sante

The impact of the tabloid newspapers in their first three or four decades—dating from the birth of the *Daily News* in 1919—is something we can now imagine only with difficulty. They dominated a field, narrow then, that has since expanded across the entire width of our world. On a regular basis they forcefully threw images at citizens, new and loud images, constantly changing, only a few hours removed from the events they depicted. The tabs really had no competition in this image traffic before television in the 1950s. Even then, for a decade or more, the expense of owning a TV meant that viewing one, for working people, remained an occasional and ceremonial community affair. There were newsreels in the movie houses, but they concentrated on national events and mostly, except in wartime, on staged handshakes and potted displays. For many years the broadsheets primarily carried portraits in their daily editions, not wanting to sacrifice space allotted to text; anything larger or more dramatic was kept for the rotogravure section of the Sunday package.

It was left to the tabloids to exploit the visual drama of breaking news. The bank robbery or love-nest raid that occurred while you were sleeping would be splashed across the front pages of the tabs when you woke up. In New York City you'd go to the newsstand and confront a riot of competing headline-and-photo combinations: the *News*, the *Mirror*, the *Graphic* for the better part of forty years, with other morning and evening papers contending for shorter periods. While the *Times* and the *Herald Tribune* would murmur about tariff acts and disarmament conferences, and cover the current local scandal or panic in one paragraph, if at all, on a remote inside page hard by the shipping registry, the tabloids retailed exclamation points. The photographs in the tabloids, especially those on the front pages, therefore took on an extra dimension, as if they had been endowed with motion and sound. Every day they had the task of waking up passersby while outshouting their neighbors on the racks. Every day, even if nothing much had happened in the previous twenty-four hours, they were required to say SOCKO!

The most fertile ground for drama was of course the police blotter. Fires and car crashes occurred sporadically, but crime happened daily. Fires and car crashes provoked bursts of *there but for the grace of God*, but by their nature such reactions were only bursts. Crime, though, was a story. Crime triggered a serial response mechanism in the tabloid audience: shock, blush, fear, rage, suspense, decent and indecent curiosity—some sequence of any or all of those items depending on the individual personality. The audience would be made party to a narrative, could follow the progress of a mystery,

GANG GETS REVENGE

JANUARY 29, 1939
Photographer: McCory

Gang Gets Revenge. Detectives examine body of Louis Cohen, put on spot in Lewis St., between Broome and Grand Sts., last night. Circle: his gun. He killed Kid Dropper 15 years ago.

follow the pursuit of a felon, follow the twists and turns of a trial. Non-fiction short stories were generated on a daily basis, and each era had its Crime of the Century, the equivalent of a real-life novel as it unfolded in the papers. The famous picture of Ruth Snyder in the electric chair, it should be recalled, was the capper to a courtroom drama that preoccupied the whole country for a year. As great as its emotional power is to us, its impact was immeasurably greater on readers who had hung on every detail of the case and felt as though they had come to know Ruth Snyder.

The picture of Snyder's execution is one of the icons of the twentieth century, but a rapid glance through this book will demonstrate that crime has a bottomless capacity for producing potential icons, no matter how mundane, how local, how quickly forgotten the facts of the matter. There are images here, as hook-laden as pop songs, that will carve out a permanent place in your memory. In part this is due to the kind of violence that crime perpetrates upon normal expectation. Like humor, crime acts upon disinterested parties as the forcible interruption of a train of thought. The banal sequence of everyday life, its details beneath notice when it is functioning normally, is suddenly shattered. The body lying face-down on the sidewalk looks all wrong, but maybe at first you don't see the blood or the wound, so that the body looks all wrong the way it would if it were snoring in a four-poster bed on the sidewalk. The suspect hiding his face with his hat makes a more memorable image than the barefaced suspect, particular circumstances aside, also because the action is memorably abnormal: the hat could be a cream pie or a stop sign. In looking at a crime photo we know we are looking at an image of radical disjunction before we are consciously aware of its narrative content.

But then crime retails death, or at best loss, so that even for spectators with no personal stake in the matter it is charged. It is surrealism with a knife. It radiates a dark glamour that no amount of deploring can eliminate. To those of us who were not killed or robbed it transmits a sort of contact high, a fleeting illusion of strength by virtue of our having been spared. Along the way it sweeps up into its aura all manner of props and settings. The photographs in this collection show among other things how the perfectly ordinary clothing of past decades—men's and women's suits, raincoats, fedoras—has been magnetized by association with the imagery of crime. Hats once worn by greater numbers of church deacons than by racketeers have in the popular imagination become the exclusive property of racketeers. And the more tawdry, feeble, pathetic the prop—the floral wallpaper, the scummy bedspread, the overworked linoleum—the more menacing its flavor will be.

We are looking at these photographs across a gulf of decades. Many of the living are now as dead as the dead;

the details of appearance and décor have been reassigned to nostalgia and connoisseurship; the stories themselves long ago departed not just from immediacy but from lore, and in all but a few cases from living memory altogether. Very few people who came into contact with these photographs—from their makers to their subjects to their original viewers—would ever have suspected that the beings of the future would find them interesting. Newspapers were perishables, to be bought, drained, and discarded, like cartons of milk or corn-flake boxes or calendars (and those who hung on to them were presumed to be touched in the head). Their contents immediately fled from most minds—how many readers could have identified LeRoy Luscomb (page 49), for example, even one day after his picture ran? The notion that such pocket lint could go on to enjoy a second life, as art, no less, would have seemed perverse.

Today, whatever qualms we may possibly feel in regard to a disinterested appreciation of these pictures has to do not with the triviality of their content, but on the contrary with their gravity. Lives were lost, and not on the field of honor, where an image taken and preserved would have a commemorative or expiatory function. These cheap, mean, banal deaths are nightmarishly distended by the process of reproduction. Again and again and again the lug gets his through the car window, the businessman crumples on the sidewalk in front of the gin mill, the war veteran shoots himself on the observation deck of the Empire State Building. You could argue that newspaper photography accomplishes this sort of serial killing on a daily basis. The idea is caught in the photographer William Klein's 1955 picture *Gun, Gun, Gun, New York*: six copies of the *Daily Mirror*, staggered along a rack, show cops hauling a corpse down a flight of stairs. The body was hauled down—*bam bam bam bam bam*—as many flights as there were copies printed.

The alchemical transformation of passing trivia and historically moot tragedy into art is a process usually assigned to the artist. Here, however—to take nothing away from the makers of these photographs—it is accomplished by the viewer, who adds a decisive distance that confers upon the photographs a condition opposite to that of their origins, a certain universality. The viewer looks at obscure individuals and sees archetypes, looks at chaos and sees design, looks at time fleeing and sees time standing still. Photography is in several ways a collaborative art, by virtue of the relative powerlessness of its practitioners, who can only frame, which is a relative and conditional operation. Because the photographer—at least the photographer on the street—cannot assert complete control over the contents of the frame, chance determines a measure of its contents, which keeps its meaning in flux. The meaning of photographs can thus effectively change over time; they can in fact come to a peak of significance, but

photography's history is too short for us to know whether
they can also die.

The photographers in this collection—with the
exception of the ubiquitous publicity hound Arthur
Fellig, known as Weegee—are not household names,
and we don't know enough about their collected output
to know how many of them were great, how many were
workmanlike, and how many were merely lucky. A
number of the pictures could have been made by any-
one reasonably competent who happened to be on the
scene with a camera. The artist in some cases may not
be the photographer at all but a non-human entity,
some amalgam of history, circumstance, equipment,
and association. Although drama is necessary to the
success of the pictures, it was nearly guaranteed by their
subjects; the photographers were usually trying less for
effect than for full coverage. Lighting and lens supplied
mood, sometimes inadvertently—sometimes night itself
deserves a credit.

This is not to detract from the talents and achieve-
ments of the photographers represented here, only
some of whose names we have. They were, after all,
working toward a specific end; they knew their grand
compositions might be cropped down to a two-shot, or
even a cameo. Vernacular photography is always subject
to such ambiguity. Its specific mission—newspaper
coverage, forensic evidence, scientific record-keeping,
insurance-claim documentation, whatever—establishes

a set of constraints that can liberate an artist from the
burden of excess choice, just as they can make it possi-
ble for a non-artist to produce the fortuitous work of art
through a collaboration of luck and formula. These
constraints, strategic or mercantile or procedural in
design but usually intended to reduce distraction and
get to the point, function like some hybrid between the
rigors of tradition and the chance operations of mod-
ernism. (It might be said, anyway, that those chance
operations, such as the games devised by the Surreal-
ists, were ways for rebels to approximate the benefits of
tradition—rituals for freethinkers.) Tradition in art has
benefits that are the same as its drawbacks: It allows
thought to be suspended in favor of feeling, architec-
ture in favor of embellishment, doubt in favor of faith.
While the result can be feeble, servile, repetitive work,
tradition can also free the imagination by giving it some-
thing to push against.

There were two principal sets of constraints for
news photographers: editorial (the need to compress as
much information as possible into the frame) and envi-
ronmental (the need to compromise on the scene with
the presence of obtrusive random factors ranging from
humans to headlights to weather). The photographers
could do virtually anything as long as they respected
those two rules. They were permitted effects if the
effects were indistinguishable from necessity—they
could not seek out a dramatic angle for its own sake,

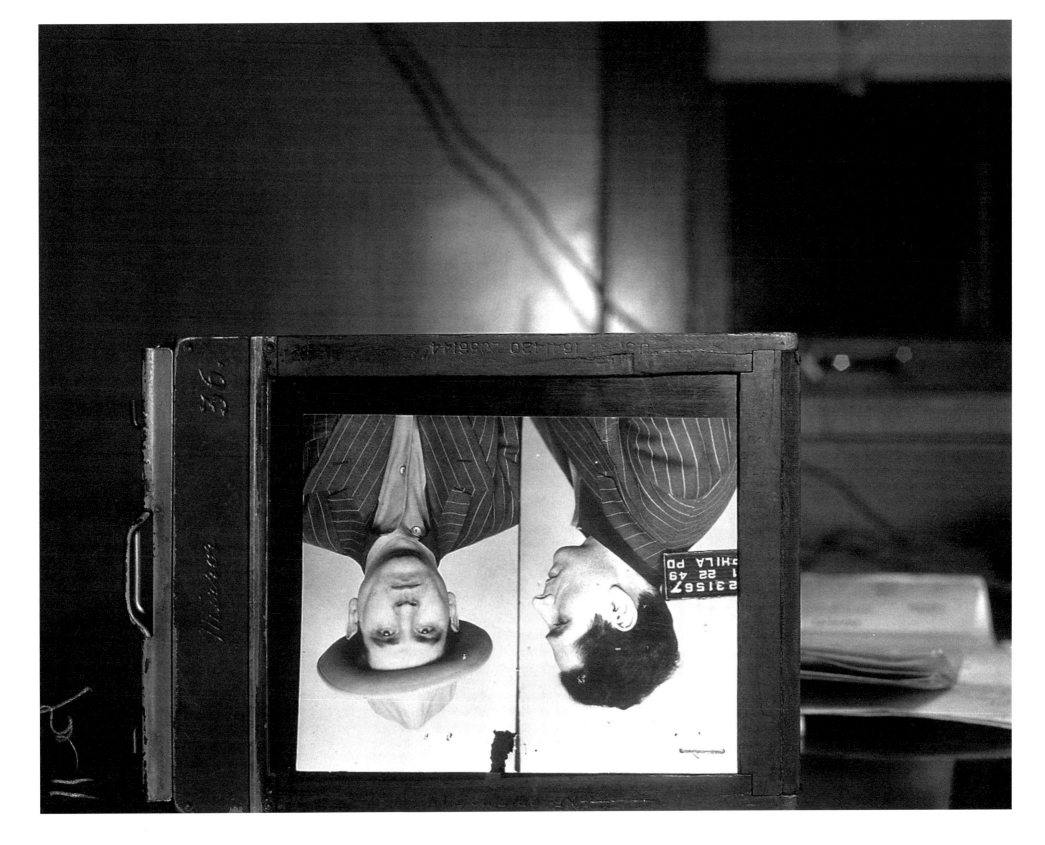

for example, but might have such an angle imposed on them by the need to get a shot over the heads of a crowd of onlookers. News photographers were conscripted into an avant-garde of making do. They were forced by circumstances into violating conventions of photography concerning lighting, composition, and so on. They themselves most likely did not think they were making art, and neither did anyone else at the time. We know otherwise in part because we have seen how avowedly artistic work, in photography and related media, belatedly caught up with advances made on the fly by the tabloid workers.

When we cast around for analogues to the work reproduced here, we don't think of the artistic photography of its time, or not at least until we consider the late 1940s or early fifties, when New York City–based photographers (Klein, Louis Faurer, Todd Webb, Dan Weiner, Gordon Parks, Robert Frank, to name a few) begin reflecting the influence of the tabloids. Of course we instantly think of Weegee, who through persistent salesmanship achieved metonymic stature. To people only superficially interested in newspaper street photography he embodied the genre, in part because of the legends he circulated about his singular gifts (his aptitude for getting to the scene before the cops did, say, or his unblinking eye) and in part because the publication of *Naked City*, in 1945, sacramentally elevated the work from throwaway to permanent. This is not to say that

Weegee wasn't a considerable photographer, but that he shared that unblinking eye with a host of lesser-known artists, many of them represented here, who may well be his equals. We can leave it to future scholars to take inventory of the collected output of Osmund Leviness and Jack Clarity and Alan Aaronson and Pat Candido and render judgment accordingly.

When we look at these pictures we also think of the movies. Conventional wisdom has it that film noir derives primarily from German Expressionism, from the stark lighting and tortured sensibility of *M.* and *The Cabinet of Dr. Caligari* as transmitted by European refugees in Hollywood in the 1940s. While this is true to a certain extent—the work of such transplants as Fritz Lang, Edgar G. Ulmer, and Billy Wilder was among the most significant—the look of the tabloids could not have failed to influence the genre. You can trace the progress of this influence over the decades represented here. A 1930 shot of a murder at the Chinatown People's Theater, for example, by a photographer identified only as "Condon," has a diffused background and a formal rigor we can compare to the look of Howard Hawks's *Scarface* (1932). McCory's 1945 picture of a slaying at Tony's Restaurant, with its violent angle, oblique window approach, and mocking use of advertisements, anticipates the blunt force of Anthony Mann's *T-Men* (1948) and the jazzy chill of Robert Aldrich's *Kiss Me Deadly* (1955). But then Rynders's 1956 floor-level picture of a

murderer's mother waiting alone in an empty courtroom hallway jumps all the way forward to the minimalist look of movies made by Jean-Pierre Melville in the 1960s and Francesco Rosi in the 1970s, and his agonizing shots of the murdered Bauer family, also from 1956, have a frontal impact that seems utterly contemporary today. It is notable, incidentally, that while the first picture resolutely says "art," the other two are equally emphatic about saying "this is not art," in just the way that artists for the last decade and a half have been prone to do.

How intentional were these choices? It is easy to imagine that every point along the scale from calculation to accident is represented in this collection, but that question is the wrong one. These pictures were made to satisfy the need of editors for bold layouts and of readers for eye-catching images. Perhaps they were also made, in some cases, in response to a photographer's private needs for structure, rigor, clarity, maybe even the odd bit of transgression. But now they have been reconceived for our eyes. The public that appreciated Weegee in 1945 could only take one of him, and in

addition it required a dose of his interlinear moralizing. Disinterested assessment had to wait for a time when the subjects of these pictures were no longer a part of living memory, for one thing. It also needed for aesthetic winds to shift, not to mention for a greater understanding of the ways in which photography is distinct from other visual media.

All photographers are to a certain extent powerless, subject to chance, acting in collaboration with factors beyond their control. We are now in a position to appreciate how that does not limit their art, but on the contrary gives their photographs the capacity to unfurl new meanings many years after the shutter was snapped. The pictures in this book are, to be sure, specific historical records of a now-vanished era. But they are also brand-new entries into the pool of living images, as new as anything on any canister now being developed. Bill Hannigan's unearthing and selection of them is in itself a work of art, one that challenges our understanding not just of photography's history, but of its present and its future as well.

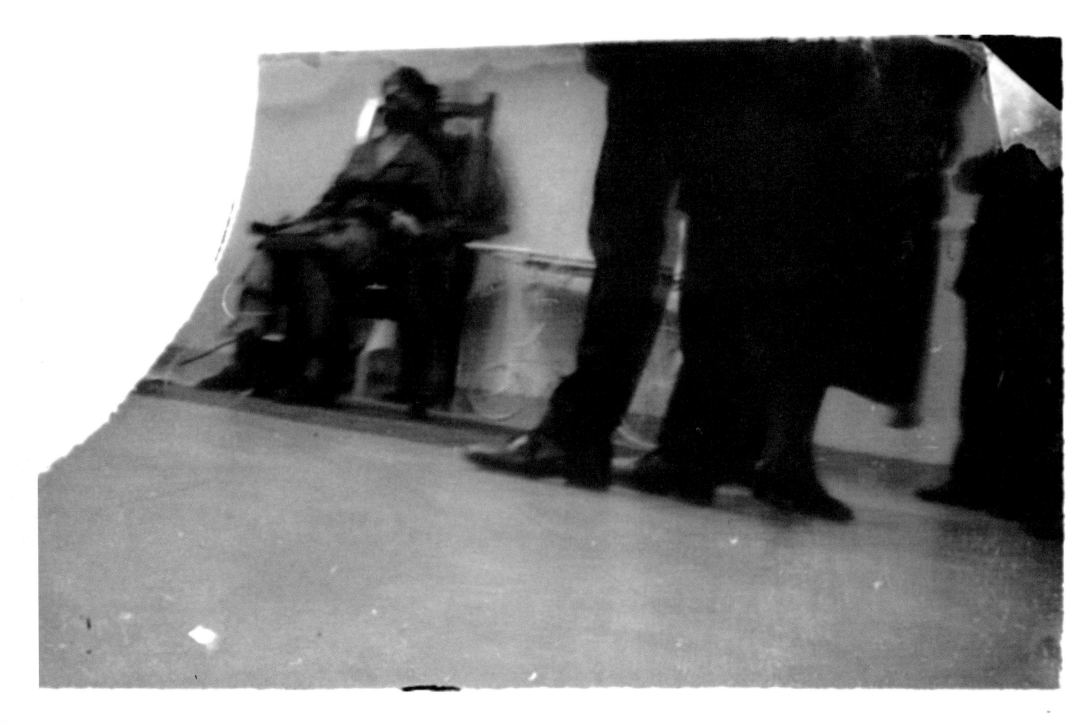

NEWS NOIR

William Hannigan

Shortly after 11 p.m. on the night of January 12, 1928, the convicted murderess Ruth Snyder was led into the death house at Sing Sing Prison, the first woman ever to face the electric chair. A small crowd of prison officials and reporters who had been gathered to witness the historic execution watched in silence while an ominous black hood was lowered over her head. Her eyes still peering out, she was bound and shackled, and the electrodes were set. This was society's price for the calculated bludgeoning, poisoning, and strangulation of a husband she no longer cared for. At 11:06 the executioner threw the switch, sending the retribution coursing through her body. At precisely the same moment, however, another device was activated, one that would forever capture the moment and blanket it in controversy. Unbeknownst to prison officials, Tom Howard, a photographer from the *Daily News,* had covertly raised his pant cuff to uncover a miniature camera linked to a shutter release that snaked up his leg and into his pocket. "DEAD!" was the single word that accompanied the picture he made, which ran on the paper's front page for the next two days, selling a sensational half million extra copies (page 17).

During the first nine years of its existence, the New York *Daily News*—or *The News,* as it styled itself—pushed the envelope of photojournalism to a level some thought reprehensible. To those critics, the Snyder picture was proof positive. The picture's publication unleashed a national furor. The *News* defended its position with the following statement:

> We doubt that many readers of THE NEWS want any apology from us for having obtained and printed this picture. Considered a feat of newspaper enterprise, the publication of the photograph was remarkable and will not soon be forgotten.... the incident throws light on the vividness of reporting when done by camera instead of pencil and typewriter.... We think that picture took the romance out of murder.... Why other newspapers, which gave column after column of infinitely more gruesome descriptive language to the Snyder execution, should criticize THE NEWS for publishing a photograph thereof is something we cannot understand.

Managing Editor Frank Hause, ignoring opposition from other department heads who found the image too grisly, ran the picture in the absence of the publisher, Joseph Medill Patterson, who, upon returning, backed Hause's decision. That decision ended a heated war among New

RUTH SNYDER EXECUTED

JANUARY 12, 1928

Photographer: Tom Howard

Print made from the original negative so famously acquired by the *News* of Ruth Snyder's execution.

Right: The camera strapped to Tom Howard's ankle.

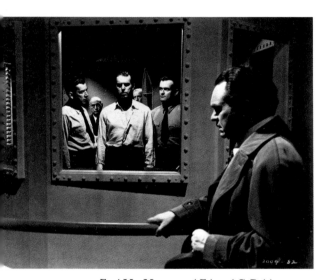

Fred MacMurray and Edward G. Robinson (foreground) in *Double Indemnity*.

York's tabloids, which had been vying for position with sensationalist headlines and photos that helped to fuel the national backlash led by "respectable papers," religious figures, and other reformers. But despite this opposition the influence that the tabloids had on America continued to grow and infiltrate other cultural realms. The quintessential film noir, *Double Indemnity* (1944), was one among many products of the Snyder case. Though it was produced fifteen years after the publication of the Snyder photo, director Billy Wilder was forced by the Hayes Commission to cut a twenty-minute conclusion that depicted the execution of a convicted murderer. While Hause did not face an established authority safeguarding public morals, he knew he would face a reaction from self-appointed moralists in the community. He nevertheless decided to run the photograph, standing on the no-holds-barred foundation the *News* had established upon its debut as America's first tabloid newspaper.

On the twenty-sixth of June, 1919, the *Illustrated Daily News* hit the news stands with little fanfare. ("Illustrated" was dropped on Nov. 20, 1919). The *News* was the vision of Patterson and his co-founder and cousin Robert R. McCormick. The two were co-editors of the *Chicago Tribune*, which had been built by their grandfather Joseph Medill, but after he met Lord Northcliffe in London and witnessed the popularity of his *Daily Mirror*, Patterson had become convinced that the tabloid format (half the size of the standard news-

paper page) would be a success. Patterson, who had declared himself a socialist in 1908, set out to build a paper for "the common people," and the editorial of the premier issue defined a paper that sought to change the face of American journalism:

> The *Illustrated Daily News* is going to be your newspaper. Its interests will be your interests. It is not an experiment, for the appeal of news pictures and brief, well-told stories will be as apparent to you as it has been to millions of readers in European cities. We shall give you the best and newest pictures. The story that is told by a picture can be grasped instantly. The policy of the *Illustrated Daily News* will be your policy. It will be aggressively for America and for the people of New York. It will have no entangling alliance with any class whatever.

Patterson recognized the potential of the photograph not only as a device for relaying the news, but also for its appeal to a semiliterate immigrant population. While other newspapers of the day focused on serious issues such as labor unrest and the approach of Prohibition, the first two feature items in the *Illustrated Daily News* were its own beauty contest and a "new and original series of detective stories by E. Phillips Oppenheim." Combined with a full-page photograph of the Prince of Wales on horseback, it announced a New York paper like no other.

The time was right. In New York, the effects of industrialization and immigration had transformed the

Average net paid circulation of THE NEWS, Dec., 1927; Sunday, 1,357,556 Daily, 1,193,297

DAILY ⬭ NEWS EXTRA EDITION

NEW YORK'S ⬭ PICTURE NEWSPAPER

Vol. 9. No. 173 56 Pages New York, Friday, January 13, 1928 2 Cents

DEAD!

—Story on page 3

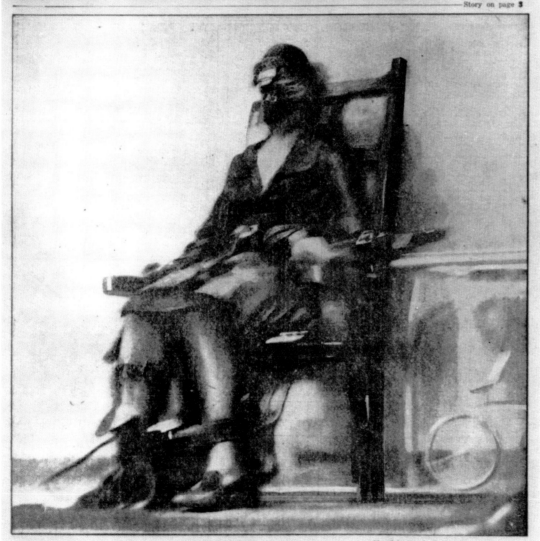

(Copyright: 1928: by Pacific and Atlantic photos)

RUTH SNYDER'S DEATH PICTURED!—This is perhaps the most remarkable exclusive picture in the history of criminology. It shows the actual scene in the Sing Sing death house as the lethal current surged through Ruth Snyder's body at 11:06 last night. Her helmeted head is stiffened in death, her face masked and an electrode strapped to her bare right leg. The autopsy table on which her body was removed is beside her. Judd Gray, mumbling a prayer, followed her down the narrow corridor at 11:11. "Father, forgive them, for they don't know what they are doing?" were Ruth's last words. The picture is the first Sing Sing execution picture and the first of a woman's electrocution.

city into a congested and fast-paced metropolis. As the city spilled into the outer boroughs and the subway system expanded, people were travelling greater distances between work and home. Large headlines, pictures, and condensed coverage, coupled with the tabloid format, made the *News* an ideal commuter paper. It soon took its place among the many new wonders of the rising city—the movie house, the skyscraper, jazz—and captured the attention of readers with lurid and sensational stories. In the era of Prohibition and the Depression, there were plenty.

During Prohibition, from 1920 to 1933, the murder rate in New York rose significantly, reaching a peak that would not be equalled until the early 1960s. In tandem with this growth, the *News* increased the space allocated to crime. In 1920 it devoted only six percent of its space to crime; by 1930 crime coverage had expanded to twenty-three percent. Crime paid, and pictures of crime paid even better. Circulation soared to over a million by December of 1925; only six years after its inception, the *News* was the largest-selling paper in the nation. This made it the most widely viewed forum not only for photojournalism, but also for photography in general. Like the city it covered, the *News* continued its phenomenal growth, reaching a peak of nearly five million Sunday circulation in 1948.

Sensational block headlines and accompanying photographs led to a trail of imitators—the *Daily Mirror*

and the *Evening Graphic* in particular—and to unceasing attacks against its editorial morals and ethics. But nothing sold papers like a good love triangle that ended in murder, and in the *News,* "sex was happily blended with homicide," as a *New Yorker* writer observed in 1938. This editorial focus, coupled with an emphasis on photography, brought forth relentless efforts at "getting the shot." The concentration on pictures established a standard, and an aesthetic, unique to the *News.*

In the early days of "New York's Picture Newspaper," Eddie Jackson was hired as its first photographer, and he, along with Hank Olen and Louis Walker, formed a department that would come to shape the character and content of the young daily. Jackson would provide the *News* with its first big scoop when he captured the carnage caused by an anarchist's bomb outside the J. P. Morgan offices on Wall St. in September 1920. The staff existed as a collective of versatile and innovative photographers who were able to adapt to any assignment. A survey of available credit lines illustrates the democratic approach to assignments and the presence of a strong editorial focus. Outside the studio, it was not until the 1960s that specialists emerged at the *News.*

The crime photographs produced in the 1920s and early thirties were unique in form from all that would follow, the most notable distinctions being that in the early years few of the images were shot outdoors, and

none were shot outdoors at night. The photographers were bound by their medium. Flash bars, lenses, and film speeds were neither powerful nor fast enough to capture images that could be reproduced on newsprint. This constraint profoundly contributed to the developing aesthetic of the images. It produced the softness and glow inherent in many of the early photographs, as well as the blurring of subjects or settings that lent them a mysterious, unearthly feel. However, the subjective gaze of the photographer was also a defining factor. Driven by a rising demand from editors and readers. and by competition among themselves, the photographers sought new ways to relay the story and portray the players. The images of courtroom scenes from this period illustrate both the technical characteristics and subjective characteristics of *News* photography. The efficacious components of these images are, first, their immediacy, the simple fact that photographers were allowed such close access to the court proceedings, and, secondly, the lack of flash. (Although photographers were permitted in the courtroom, they were prohibited from using their flash bars.) But, as is inherent in photography, the subjective decision of when to release the shutter and how to frame the subject completes the image and thus sets the *News* apart. In the image of D. A. Frank Coyne on page 25, for example, the photographer shoots from the perspective of the man who sits accused of killing his wife,

behind the witness stand, as Coyne presents a photo of the key piece of evidence that would convict the murderer. The power of this image lies in the combination of these factors.

Between 1930 and 1935, *News* photography was transformed by technical advances. In 1930 came the introduction of the bulb flash, which allowed for faster shutter speeds. At about the same time, the staff gradually switched from glass plates to acetate-based films, which allowed for faster film speeds. When coupled with the new, faster optics, this meant sharper images and fewer limitations. The photographer could now shoot almost anywhere, in any or no light. But the single biggest advance of the time may have been the Speed Graphic, a camera that would become the quintessential press camera from the 1930s through the 1960s. Primarily using a four-by-five-inch film format, the lightweight Speed and the later Crown Graphics replaced the German-made Ica which used four-by-six-inch glass plates. Folding into a compact box and easy to use, the handheld Speed Graphic incorporated all the newest technical developments, and by liberating the photographer from cumbersome equipment and highlighting the element of speed, it helped to shape a new aesthetic.

The crime image in the *News* continued to evolve. The introduction of the flash gun (battery case, flash bulb, and reflector), all attached and synchronized with the shutter release, added the most significant component—greater depth of field with heavy shadow. Images gained a heightened focus and deep, sensuous blacks that, like the development of stage lights in the theaters along the Bowery, induced a visceral sense of drama. In the image of William Turner (page 21), an early bulb flash photo from late 1932, all these elements are apparent; the sharp focus and the heightened shadows adding vitality to this undoubtedly posed photograph.

This new style of photography was not always treated generously by critics. In his history of photography, Beaumont Newhall described the effect of the flash gun as being, "for the most part, grotesque, because the harsh light flattened faces, cast unpleasant shadows, and fell off so abruptly that backgrounds were unrelieved black." Subsequent critics have understood that the introduction of flash photography brought something new to photojournalism. John Szarkowski noted, in *Photography Until Now* (1989), "The flash did more than provide light; it defined a plane of importance, in which the subject was described with posterlike simplicity and force, and beyond which the world receded quickly into darkness. The lack of naturalness in these pictures was not a shortcoming but a source of their melodramatic power. It is as though terrible and exemplary secrets were revealed for an instant by lightning." Nevertheless, as evidenced by Newhall's comment, the tabloid photog-

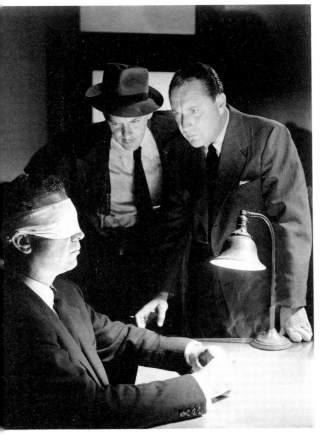

Victor Powell (blindfolded) in *Murder My Sweet* (1945), directed by Edward Dmytryk.

WAITING FOR A GRILLING

JANUARY 8, 1932
Photographer: Costa

Holdup and Murder. Confessed killer William Turner handcuffed to Detective Jacobs, waiting for a grilling in the District Attorney's office.

rapher's pictures, with the possible exception of those made by the self-promoting Weegee, were not, until fairly recently, considered significant in the history of photography. But their influence is undeniable.

The images published by the *News* and by the tabloids that followed were everywhere. On newsstands, in Automats, and on subways, the tabloid's block headlines and graphic cover photos left an indelible mark on the city, altering the way it viewed itself, and how it was viewed by the rest of the country. These images became signifiers of the Big City, and the crime photograph was projected onto the public psyche.

The other significant factor in the evolution of the tabloid crime image is subjective—the editorial choices made by a photographer (and his editors) in representing a crime, the crime scene, the criminal, and the victim. As opposed to the forensic photograph, the images in the pages of the *News* fed on drama. The photographers at the *News* developed a distinctive visual language as they investigated components of explanation. In it roles were defined: criminals, cops, D.A.'s, politicians, and marginal cast members became associated with certain codes that enabled the reader to understand the story at a glance. Body language and dress were the most immediate. At its height, during Prohibition, an era that saw the invention of the public enemy and the celebrity gangster, the *News* worked within this set of signifiers and

helped define the roles of criminal life. Each player, caught up in his or her part, invariably utilized that language to manufacture the personae captured for the paper. The Turner image shows the triangulation of criminal, cop, and photographer, all contributing to the message the reader received.

In this 1932 photograph, we see in place certain elements that, as they flooded the public imagination, aided in establishing this visual code, which would in turn come to define the look of the gangster film, and the aesthetic that would become known as film noir. Although the noir look is conventionally understood to have grown out of German Expressionism, there can be little doubt that tabloid photography provided the raw visual data at the heart of noir. The *News* helped define the dangerous big-city streets that were its setting, and the photographs of what transpired in this dark world, with its ubiquitous criminality and unyielding sexuality, were a part of the public's visual language years before the films now associated with this style. Using dark shadows and high contrast lighting, the *News* expressed the real and imagined aspects of the city that are the vocabulary of noir.

The photographs that follow of Harry F. Powers (page 41), David Beadle (page 43), Hope Dare (page 45), and William Turner, none taken later than 1941, show direct similarities with films noir of the forties and fifties. The still from *Murder, My Sweet* (1944) repro-

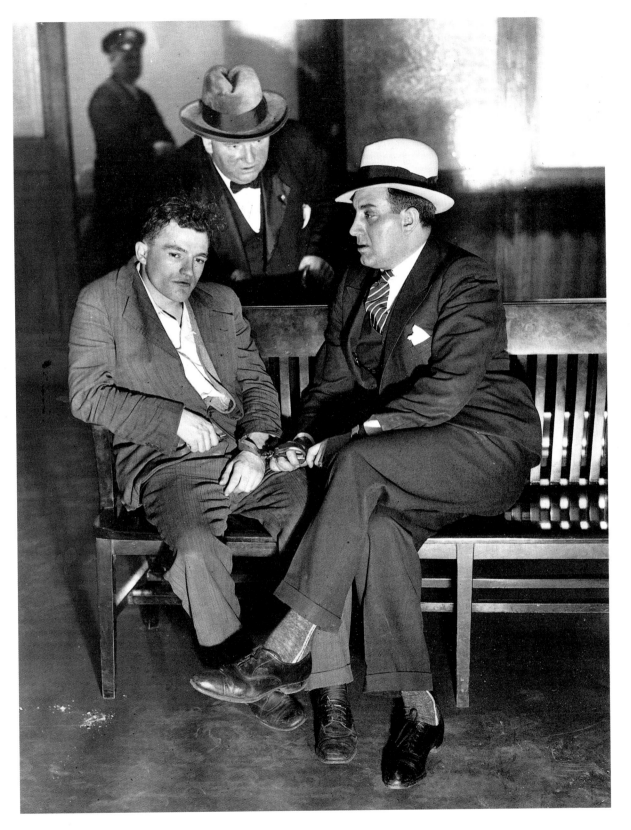

duced here incorporates the lighting, postures, and composition of the Turner image, which predates the film by twelve years. One of the most influential of all noir films, *Double Indemnity* (1944), also imitates tabloid photography. In a still depicting the murder scene, Fred MacMurray and Barbara Stanwyck stand over their victim (page 22). The framing of the body, the desolate surroundings, and, most importantly, the single light source mimicking a news photographer's flash gun, are all visual elements the public recognized through tabloids. By using this established visual language, the studios were able to convey theme and plot to viewers, the viewer knowing what to expect. It is without question that by the time these films were made, tabloid images had permeated the visual language of the filmmakers. Ben Hecht, a prominent newspaperman, went on to pen the screenplays for many noir films, including *Where the Sidewalk Ends, Kiss of Death*, and *Ride the Pink Horse*. Once the noir aesthetic became fully established in Hollywood, the form and content of the *News* still functioned to reinforce it, as America's growing fascination with crime and the city outlasted even the most fervent reform attempts through the late forties and fifties.

It was not until certain other significant technical changes occurred in photojournalism that the aesthetic changed again. With the advent of smaller cameras, medium format and then 35mm, and as electronic flashes replaced the flash bulb, the clandestine activities

Fred MacMurray and Barbara Stanwyck in *Double Indemnity*.

of New York took on another look. The high-contrast, deeply shadowed photographs of the tabloid slowly faded as one photographer after another retired the Speed Graphics for the more lightweight 35mm models. Also affected was the subjective gaze: the instinct that the career photojournalist had developed for knowing the exact moment to release the shutter was lost to the motor drive. Gone too was the relationship of cop, criminal, and photographer. The openness that allowed the photographers to make these images was replaced by antagonism. Access to the crime scene and police, and therefore the subject matter, was lost. These images not only aided in defining and recording an era but also became part of the public's vision of the dangerous metropolis in the era leading up to the suburbanization of America. They are not only compelling records of New York but also an intricate part of the visual language that has come to define the city.

References

Alexander, Jack. 1938. Profiles: Vox Populi. *The New Yorker* (August 6, 13, 20, 1938).

Bessie, Simon Michael. 1938. *Jazz Journalism: The Story of Tabloid Newspapers*. New York: E. P. Dutton & Co.

Chapman, John. 1961. *Tell It To Sweeney: The Informal History of the New York Daily News*. Garden City, N.Y.: Doubleday and Co.

Daily News Library. Back issues and clipping files.

McGivena, Leo. 1969. *The News: The First Fifty Years of New York's Picture Paper*. New York: News Syndicate Co.

Newhall, Beaumont. 1982. *The History of Photography*. New York: The Museum of Modern Art.

Ruth, David E. 1996. *Inventing the Public Enemy: The Gangster in American Culture, 1918–1934*. Chicago: Univ. of Chicago Press.

Szarkowski, John. 1989. *Photography Until Now.* New York: The Museum of Modern Art.

Tebbel, John W. 1968. *An American Dynasty*. New York: Greenwood Publishing Group.

PLATES

The headline and descriptive text in a plate caption is taken from the caption that originally appeared with the photograph, when the caption could be located. Descriptions in italic type are transcriptions of captions provided by the photographers at the time the pictures were made. The date given in the plate caption is the "run date," or date of publication, if the date is known.

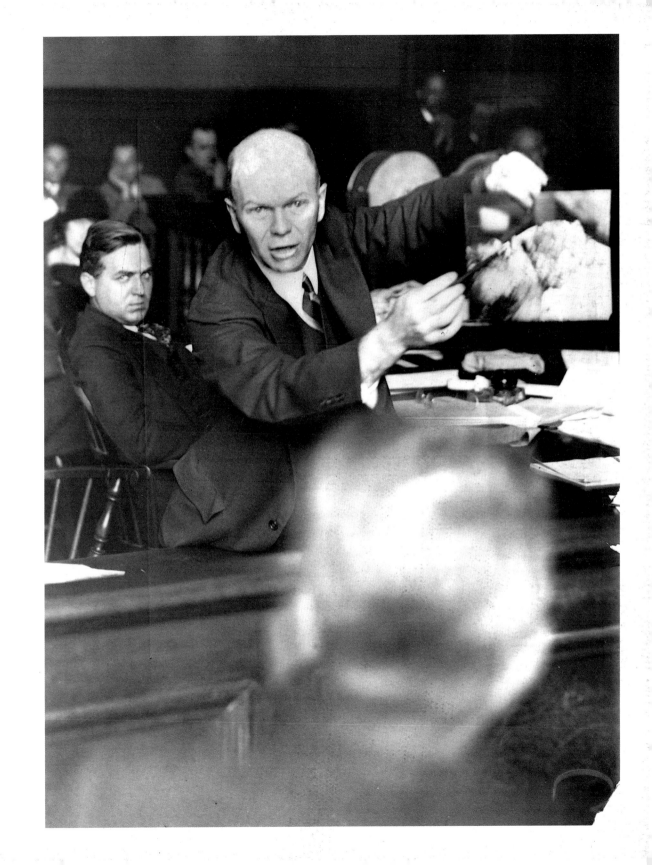

D. A. ADDRESSES JURY

September 28, 1929

Daily News photo

District Attorney Frank Coyne addresses jury during
Peacox murder trial.

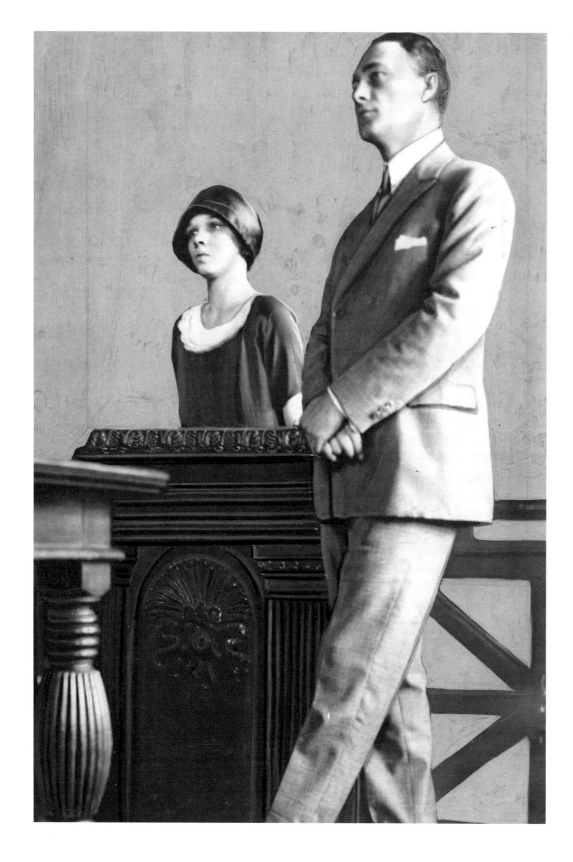

YOUNGEST MURDERESS

June 22, 1925
Daily News photo

Sentenced. After Judge McIntyre yesterday sentenced Dorothy Perkins (above, with Attorney Brooks) to from five to fifteen years in Auburn prison, youngest girl to be tried on first degree murder charges in state, [he] vowed to take steps to prosecute Michael Connors, man she blames for downfall, on a serious charge.

YOUNG KILLER

February 24, 1930
Photographers: Twyman & Hoff

A study of the young killer James Baker, note the reflection. Made on train just before arriving at Pennsylvania Station—photographer's caption

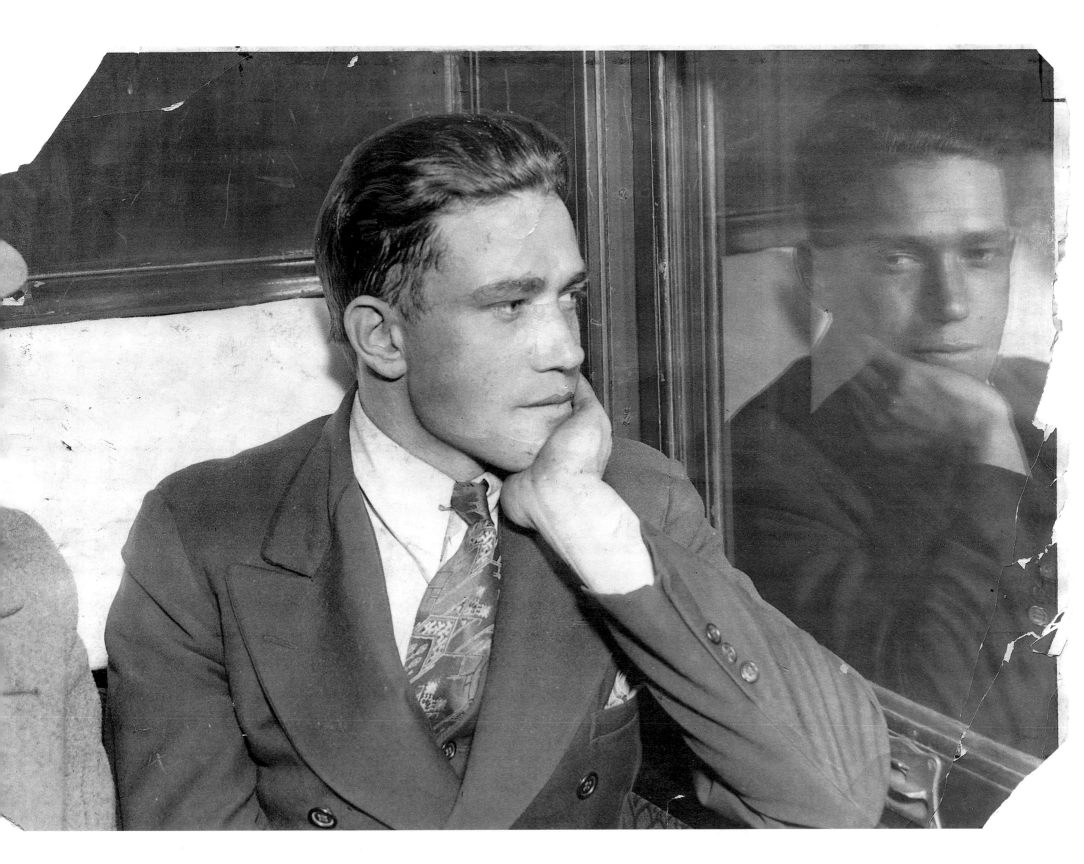

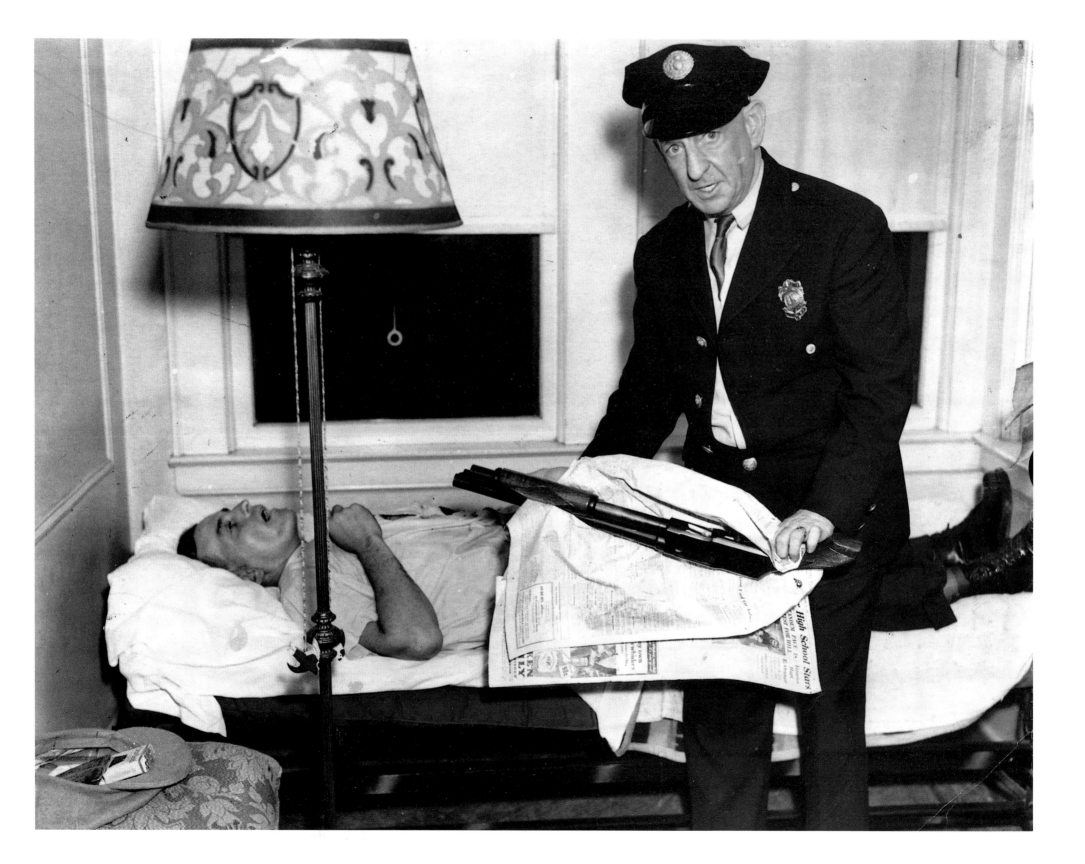

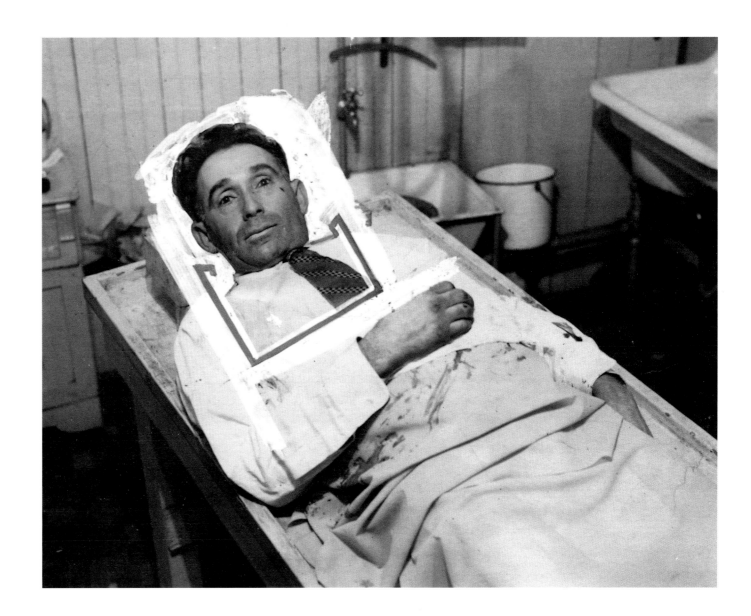

MASS MURDER EXECUTIONER

SEPTEMBER 19, 1935
Photographer: R. Morgan

Mass Murder Executioner. Policeman holds sawed off shotgun with which Charles Geery, whose body is shown lying on the bed, slew three others in suicide pact in Newark early today. The executioner telephoned police and then killed himself.

VICTIM OF GANG GUNS

DECEMBER 13, 1935
Photographer: Detrick

Samuel Mandel. Victim of gang guns in Paterson.

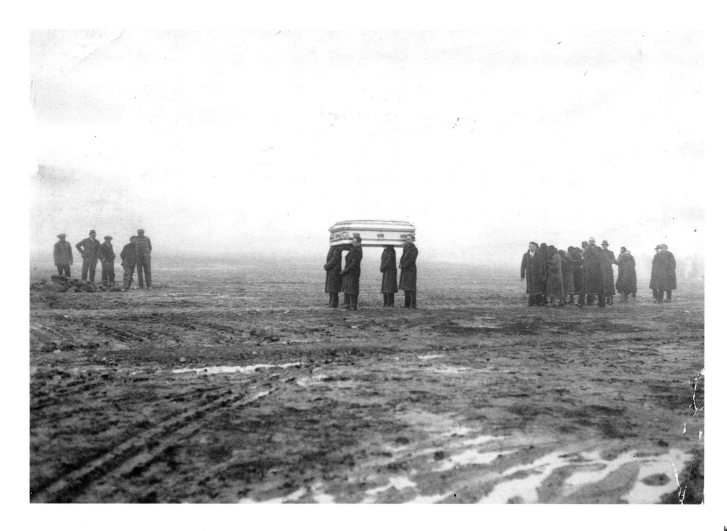

KILLER'S END
February 12, 1932
Photographer: Osmund Leviness

Killer's End. A dreary sky…a rain soaked grave…
a casket borne by professional pallbearers…a weep-
ing widow…a dozen mourners. Graphically the
camera portrays killer Vincent Coll's epilogue in St.
Raymond's cemetery.

MOTHER OF THE ACCUSED
August 21, 1931
Photographer: Boesser

West Side Ct.

*Mrs. Hannah Cranmer, mother of Ruth Jayne
Cranmer in court.*—photographer's caption

SHOOTING AT A CHINESE THEATRE

JULY 10, 1930
Photographer: Condon

Chink shot—At the People Theater—Bowery

*Photo shows Patrolman Herman Guran, of the
Elizabeth street Police station looking over the body
[of] Hangwah Hung—photographer's caption*

AMUSED BY MURDER

SEPTEMBER 19, 1929
Daily News photo

Elvira Howard, friend of the slain girl, seemed to take
a portion of the trial as a joke.

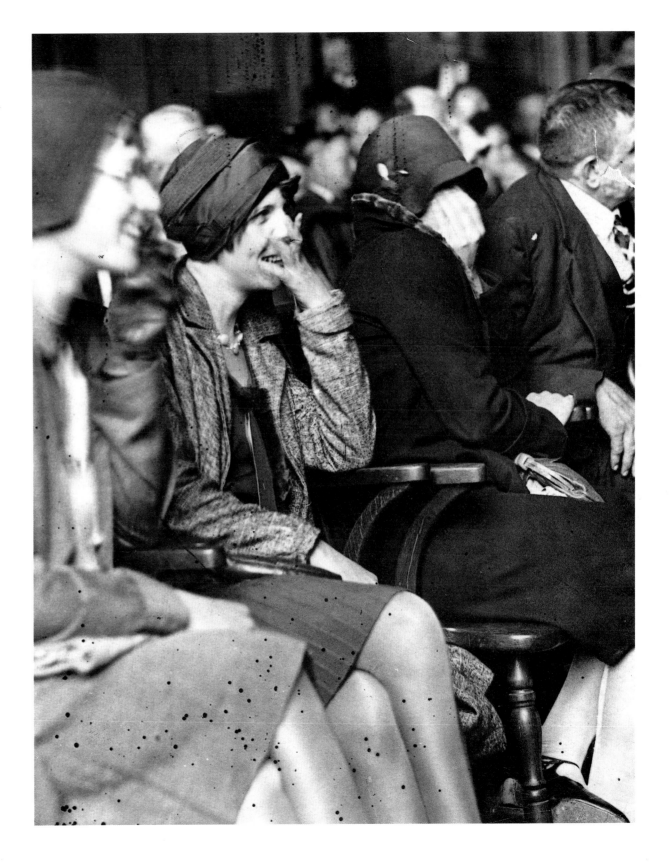

33

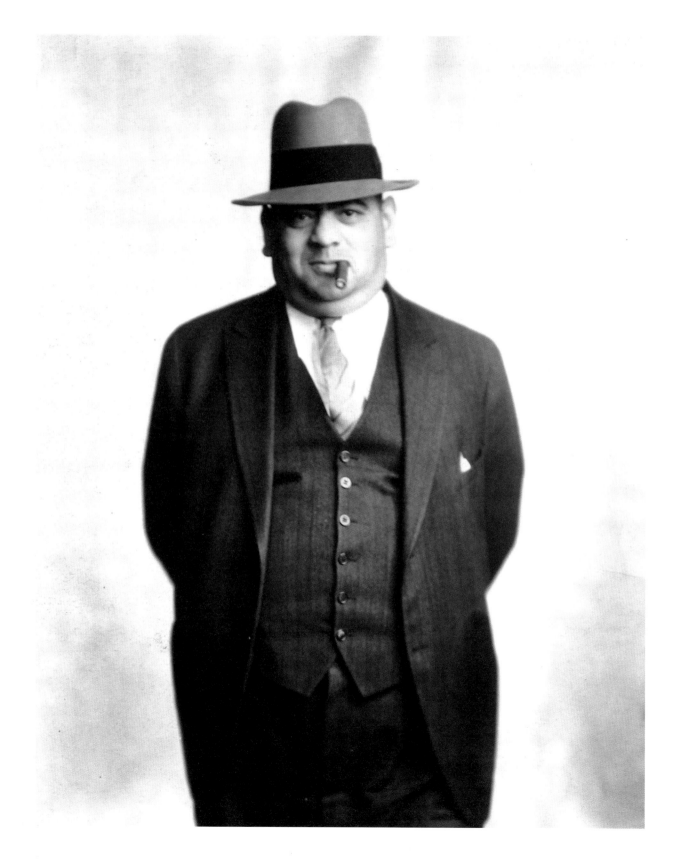

"CHOWDERHEAD COHEN"
APRIL 9, 1931
Daily News photo

DAPPER ATTORNEY GENERAL
FEBRUARY 12, 1935
Daily News photo

Cigar in mouth, dapper Attorney General Wilentz
(center) walks up courthouse steps for afternoon
session.

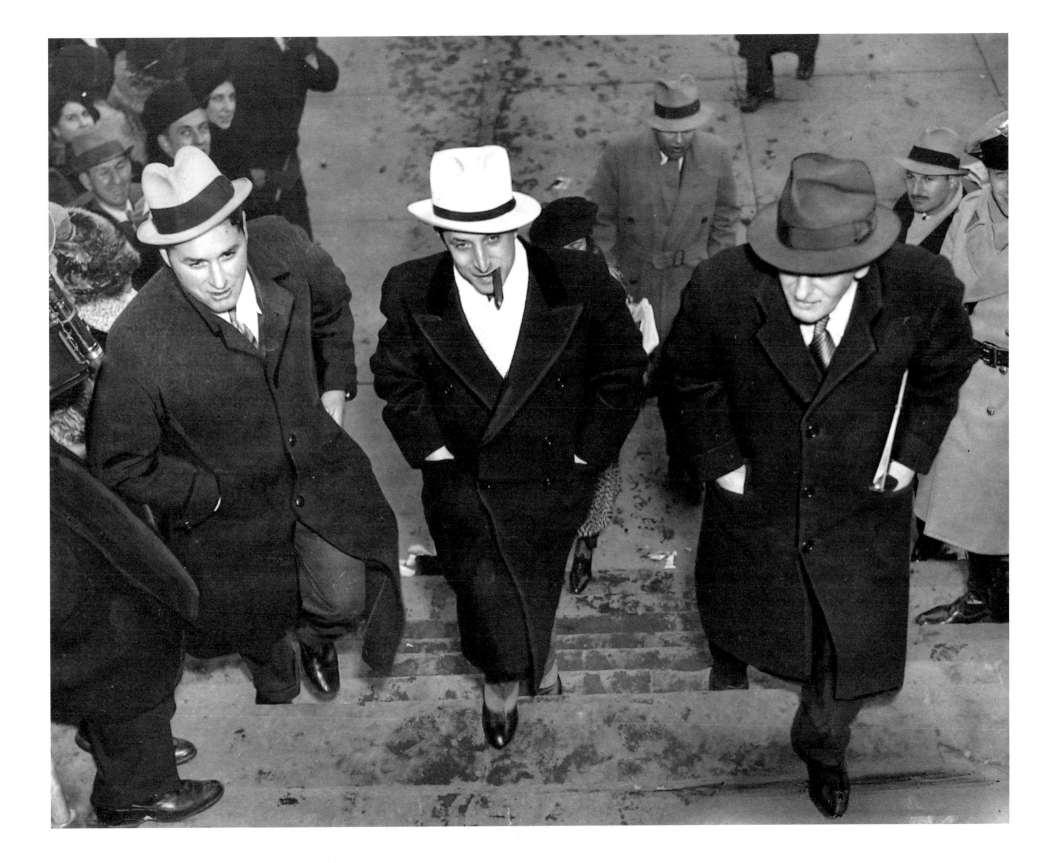

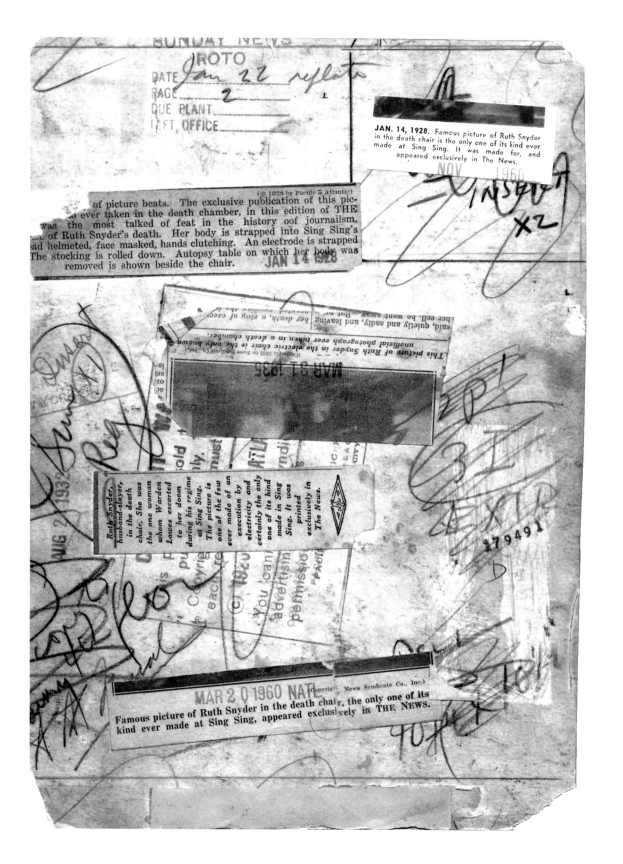

JAN. 14, 1928. Famous picture of Ruth Snyder in the death chair is the only one of its kind ever made at Sing Sing. It was made for, and appeared exclusively in The News.

NOV 1960

(© 1928 by Pacific & Atlantic)

of picture beats. The exclusive publication of this pic-
o ever taken in the death chamber, in this edition of THE
was the most talked of feat in the history oof journailsm.
of Ruth Snyder's death. Her body is strapped into Sing Sing's
ad helmeted, face masked, hands clutching. An electrode is strapped
The stocking is rolled down. Autopsy table on which her body was
removed is shown beside the chair. JAN 14 1928

said, quietly and sadly, her death, a stay of exec
her cell, he went away. But
This picture of Ruth Snyder in the electric chair is the only known
unofficial photograph ever taken in a death chamber.

MAR 31 1935

Ruth Snyder, husband-slayer, in the death chair. She was the one woman whom Warden Lawes escorted to her doom during his regime at Sing Sing. The picture is one of the few ever made of an execution by electricity and certainly the only one of its kind made in Sing Sing. It was printed exclusively in The News.

You can advertise permission

379491

MAR 20 1960 NAT

Famous picture of Ruth Snyder in the death chair, the only one of its kind ever made at Sing Sing, appeared exclusively in THE NEWS.

RUTH SNYDER EXECUTED

JANUARY 13, 1928

Photographer: Tom Howard

Left: Reverse side of the print reproduced on facing page.

Right: Print made for publication from the negative so famously acquired by the *News* of Ruth Snyder's execution.

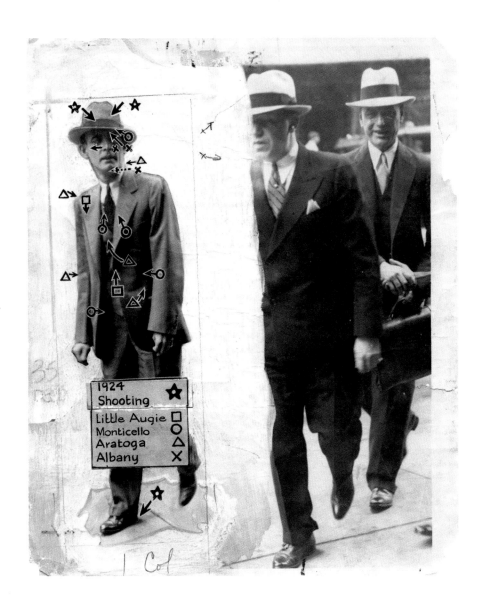

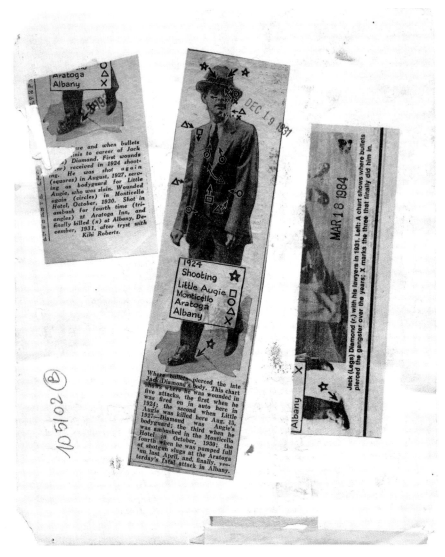

CAREER OF JACK "LEGS" DIAMOND

December 19, 1931

Daily News photodiagram

Where bullets pierced the late Jack Diamond's bodyFirst wounds (star) received in 1924 shooting. He was shot again (squares) in August, 1927, serving as bodyguard for Little Augie, who was slain. Wounded again (circles) in Monticello Hotel, October, 1930. Shot in ambush for fourth time (triangles) at Aratoga Inn, and finally killed (x) at Albany, December, 1931, after tryst with Kiki Roberts.

Reverse side of print shows photodiagram as published.

MYSTERIOUS ATTACK

June 10, 1941
Daily News photodiagram

Artist's photodiagram of pepper throwing incident which temporarily blinded Jenny Dolly in her apartment on the gold coast of Chicago, March 4, 1937.

JAILBREAK MASTERMIND

JANUARY 26, 1938

Photographer: Pat Candido

Percy Geary yelled in court yesterday. Here's another time he yelled, when he was captured after jailbreak last fall.

GRIM ROOM

APRIL 26, 1943

Photographer: Robert S. Wyer

Grim Room. In the depths of remorse, manacled LeRoy Luscomb, 32, sits in a room with his dead wife... at Delhi, N.Y. Police say Luscomb killed her with a deer rifle after she left him and their three children because of his interest in another woman. Luscomb is charged with first degree murder.

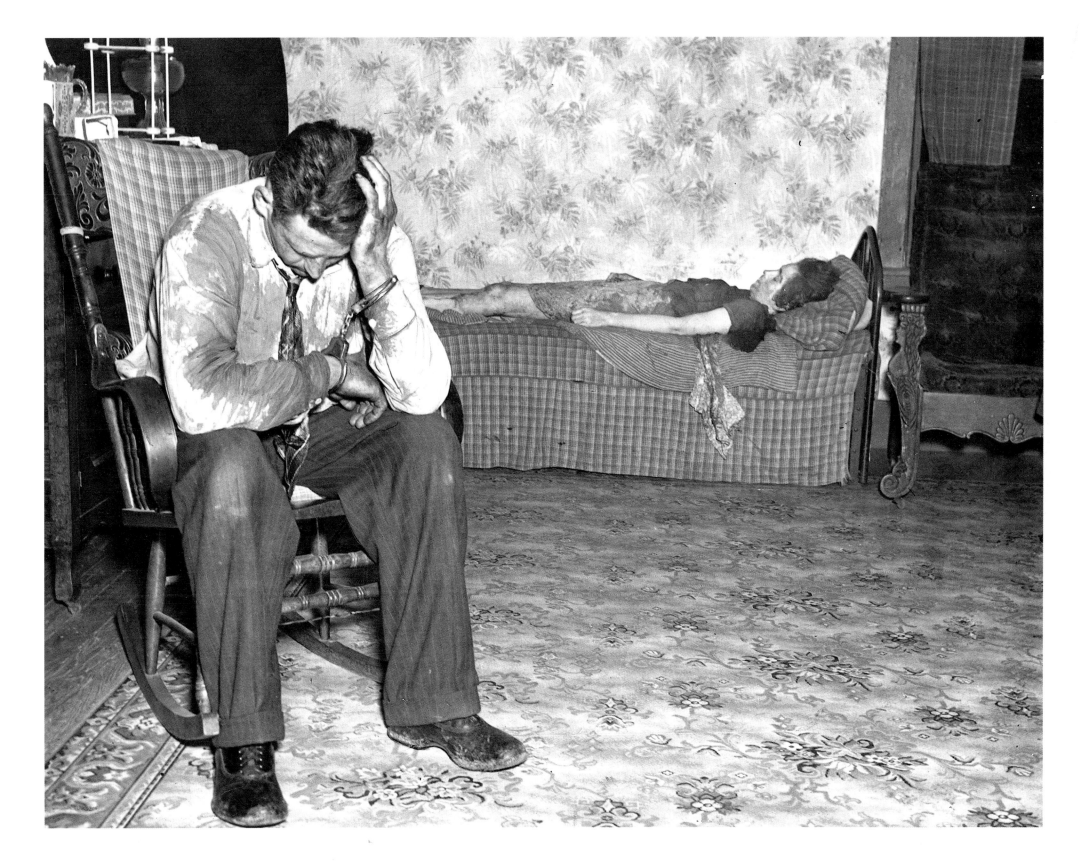

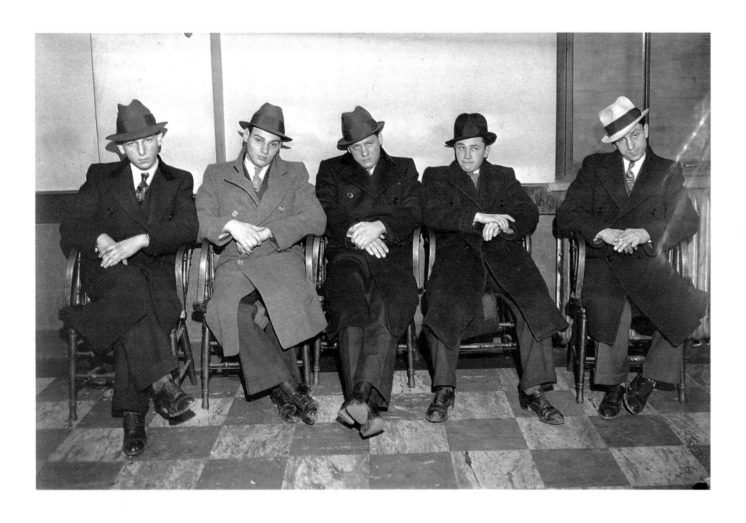

SEIZED AFTER 60-MILE-AN-HOUR CHASE

December 27, 1932

Daily News photo

Seized After 60-Mile-an-Hour Chase. The five youths at Police Headquarters after their capture. L. to r., Jerome Gans, 20; Abe Clurman, 21; Harry Spisto, 19; Sidney Kudlick, 19; and Andrew Lella, 19.

SHOOTOUT

September 12, 1923

Daily News photodiagram

Depiction of Walter Ward's version of the shootout that ended with Ward slaying Clarence E. Peters.

WOMAN GOES TO CHAIR!

DECEMBER 30, 1931
Daily News photo

Woman Goes To Chair! The first of her sex to be sentenced to death in Sing Sing from Manhattan in thirty-six years, Ruth Brown (center), 24, colored gun moll, is led to the Sing Sing death house by matron and detective. She was convicted as an accomplice in the slaying of a man in a speakeasy last May.

COP KILLER

FEBRUARY 19, 1935
Photographer: Fred Morgan

Cop Killer Metelski captured in Newark, N.J. Edward Metelski and Paul Semenkewitz, who escaped from Middlesex County Jail last Saturday.
—photographer's caption

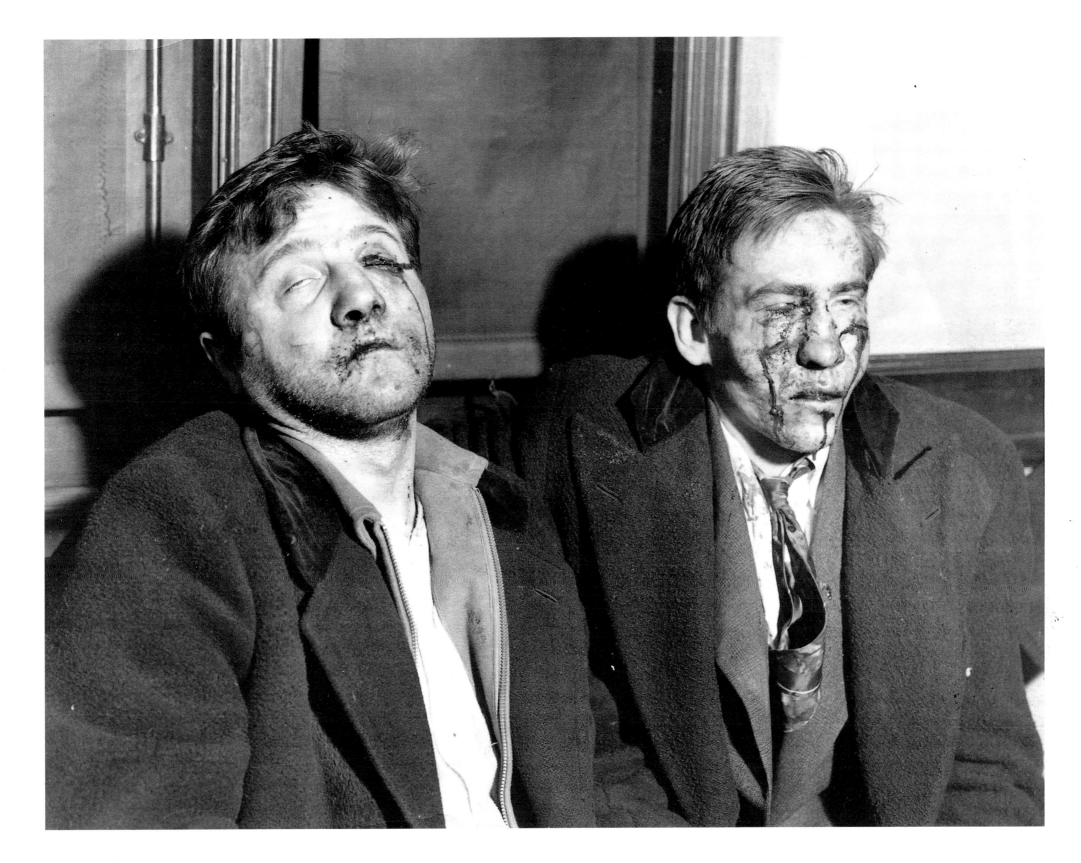

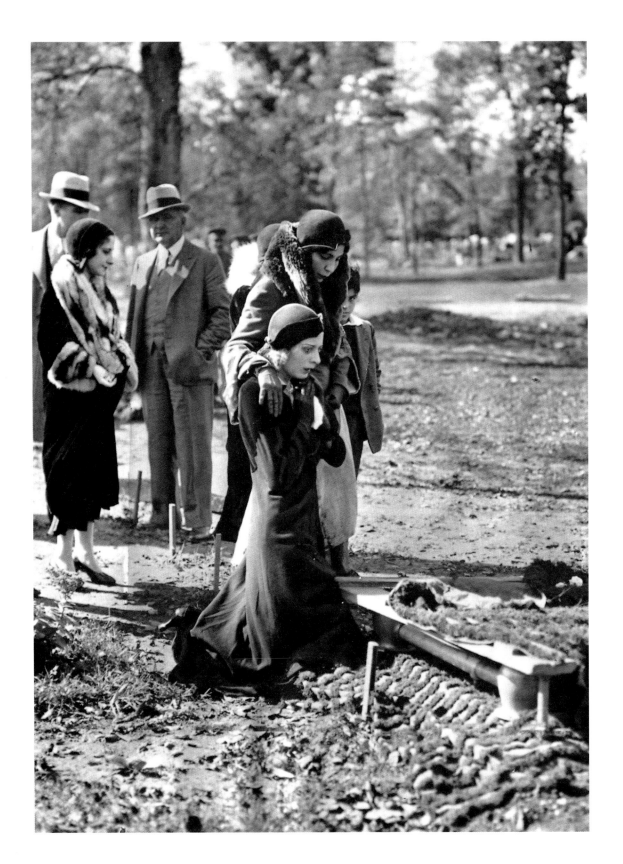

BIGAMIST MOURNED

OCTOBER 18, 1931

Photographer: John Tresilian

Picture shows Eva Mackay with Mrs. Henrietta Franchini, wife of Charles Franchini, vice perjury witness, as she prayed at his grave. Mrs. Helen Vidal Franchini, also married to the deceased, stands at the rear left.

HOTEL OF HAPPINESS

MARCH 19, 1940

Photographer: Wallace

Murder Ring. Pix shows scene near Hurleyville, N.Y. summer 1936. Underneath the "Hotel of Happiness" sign...Irving Ashkenas lies slain. Murder syndicate member Pretty Boy Levine admits complicity in the job.
—photographer's caption

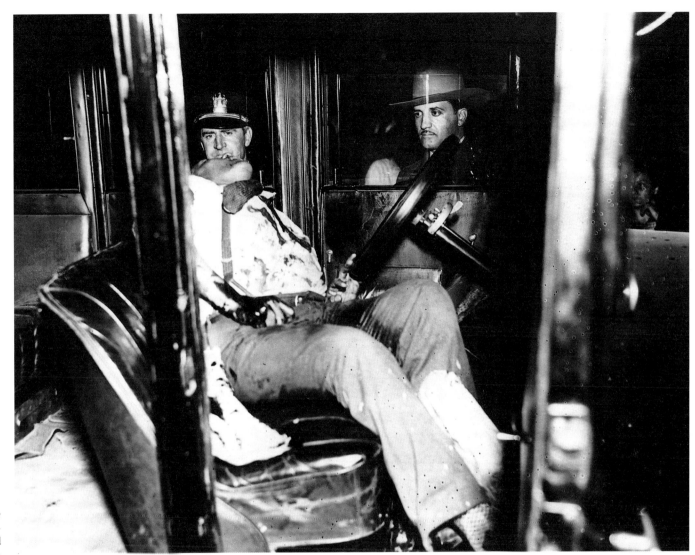

SNIPER'S BULLET SLAYS WOMAN

APRIL 9, 1934
Photographer: Levine

Sniper's Bullet Slays Woman. Yetta Einhorn, kindly ghetto mother, was shot down yesterday as she chatted with a friend in front of her Orchard Street bread store. Crowds gather around her body while mystery sniper is sought.

ANOTHER TRIANGLE CASE...

MAY 31, 1935
Photographer: Detrick

Man Murdered in Auto. Paramus, N.J.

Chief of Police, Bernard Martin of Paramus Police, and Carl De Marco of Bergen County Police, examining body of late David Corly...in Dodge Sedan in which he was killed on Howland Ave., off Spring Valley Rd., Paramus....Another triangle case....
—photographer's caption

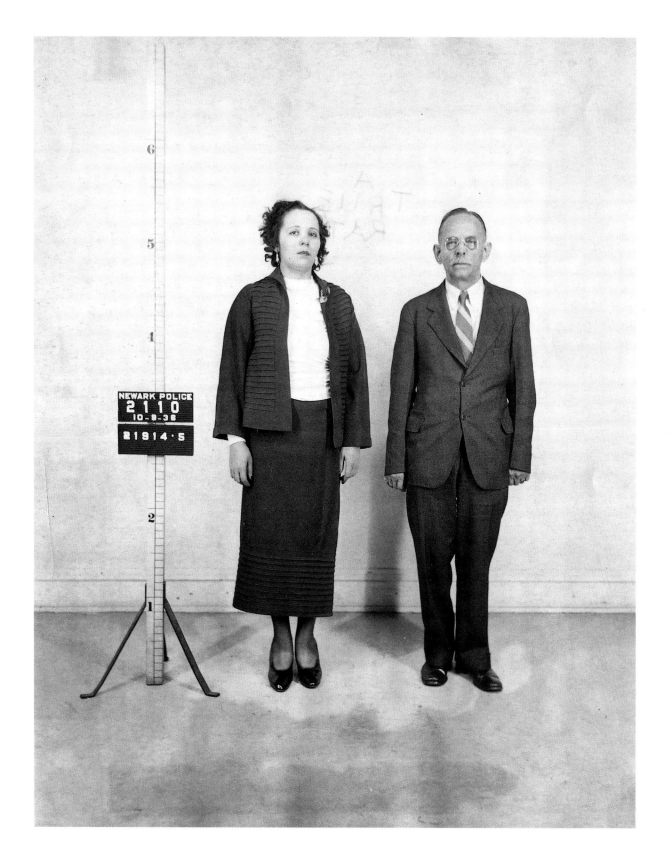

ABORTIONISTS

October 12, 1936
Photographer: Fred Morgan

*Abortion Hospital, Newark, N.J. Nurse Anna Green
and Dr. G. E. Harley.*—photographer's caption

MURDERED A GOOD SAMARITAN

February 21, 1940
Daily News photo

Annie Beatrice Henry held for press photographers
by Sheriff Henry W. Reid of Calcasieu parish.

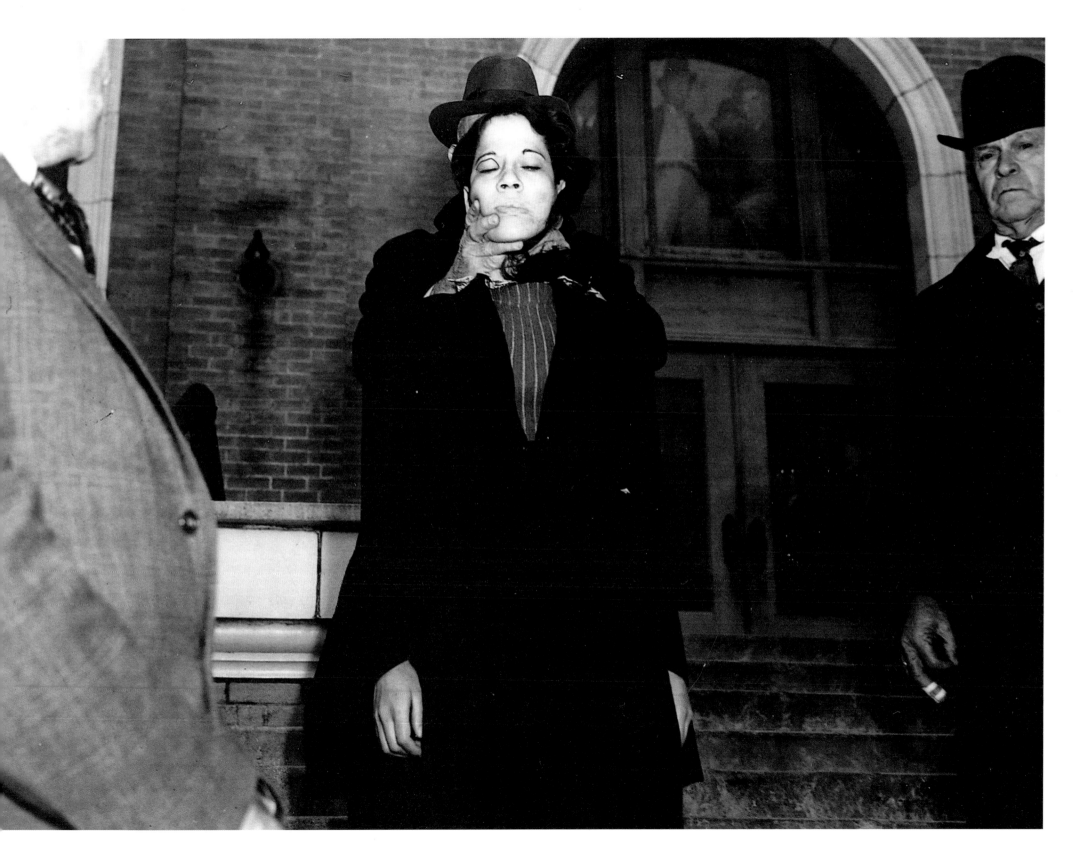

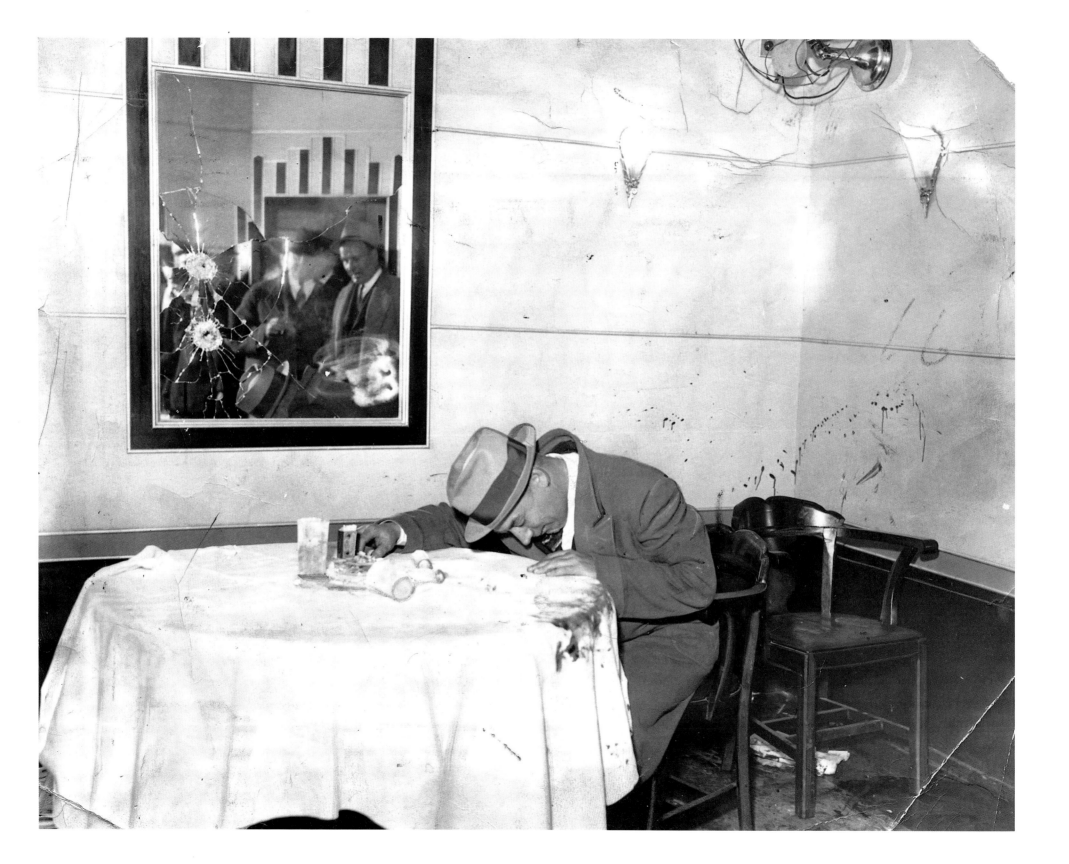

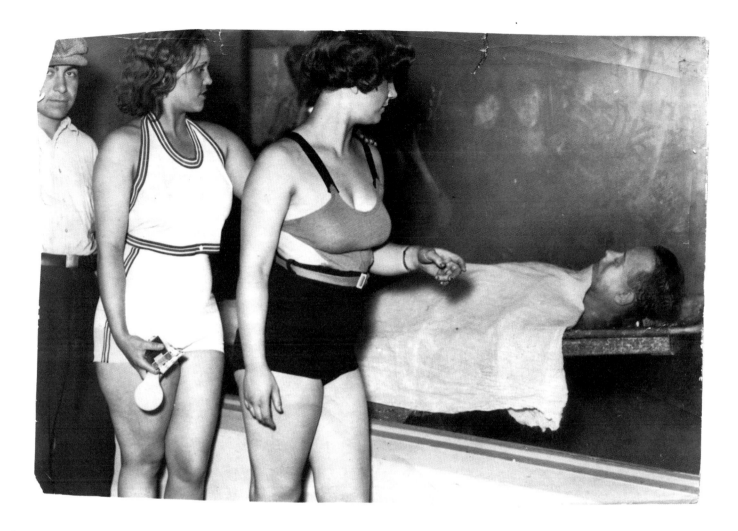

POSING AS DUTCH SCHULTZ

OCTOBER 24, 1935
Photographer: Detrick

Here is how police and ambulance doctors found Dutch Schultz in Newark cafe after machine gun attack. Detective Michael Beachman poses to show how Dutch was crumpled over table. It was on this table detectives found a tell-tale pack of tally sheets showing Schultz' income from illicit sources was $827,000 for one month.

VIEWING DILLINGER

JULY 26, 1934
Daily News photo

Betty and Rosella Nelson, sisters and entertainers at the Liberty Inn at 661 N. Clark St. come to view Dillinger body at the morgue early this morning. Make a visit in their bathing suit.
—photographer's caption

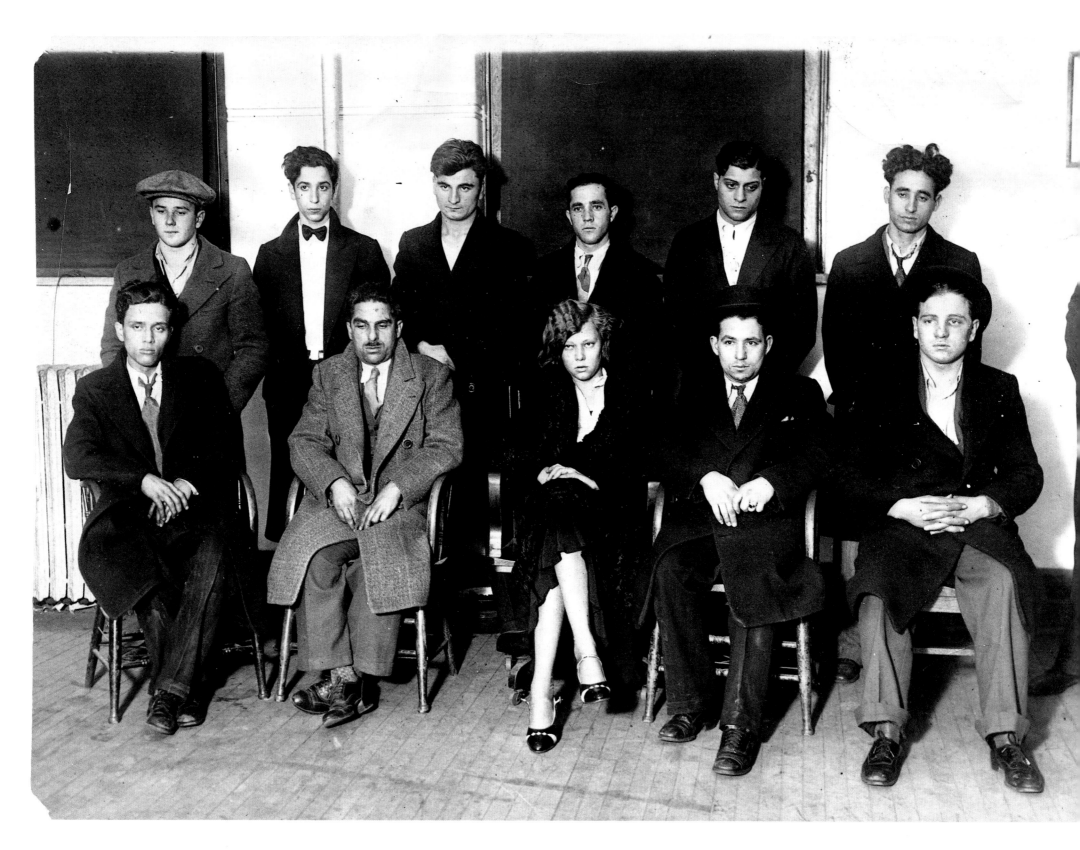

STICK-UPS

JANUARY 8, 1931
Photographer: Edger

Nine men and 1 girl held as stick-ups.
108th Precinct, L.I.C.

(Sitting L. to R.) Peter Hendrickson, 24, Mike Greco,
35, Virginia Wright, alias Bobbie Bates, 32, Frank
Summer, 26, William Fay, 19. (Standing L. to R.)
Alfred Zimmer, 19, John Scaminaci, 18, Frank
Oliveri, 21, John Woods, 19, Salvatore Giannone,
22, and Tony Sauterli, 24 yrs.
—photographer's caption

THE TOMBS

NOVEMBER 7, 1941
Photographer: Charles Payne

Tombs Layout

Officer and photographer, posing as prisoner,
trudge across the famous Bridge of Sighs from
the courthouse detention pen to the prison.
—photographer's caption

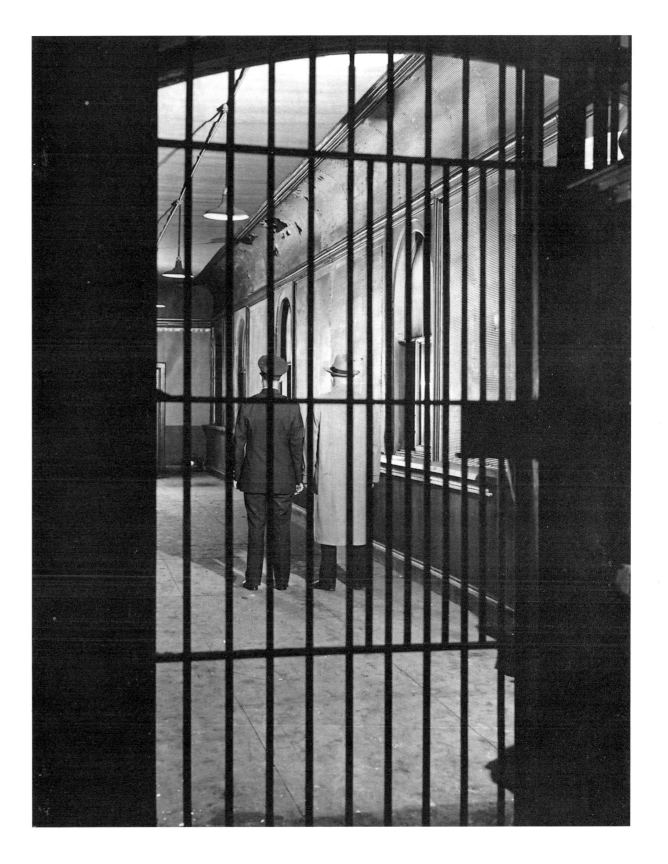

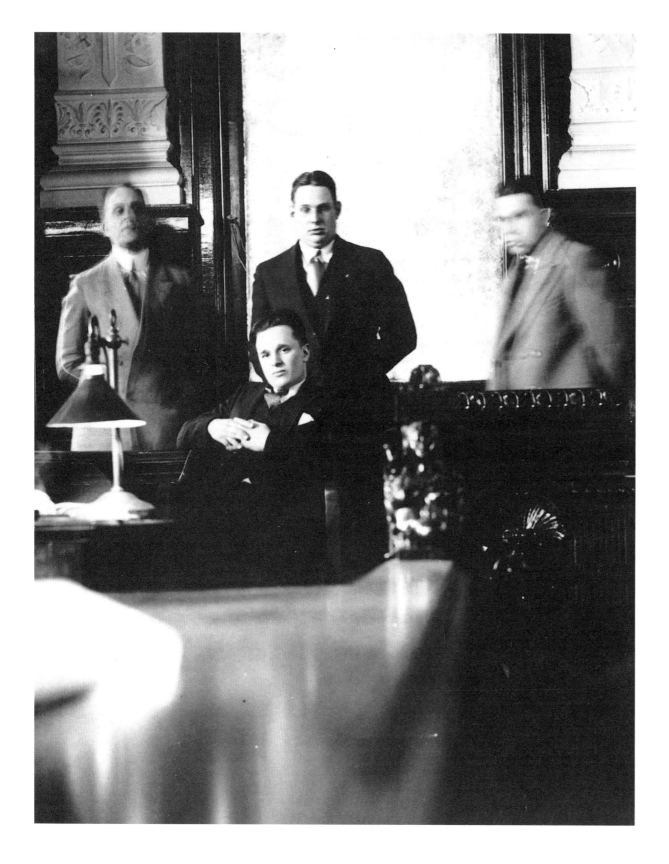

"TWO-GUN" CROWLEY

DECEMBER 3, 1931
Daily News photo

Patrick O'Brien trial
Criminal Court

Two-gun Crowley on witness stand, detectives are
standing behind him, back of the witness stand.
—photographer's caption

SPOT MURDER

AUGUST 7, 1936
Photographer: Arthur Fellig (Weegee)

Spot Murder

Close up of man [Dominick Didato] found killed
on Elizabeth St. in front of Italian resteraunt a few
blocks from police hdqs. Note gun besides body.
These photos were made a few minutes after shots
were fired—photographer's caption

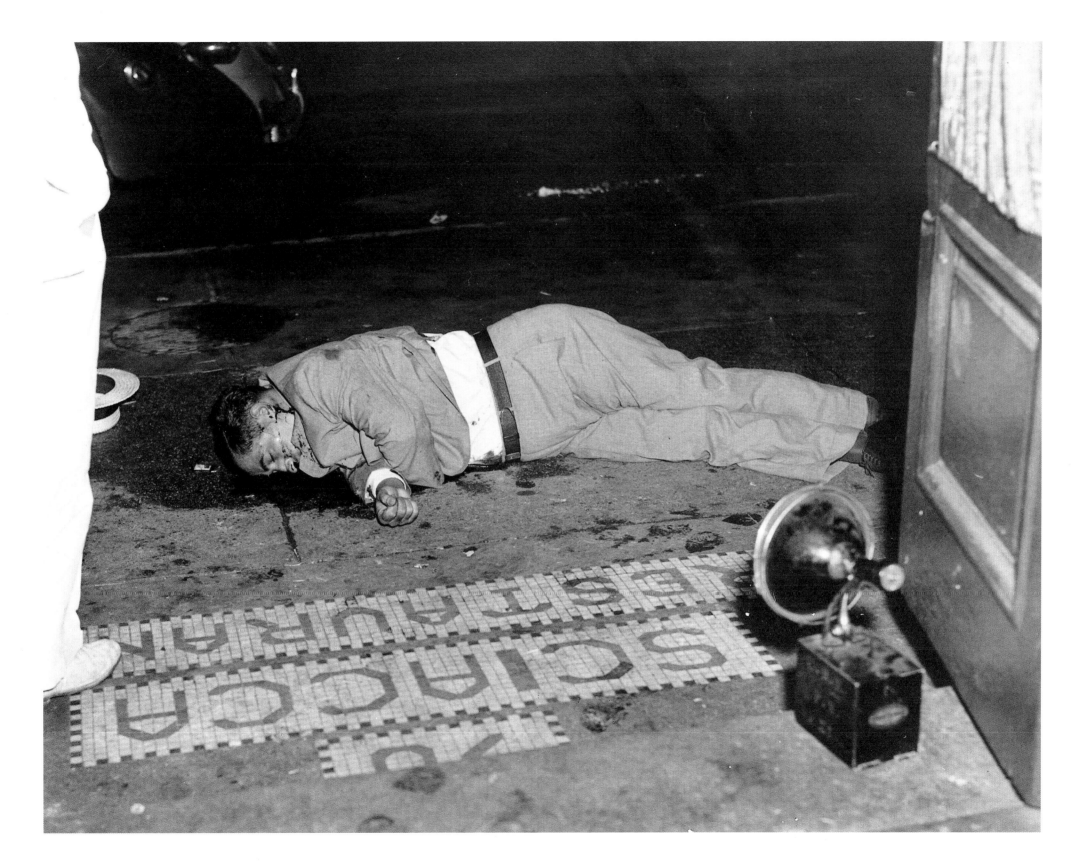

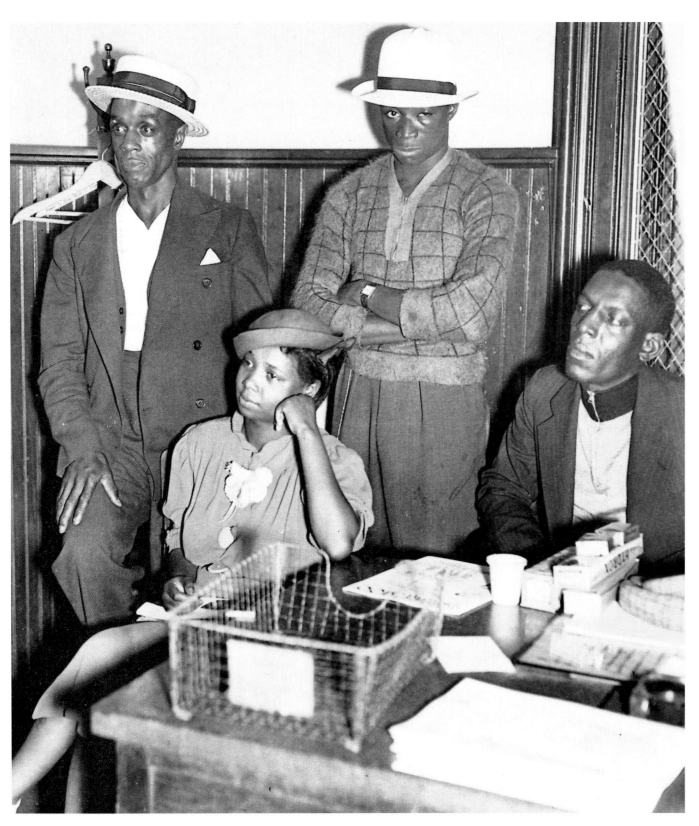

FOUR HELD IN DEATH OF CITY MARSHAL

AUGUST 9, 1936

Photographer: Osmund Leviness

*Hold four in death of city Marshal
East 126th St. police station*

*L to R: Alice Smith, Arthur Jackson, standing behind
her with straw hat—he is held as material witness
with…seated on right is Frank Coleman who
killed Florea. Standing behind him is Neil Hamilton
who confessed that Coleman struck Florea
—photographer's caption*

JAZZ-AGE SLAYER

SEPTEMBER 17, 1929
Daily News photo

Guard Ed Valentine with Prisoner Earl Peacox before his trial in a White Plains Court for the murder of his wife.

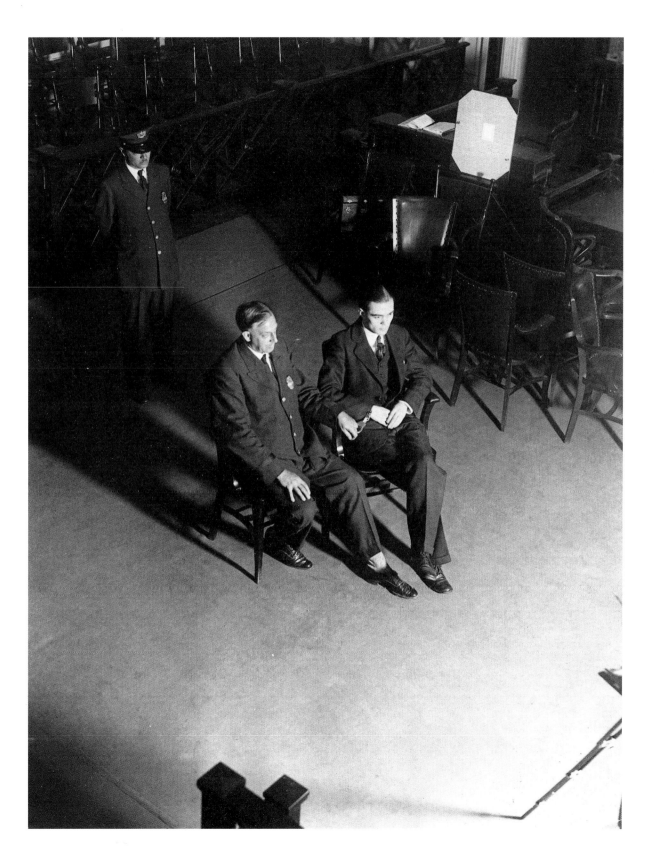

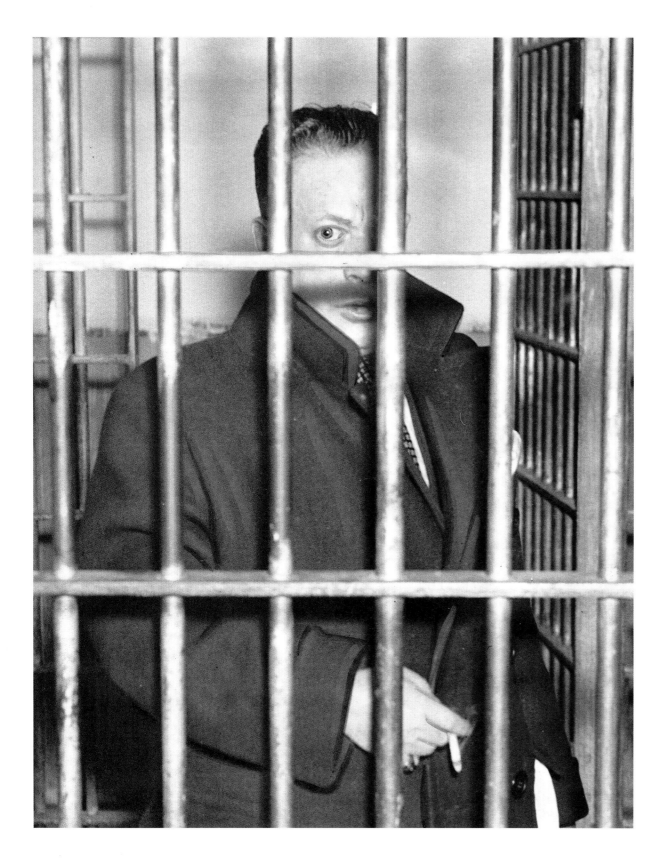

CAUGHT IN CRIME NET

January 21, 1935
Photographer: Levine

Caught in Crime Net. Included among 166 men arrested yesterday in police roundup was Isidor Strauss (above), wanted in connection with Whittemore gang job.

BANDIT

January 17, 1941
Photographer: Charles Hoff

Esposito.
Pix taken leaving Bellevue

Anthony Esposito, bandit, is shown between officers taking him from prison ward at Bellevue to the line-up at Police Headquarters.
—photographer's caption

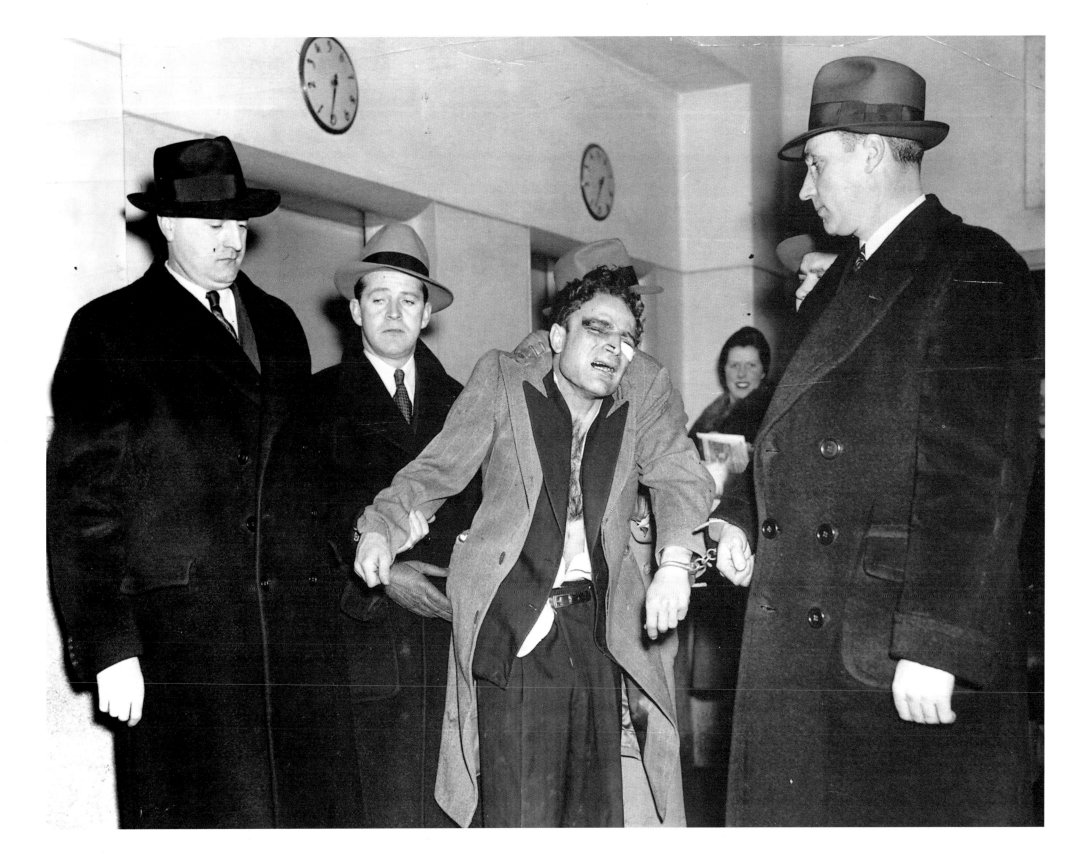

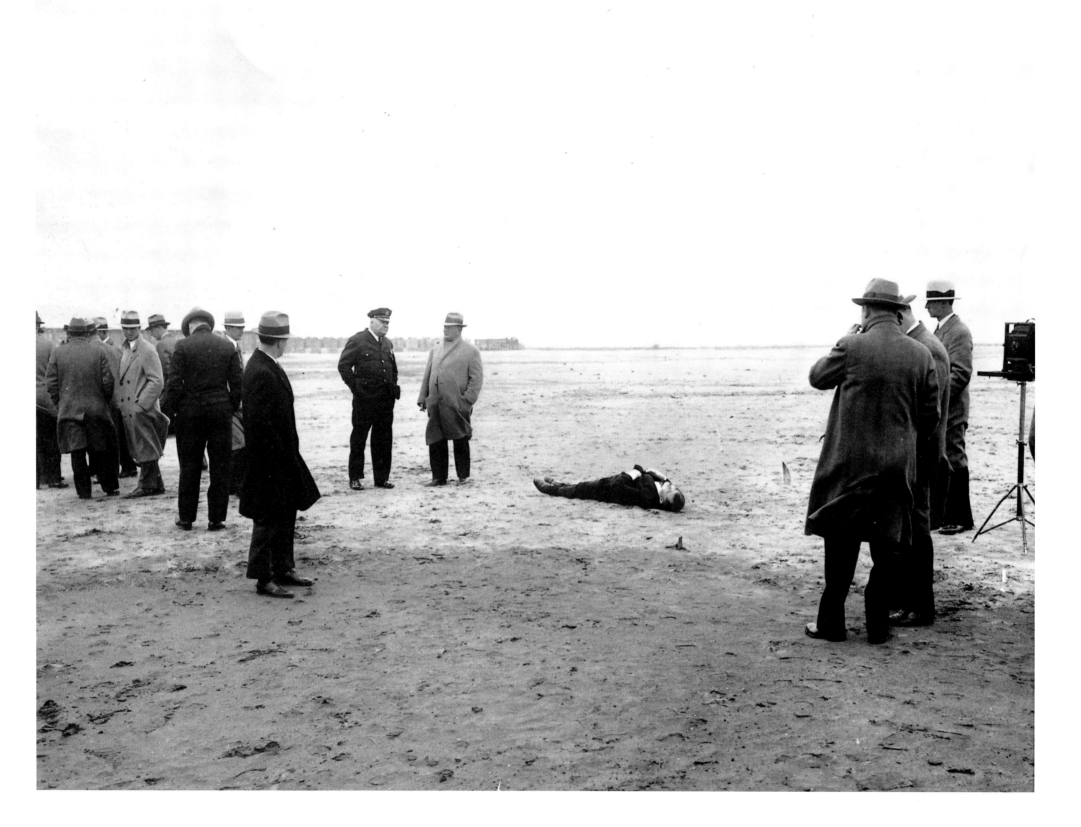

MURDER ON THE WASTELANDS

MAY 31, 1931
Daily News photo

Murder on the Wastelands. On a sandy stretch of Brooklyn's Flatlands section, the body of Dr. Joseph T. Loughlin, prominent Brooklyn surgeon, was found—shot through the head and heart. Police advanced the theory he'd been slain by a former friend with whom he left his home a few hours earlier to fight a duel.

COSTUMED A HIT MAN

APRIL 23, 1940
Photographer: Petersen

Mrs. Gurino—murder inc

Foto shows Mrs. Gertrude Gurino who was held in $50,000 bail as a material witness in the murder ring case—photographer's caption

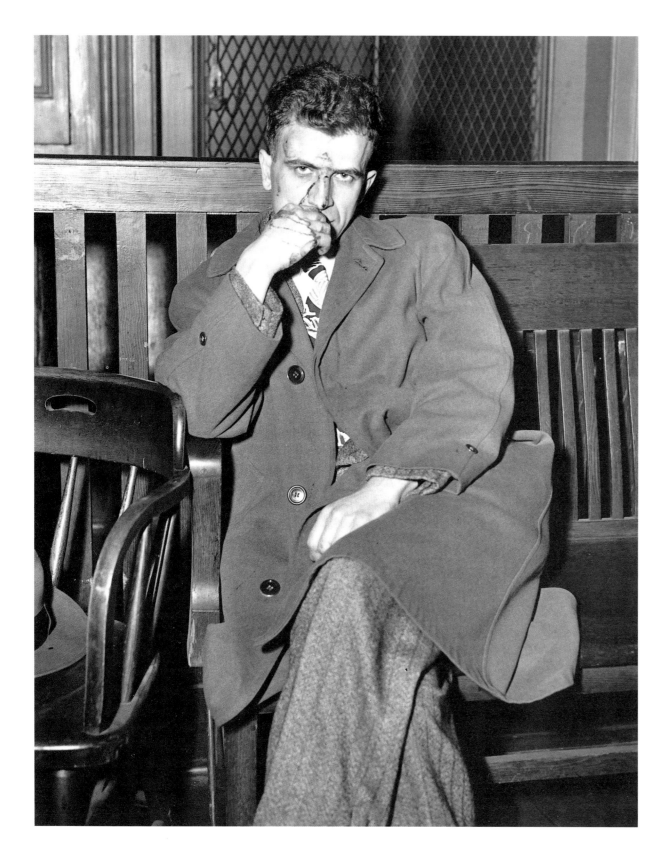

PUSHED GIRL IN FRONT OF TRAIN
MAY 10, 1947
Photographer: Twyman

Girl pushed in front of train Elizabeth St. police station Shows Jack David Didia 28 yrs. Of 21-20 72nd St. Bklyn, he is the man that pushed Bertha Patsky onto tracks.—photographer's caption

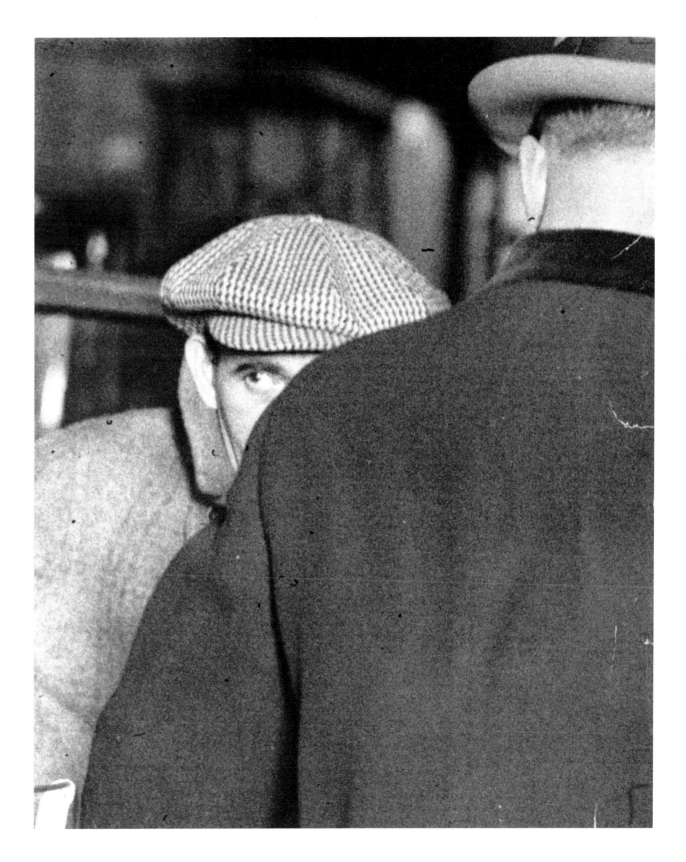

THE COBRA EYE

JANUARY 1, 1931
Photographer: Phil Levine

"The Cobra Eye"
What Did the Diamond Eye See That Caused Him to
Hide Behind a Cop

Photo shows Jack Diamond, as he left his auto to
board train at 125th St. under a police escort. His
eyes were filled with fear, and his face twitched
until he seated himself in the compartment on the
train that took him to his home...
—photographer's caption

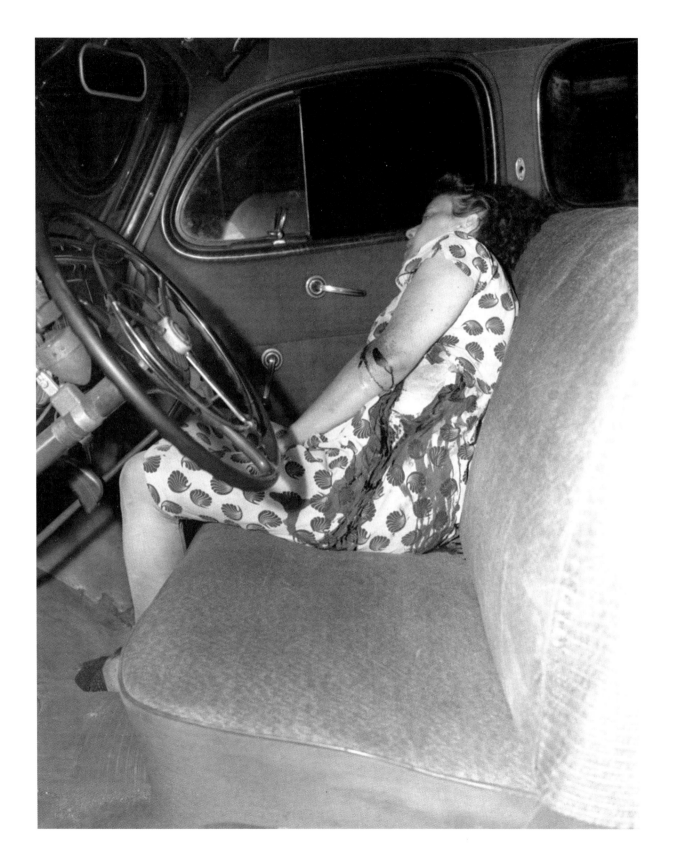

SWEETHEART SHOT

June 24, 1945

Photographer: Bob Costello

Patrolman Paul Rickli…who yesterday shot himself,
after shooting his sweetheart, Mrs. Margaret Doherty,
whose body is seen slumped in car.

VICE PROBE WITNESS MURDERED

MARCH 2, 1931

Photographer: Auerbach

Photo shows the body of Vivian Gordon at the Fordham Morgue—photographer's caption

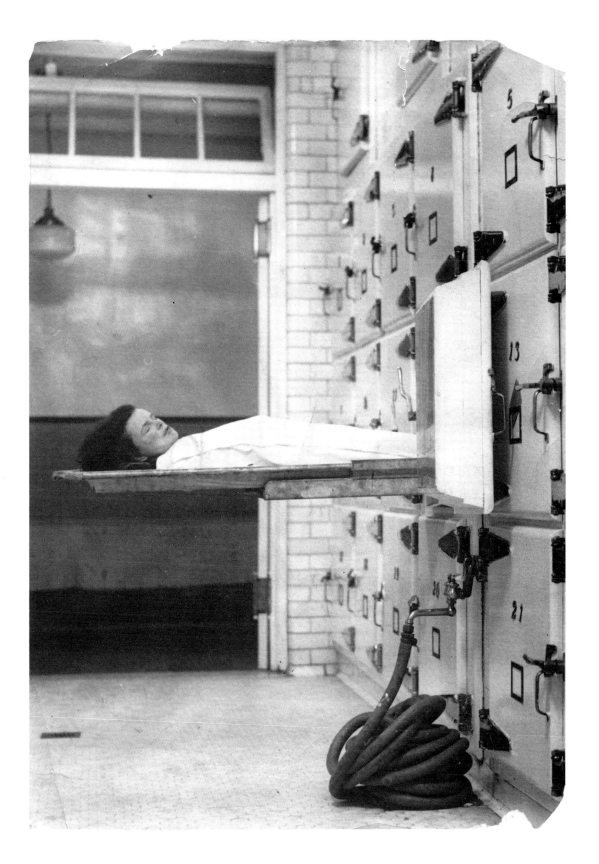

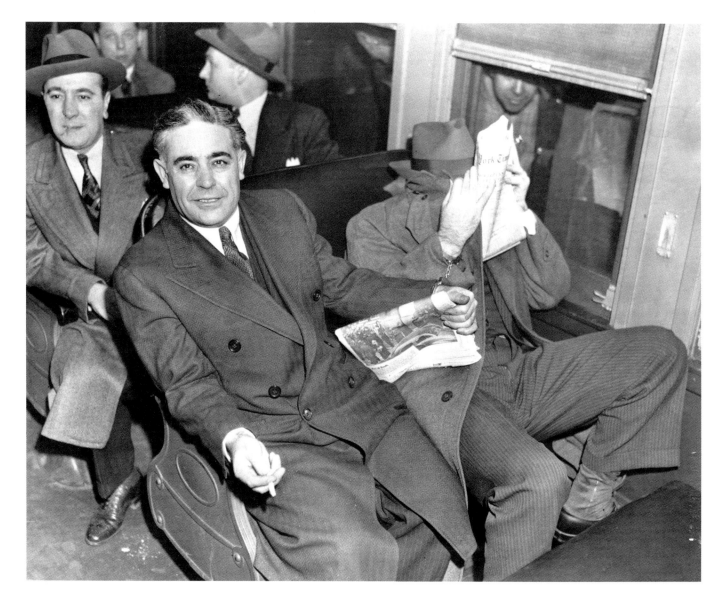

EN ROUTE TO THE CHAIR

DECEMBER 4, 1941

Photographer: Candido-Costa

Capone and Weiss leave for Sing Sing

On train en route to Sing Sing Louis Capone and
Emanuel (Mendy) Weiss (who covers up in this
picture) are on train on their way to Sing Sing.
Deputy Sheriffs surround them
—photographer's caption

DEATH OF AN ANARCHIST

JANUARY 12, 1943

Photographer: Al Amy

*Murder on Fifth Ave. Fifth Ave. & 15th St. Photo
shows the body of Carlo Tresca lying in the gutter
at the north west corner of 15th St. and Fifth Ave*
—photographer's caption

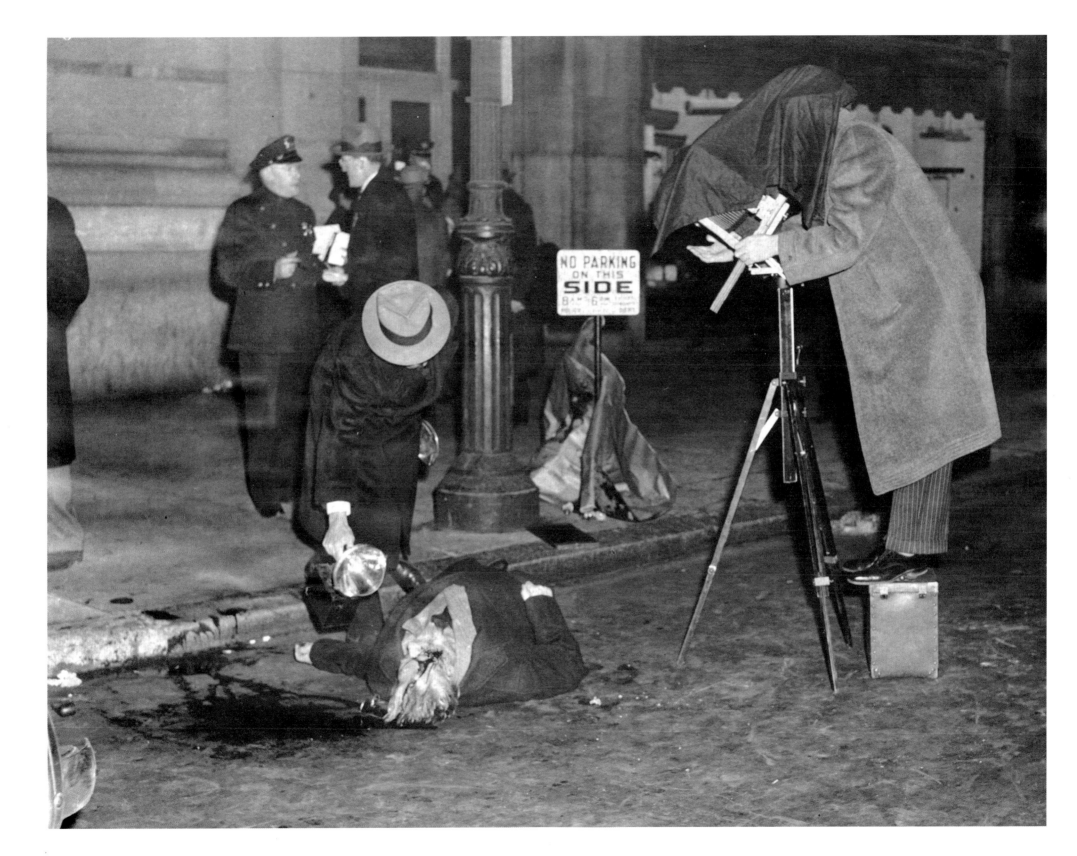

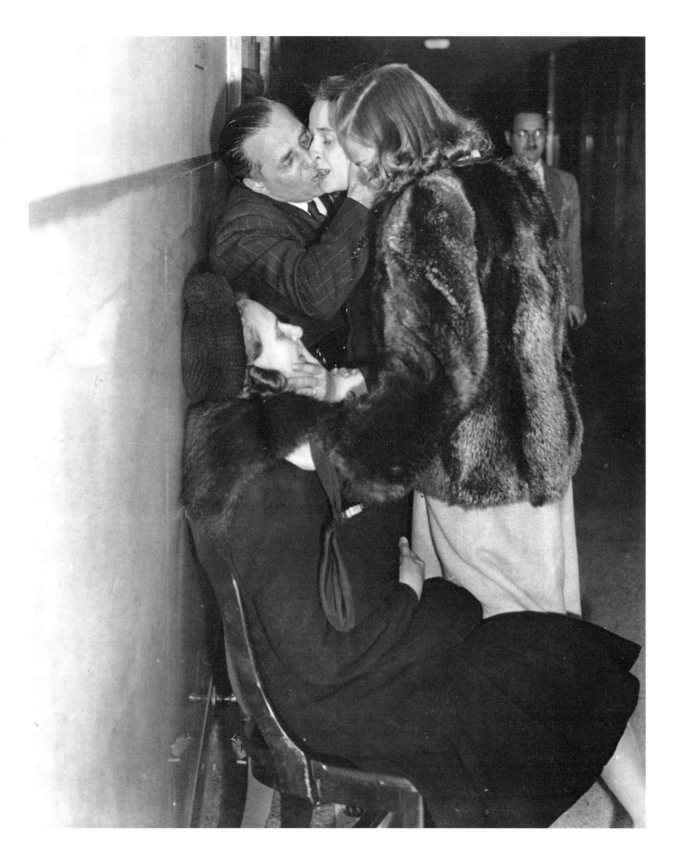

IT HURTS TO BE SO HAPPY!

November 24, 1942
Photographer: Osmund Leviness

It Hurts To Be So Happy! The long strain broken, Mrs. Anna Mirra Harrington (center) sobs in the arms of her father, John Mirra, after a Bronx County jury, at 6:42 last night, acquitted her of the murder of her 23-year-old husband, Alman Harrington.

EMPIRE STATE SUICIDE

JUNE 8, 1946

Photographer: Simon Nathan

Police examine the body of Clark I. Tunison on
30th floor terrace of the Empire State Building.
If body had cleared the terrace it might have hit
crowded street.

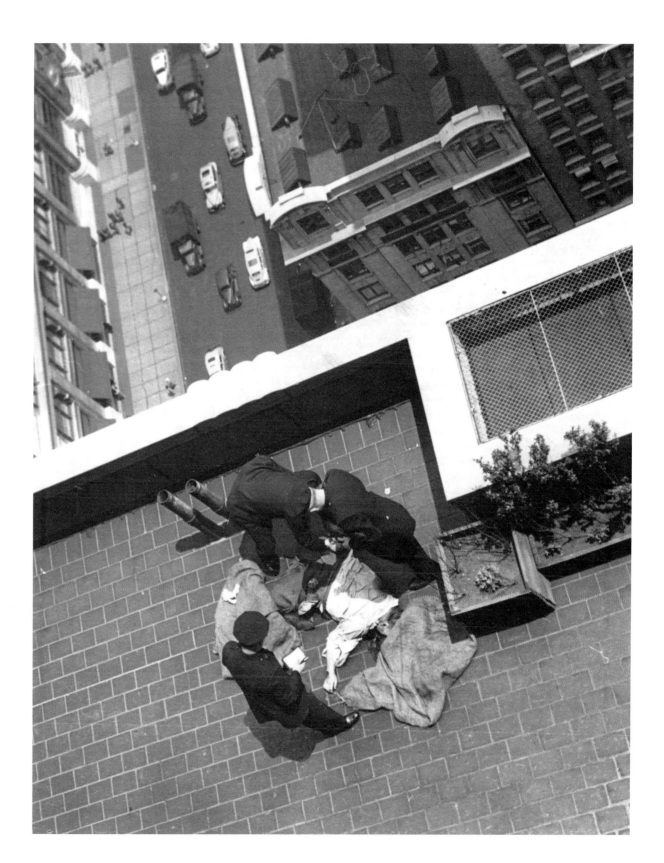

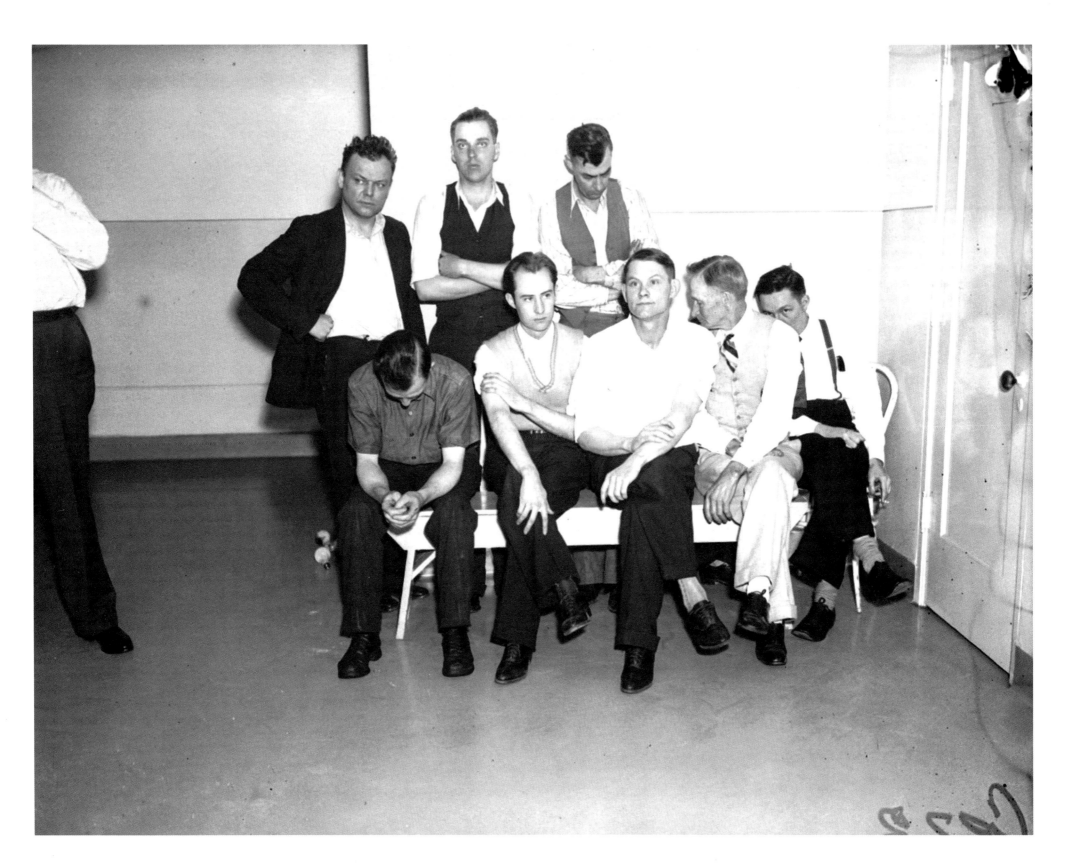

BLACK LEGION

JUNE 3, 1936

Photographer: Pat Candido

Black Legion Story
Detroit, Mich

Standing: Dayton Dean, Urban Lipps, Harvey Davis;
Seated: Ervin D. Lee, Lowell Rushing, John S. Vincent,
Edgar Baldwin—photographer's caption

A NEW ANGLE ON THE OLD TRIANGLE

JANUARY 12, 1945

Photographer: Petrella

Wife Puts Kluck In Coop with One Of His Chickens. A new angle on the old triangle developed yesterday in Dover, N.J., Police Court, when Colleen Kluck had her husband, Walter, and honey-blonde Truth Fyfar, ex-chorine, held on $1,000 bail for Grand Jury action on charges of lewdness.

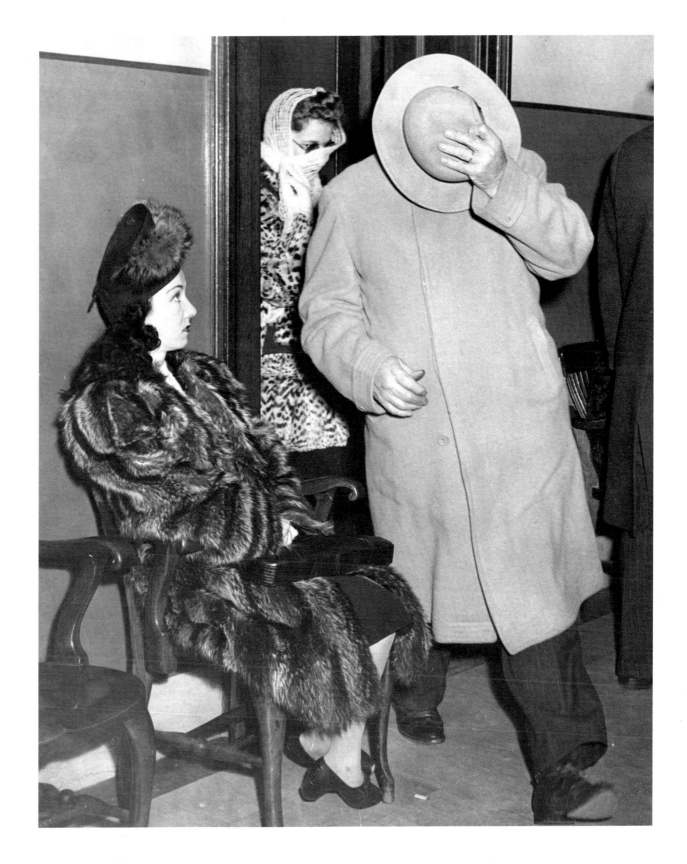

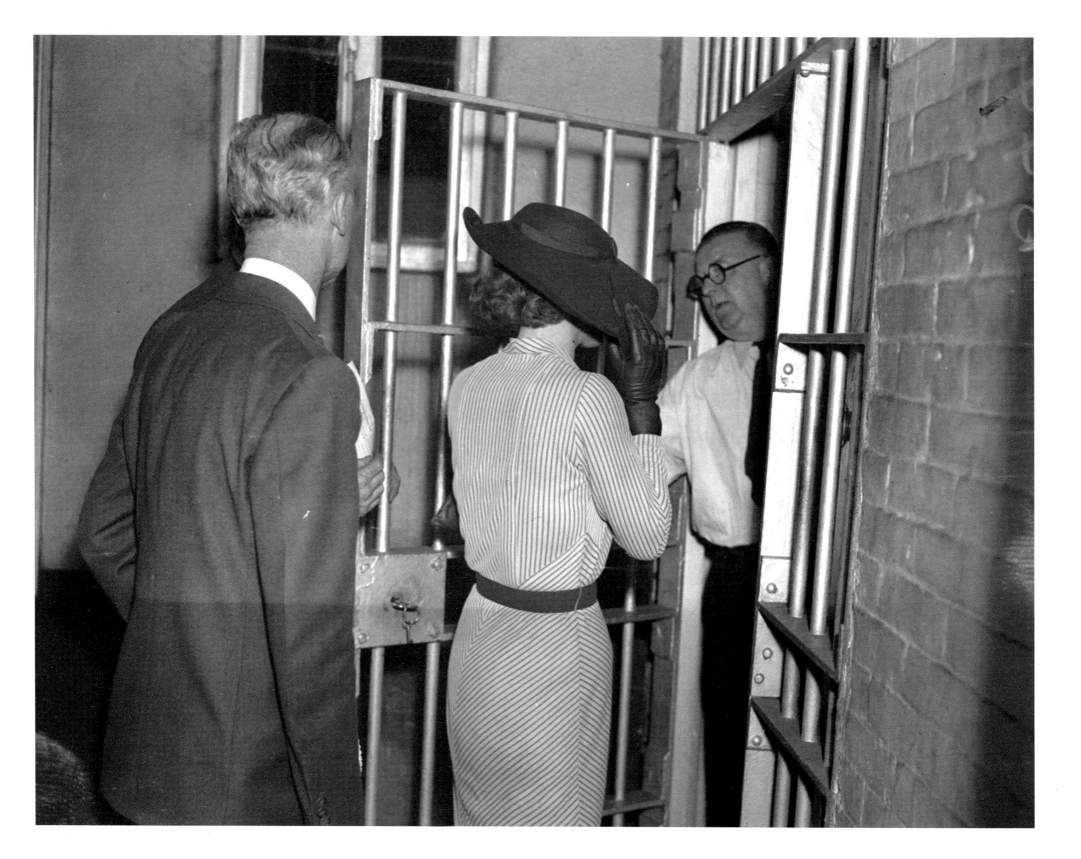

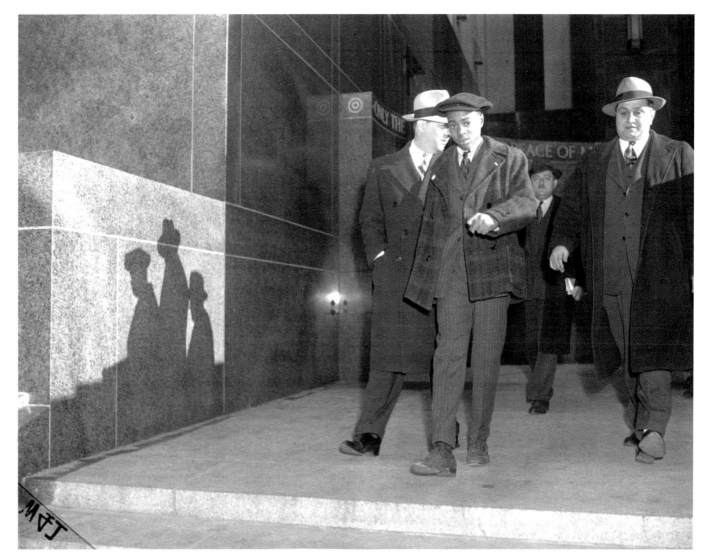

A PRISONER, BUT BLASÉ

JUNE 26, 1935

Daily News photo

A Prisoner, but Blasé. Natalie Chadwick, ex–"Follies" dancer, remains ever the woman as, in this photo, she nonchalantly gives a final touch to her hat on entering cell in Yorkville Court yesterday. Accused of taking $5,900 in furs, jewelry and perfumes from the apartment of Mrs. Simone Brooks, 400 E. 57th St., the gayly attired Natalie was held without bail by Magistrate Anna M. Kross.

HELD IN KNIFE SLAYING

NOVEMBER 24, 1941

Photographer: S. O. Wally

O'Connell Slayers arraigned…hearing postponed to Nov 27th. Homicide Court. Manhattan….

12 yr.old Jerome Dore colored boy who is shown being led down corridor which leads to court-room….case was adjourned because Grand Jury is hearing the case and no indictment was sent down.—photographer's caption

PIERCING EYES OF LINDBERGH KIDNAPPER

JANUARY 30, 1935
Daily News photos

The piercing eyes of Bruno Richard Hauptmann—
sometimes smiling, sometimes lighted with anger
and then again shining defiance.

BABY BANDITS

JUNE 18, 1935
Photographer: Edger

*Shows 3 boys who are held for shooting a man
during holdup from which he died in Jamaica
Hospital—seated on desk, Julius Damato 11 yrs.
Frank Damato 13 yrs. who done shooting and
Libson Lawrence 13 yrs.—photographer's caption*

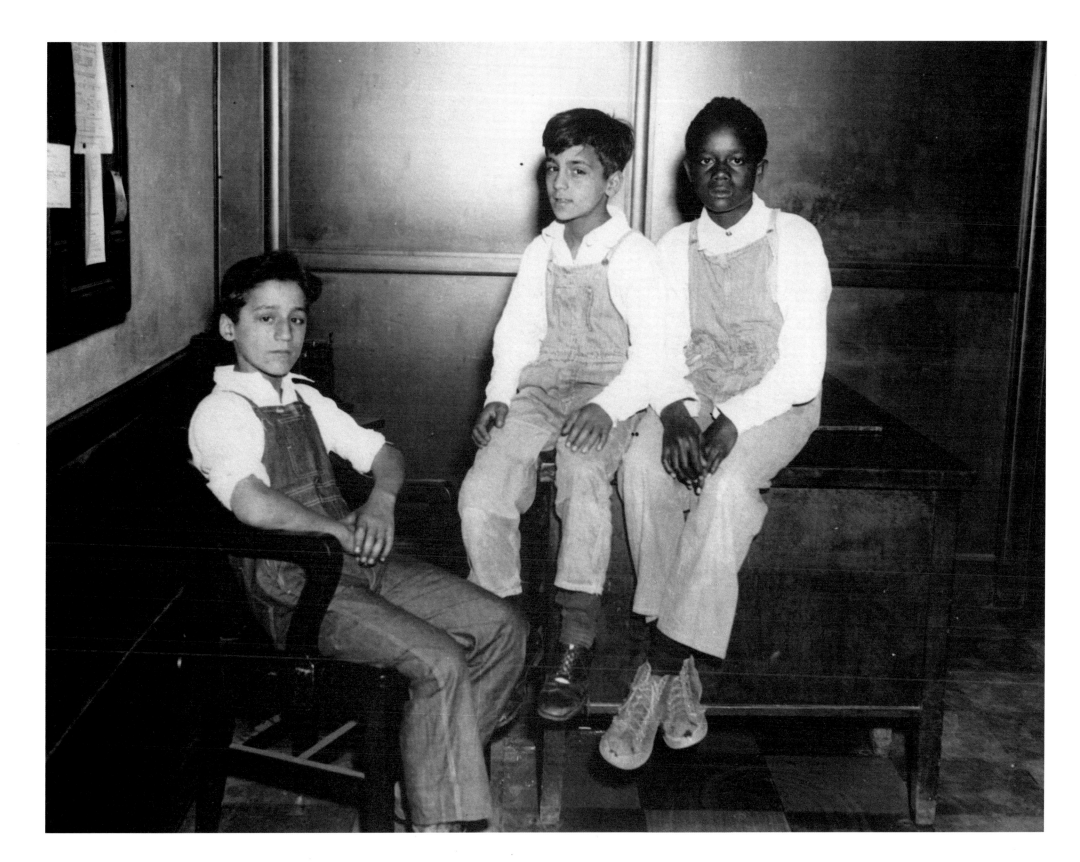

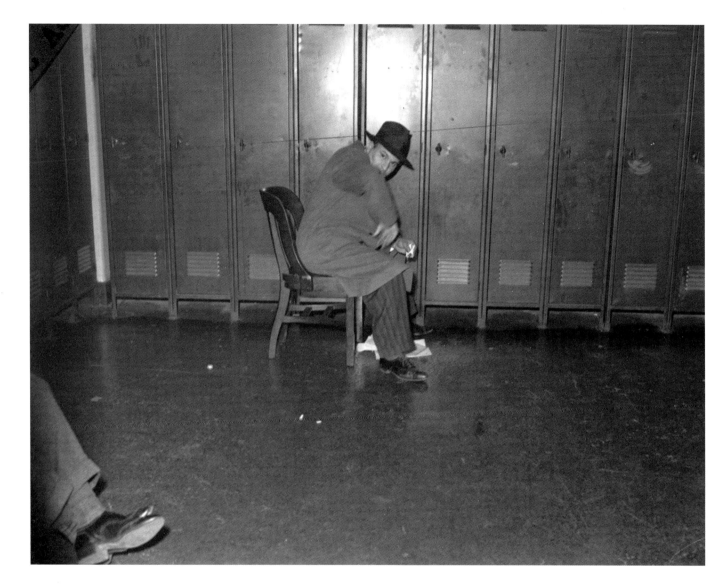

STOLEN CAR LEADS TO MURDERER

APRIL 2, 1941

Photographer: Edger

Two, possibly three, recent murders were reported near solution by Brooklyn detectives yesterday following the arrest of Carlo Barone, 28, on charges of auto theft and possession of an arsenal.

ACCUSED KILLERS LEAVING DEATH HOUSE

JANUARY 14, 1941

Photographer: Engels

Three killers out of Sing Sing Death House, Ossining

Frank (The Dasher) Abbandando, Frank Davino, and Harry (Happy) Malone come through the Ossining station enroute to the train that will take them back to Brooklyn and a new trial for their lives.—photographer's caption

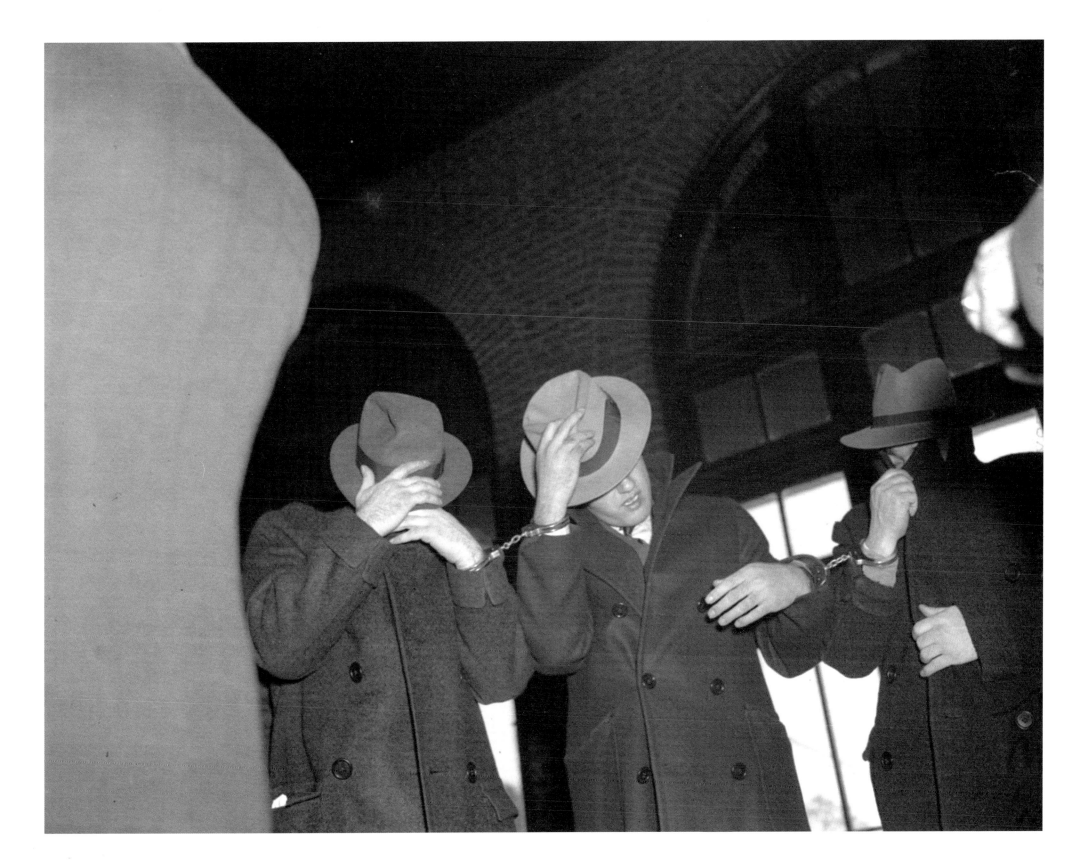

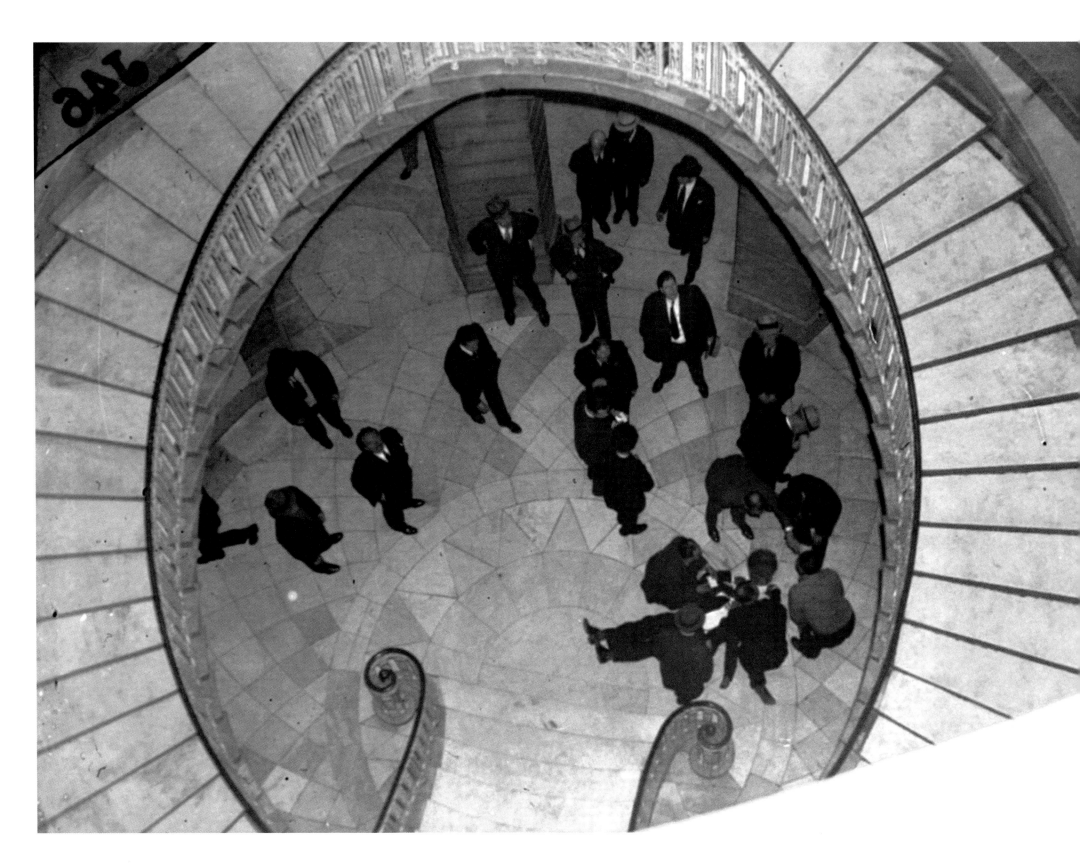

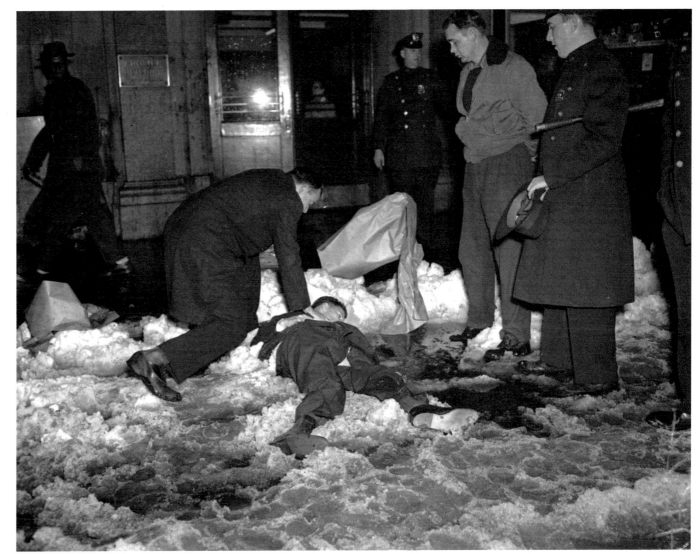

FALL FROM BALCONY

May 10, 1938

Daily News photo

Looking down from balcony from which [Charles] Costa plunged yesterday. He lies on marble floor, surrounded by people. He was taken to Beekman Street Hospital, suffering a broken back, and is in critical condition.

DEATH PLUNGE LINKED TO SPY QUIZ

December 21, 1948

Photographer: Al Pucci

Death Plunge Linked to Spy Quiz. The Rev. Edwin Broderick of St. Patrick's Cathedral gives last rites to Laurence Duggan, 43, director of the Institute of International Education and former State Department official, who plunged from his 16th-floor office at 2 W. 45th St. yesterday. Less than two weeks ago, Duggan had been mentioned to Representative Karl Mundt (R-S. D.), acting chairman of the House Un-American Activities Committee, as "one of those involved in the underground Communist apparatus in Washington."

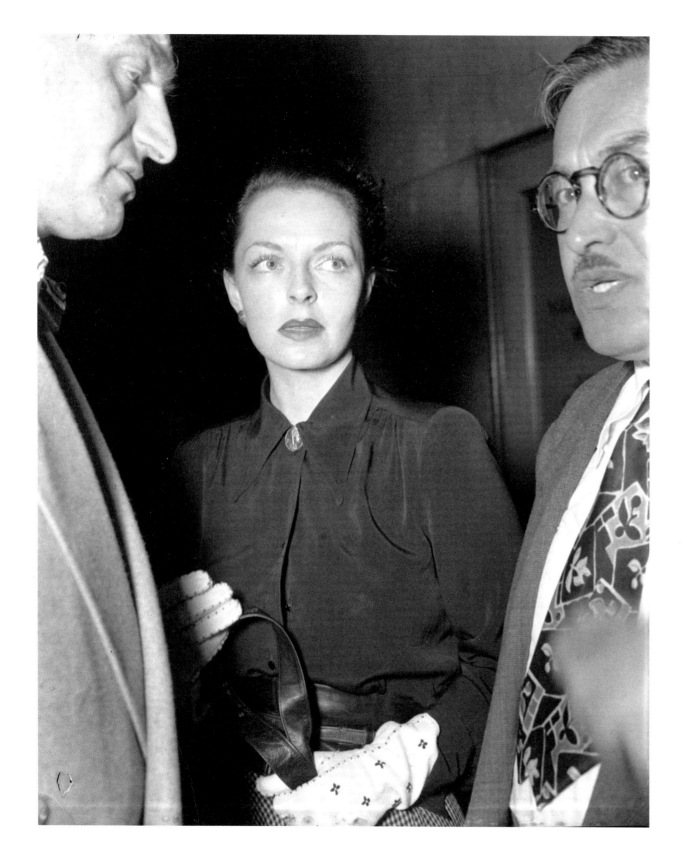

STUNNED BY VERDICT

JULY 9, 1948
Photographer: Eddie Jackson

Stunned by Verdict. Mrs. Nancy Fletcher Choremi, Margaret Starr and Madeleine Blavier appeared stunned with surprise last night when Magistrate Arthur Markewich in Women's Court found them guilty of vice charges. Nancy, who is shown outside court before the verdict, did not take the stand.

KILLED THE THING HE LOVED

May 2, 1945
Photographer: McCory

'The Man Had Killed the Thing He Loved'
Cigaret in hand, face contorted, John Balfe looks
at dead Anna Nelson. Accused of fatally stabbing
his sweetheart, John Balfe, 24, a counterman, of 168
W. 96th St., appeared in Homicide Court yesterday
and was held without bail for hearing May 15. A cop
drinking coffee in a restaurant at 200 W. 96th St.
Monday night arrested Balfe after seeing him throw
a bloodstained hunting knife behind the counter
while the woman lay dead in a nearby booth.

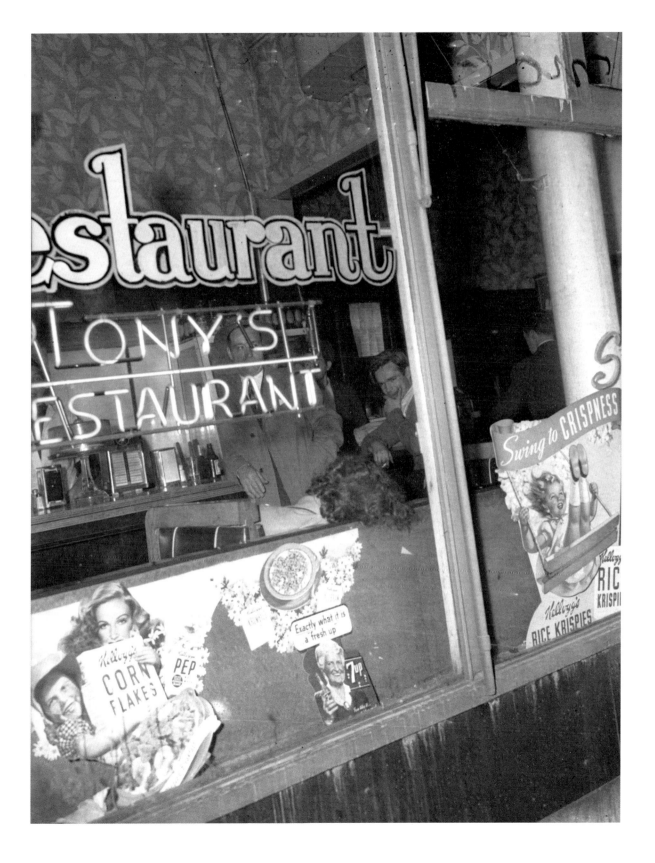

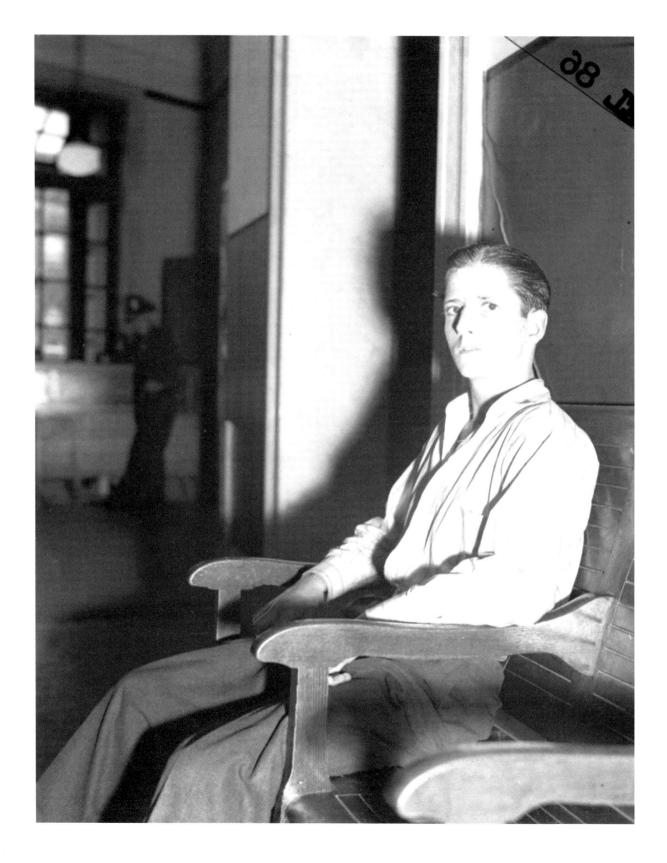

SON SAYS NO MORE

JULY 20, 1940
Photographer: Osmund Leviness

Bronx Magistrate's Court

Herbert Crowson of 3539 Third Ave shown in court after being held without bail for stabbing his father to death.—photographer's caption

HIDE AND SEEK

MARCH 29, 1949
Photographer: Watson

Hide and Seek. Pastor Paul Buenaventura (2nd from left) interrupts corridor huddle with friends outside Special Sessions to get a good look at his accuser, Mira Stefan (right), as she attempts to leave unnoticed. Mira's accusing Mr. B. of being her infant's father.

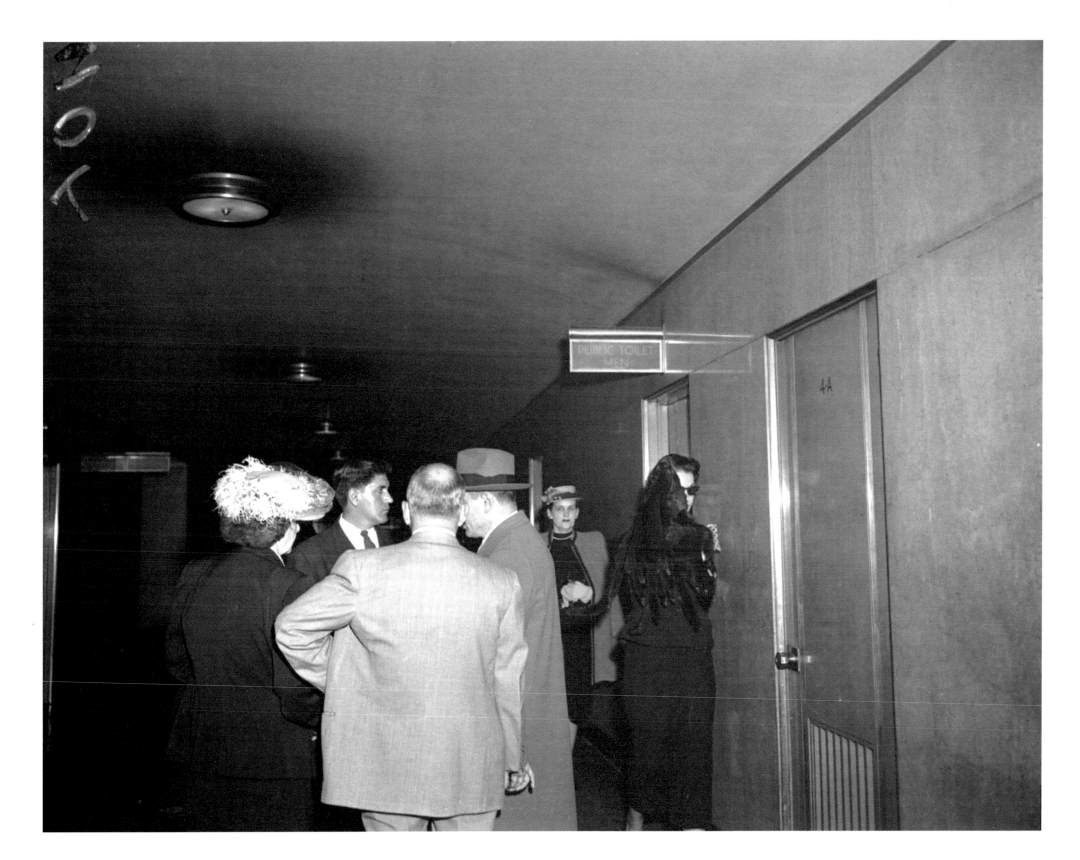

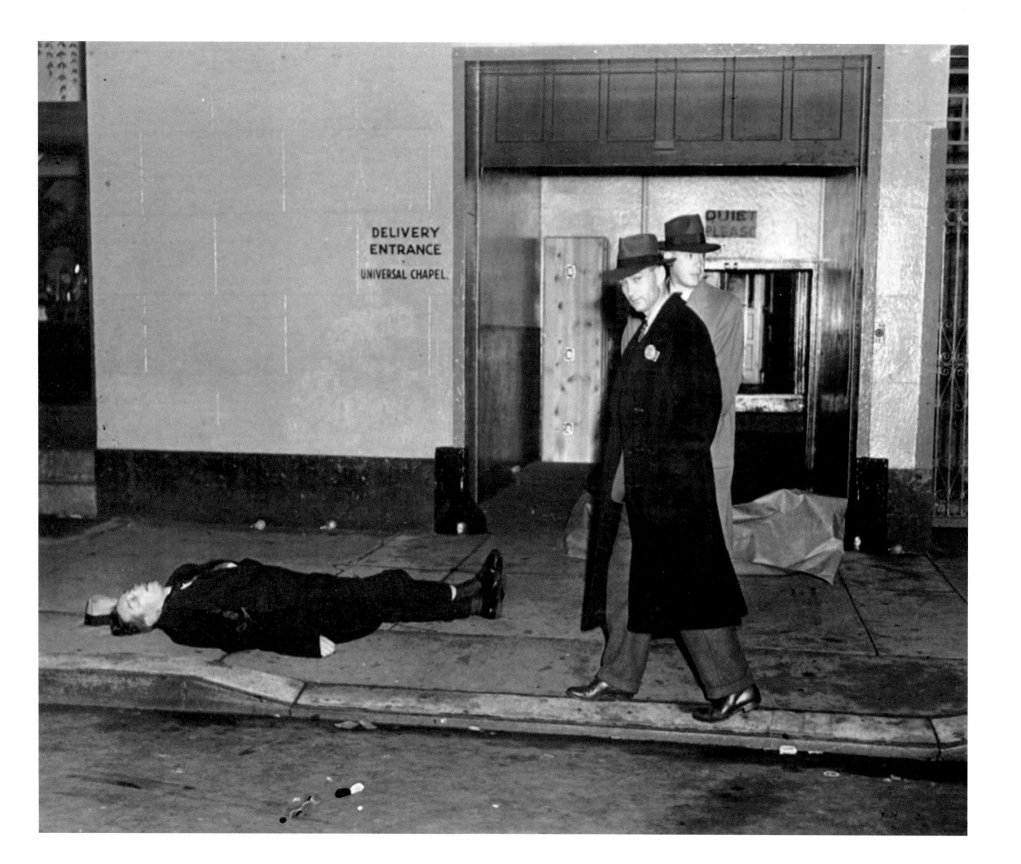

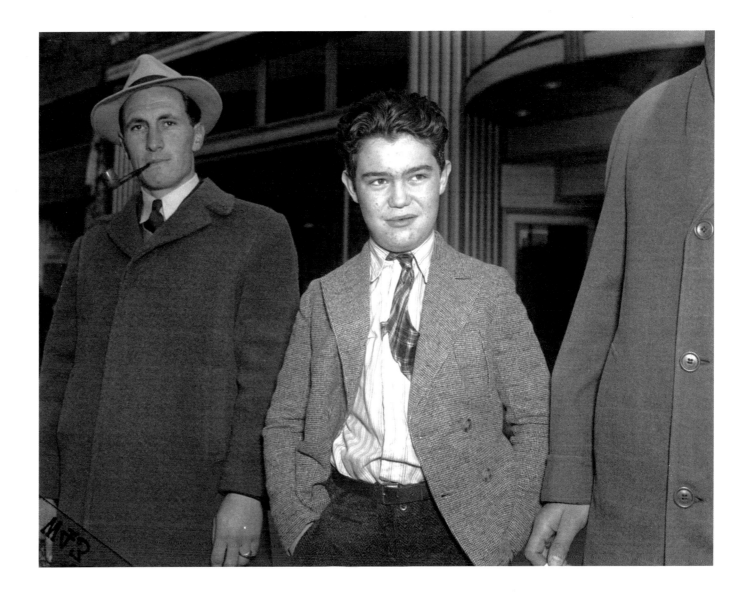

COP SLAIN
July 18, 1942
Daily News photo

Cop [Thomas J. Casey] Slain.

13-YEAR-OLD CHARGED WITH MURDER
October 20, 1943
Photographer: S. O. Wally

13 year old boy on trial for murder
168th St. and Broadway

Photo shows 13 year old Edwin Codarre, he was brought
to the Neurological Institute for examination…

He goes on trial in Fishkill, N.Y., on November 3rd
for the murder of Elizabeth Voight.
—photographer's caption

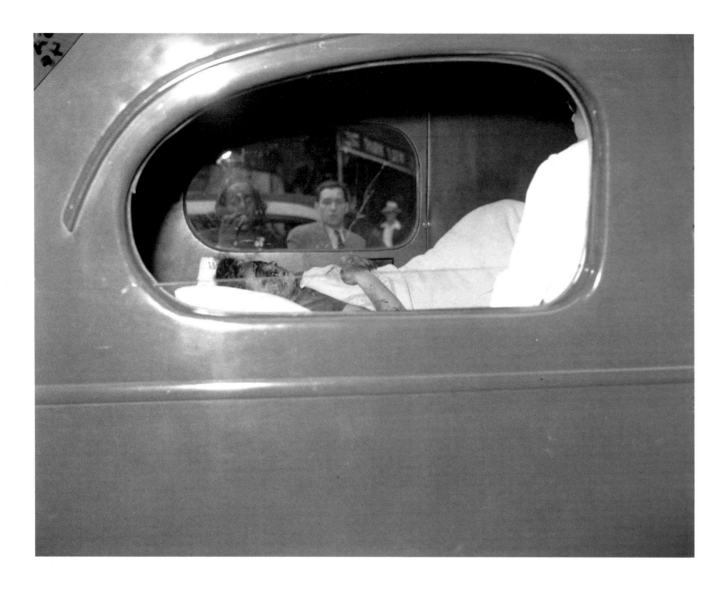

HINT BLONDE BEAT TWO WOMEN

JULY 9, 1943
Daily News photo

Hint Blonde Beat Two Women. An intruder, who may have been a woman, bludgeoned two 30-year-old businesswomen and killed one of them yesterday as they lay in bed together in their apartment at 282 Lincoln Place, Brooklyn.

An 8-inch strand of "dark blonde" hair clutched in a hand stiffened by death caused police to speculate on the possibility that the assailant might have been the same sex as the victims, both of whom were brunettes.

...Alice Clarfield, victim of a phantom clubber, lies unconscious in ambulance en route to hospital.

MURDERED FOR THRILLS

AUGUST 20, 1954
Photographer: Paul Bernius

Find Body
Foot of South Fifth Street, Brooklyn...

photo shows: Deputy Commissioner Kennedy (light suit) and Chief Inspector Thomas Nielson watch detectives examine body of Willie Mentor, which was fished out of water.
—photographer's caption

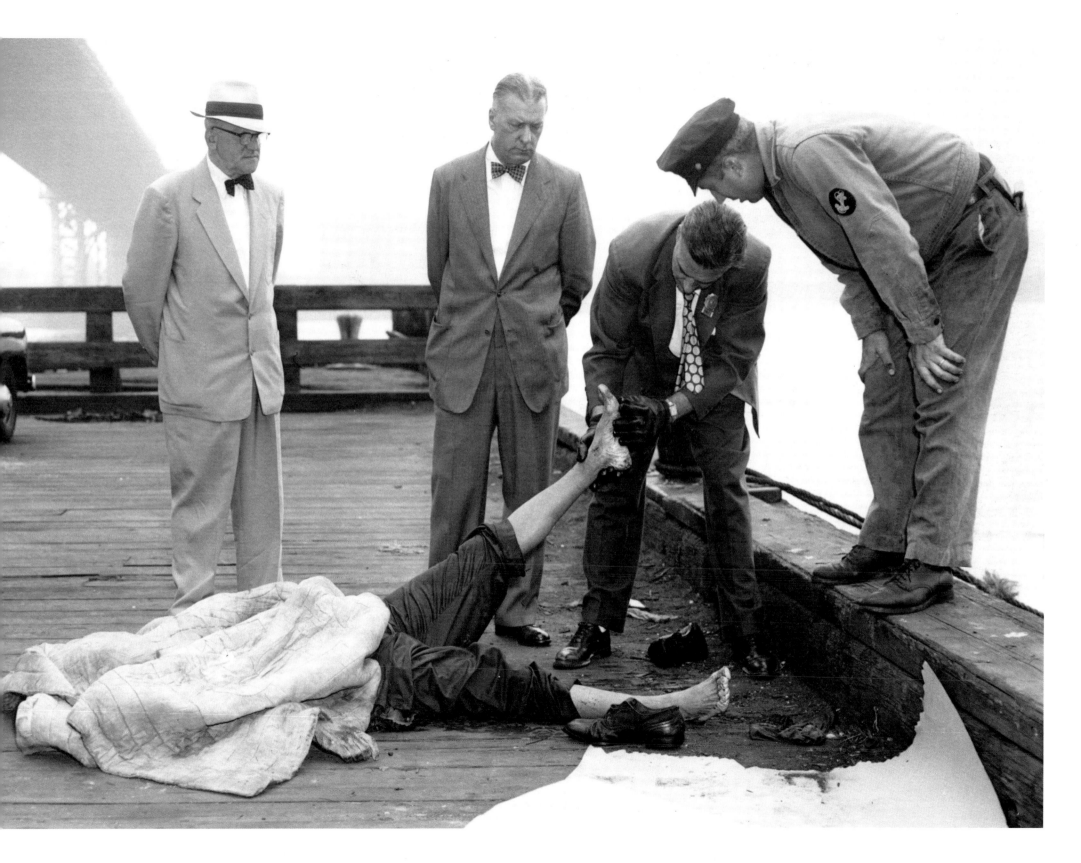

STRANGLER
ROGUE OF THE ROAD
CAMERA HOG

As he entered his opulent home at 1035 Grand Concourse in the Bronx at 10:30 on the night of February 4, 1941, John Pappas was overcome with a sense of dread. Noticing a still-lighted parlor lamp overturned on the floor and an ominous dark stain on the couch, he feared for his wife's safety. Rushing to the bedroom, he spotted his wife in a nightmarish scene: Catherine Gouass Pappas, 29, nearly naked, face down, her arms strained back and bound by a necktie at the wrists, a dish towel binding her feet. As he pulled back a black robe that had been thrown over her head, George saw that another towel was knotted tightly around her neck. He cried out to the superintendent for a doctor and then he called the police. It was too late; Kitty Pappas was dead.

As police searched the scene, some peculiarities emerged. For instance, two cups and saucers of Kitty's best china were laid out, and there were two emptied wine glasses on the coffee table. On a nearby chair a wedding photo lay face down. The house had been ransacked and cash and jewels were missing.

With nothing to go on, the police scoured the apartment. From the glasses and an aspirin bottle found on the coffee table, they came up with only one smudged fingerprint. They also found four cigarette butts of a brand different from the one Mrs. Pappas was known to smoke. Police realized they had a serial criminal on their hands when they recalled that in three other recent Bronx robberies, the assailant had overpowered housewives after claiming to be a friend of

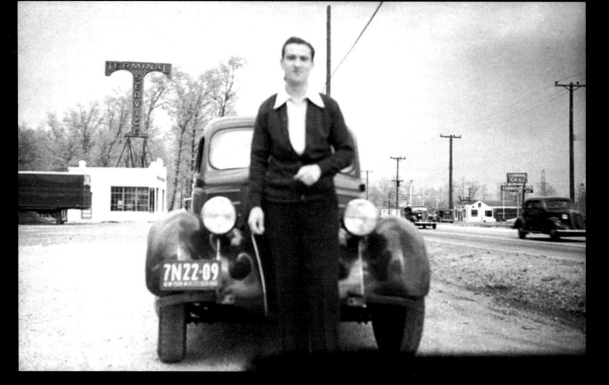

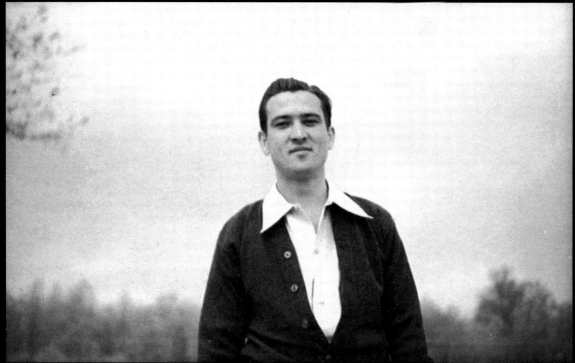

Snapshots taken in November 1940 by Frank Novak, a motion picture operator, who drove George Cvek from Morristown, N.J., to New York.

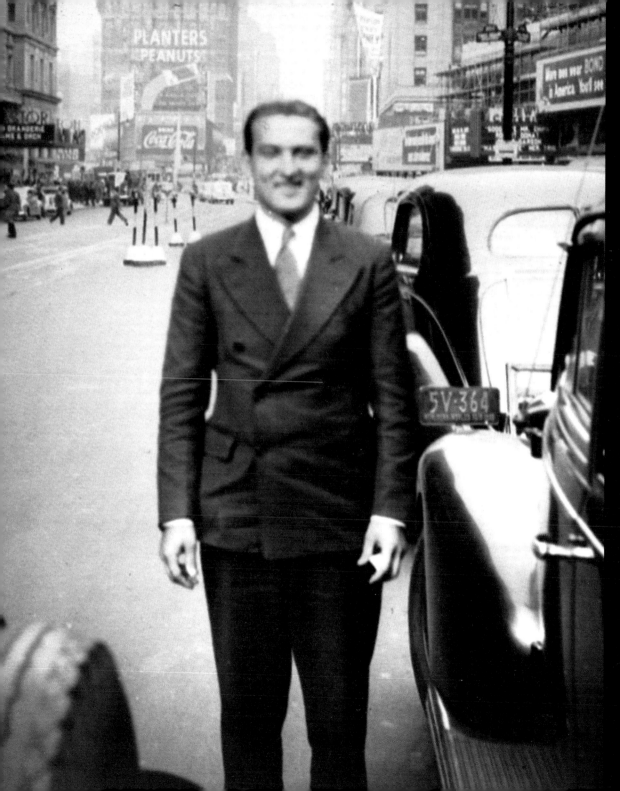

Scene: Times Square. Foto was snapped July, 1940, at Cvek's request, by a salesman who picked him up outside of New Brunswick, N.J.

their husband's, bound them, and ransacked the apartment before asking the victim for aspirin. But there was not much to go on.

Clues sometimes come from seemingly unrelated incidents, however. Far from the Bronx, in Bartonsville, Pennsylvania, a new lead came to light. R. W. Stoddard, a local insurance man, had recently given a lift to the Mayor of Boys Town, the celebrated youth rehabilitation community at Lincoln, Nebraska, run by Father Edward F. Flanagan. This may have seemed a minor event except that others who had given the hitchhiking "Mayor" a ride had found their homes robbed and their wives assaulted within a few days. A composite was sent out across the region describing a suspect "6 feet tall, 180 pounds, scar on the right cheek, pimples, cluster of nodules at bridge of nose. And he usually wore a green coat and yellow shoes." The description matched that of the Bronx strangler.

The case seemed to grow quiet, and the story fell from the headlines. But three veteran detectives continued working diligently, believing that their man was still somewhere in Manhattan. Nearly one month after Mrs. Pappas's death these detectives staked out the Mills Hotel on Thirty-sixth Street, convinced that their man had spent the last two nights there. Tension was heightened because earlier that day, Mrs. Elizabeth Jensen, 34, had been strangled with a necktie in her apartment—less than a mile from the Pappas's home. Shortly after 9 p.m. the suspect came strolling in, still wearing—to the detectives' amazement—the green coat and bright yellow shoes. The detectives moved in, nabbing the man as he spun around and made for the exit. He was identified from a Selective Service registration card found in his pocket as George Joseph Cvek.

At the Bathgate Avenue Station, Cvek continued to profess his innocence until 2 a.m.

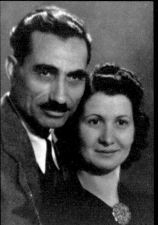

Left: Kitty and John Pappas are shown in happy portrait, before tragedy parted them. She was 29, he 54, and they had been married 21 months.

Below: **Mourns Murdered Wife.** John Pappas (second from left) stands over casket of wife, Kitty, at funeral services for murdered woman.

when a woman identified him as the man who had assaulted and robbed her. Two men appeared later and stated that he was indeed the "Mayor of Boys Town" hitchhiker they had picked up. Cvek admitted to the slaying at 4:45 a.m. By 6 a.m. he confessed to assaulting and robbing as many as fifteen other women. As he spent the morning in a police lineup, a steady flow of witnesses came forward. They reported in from New York, New Jersey, Pennsylvania, and Washington, D.C. Cvek had followed a definite pattern, each attack being a carbon copy of the previous one. After being offered a ride, a meal, and even sometimes cash, Cvek would return the generosity by visiting the man's home, assaulting his wife, and ransacking the house, stealing anything of value. It appears that he was also very fond of having his picture taken during his travels—not the practice of a calculating criminal mind. The people he asked to take these photos documenting his travels were the same ones who picked him up at the side of the road. The *News* had obtained the original negatives of some of these snap shots, which are reproduced on these pages. Although Cvek never admitted to the slaying of Elizabeth Jensen, he was convicted of first-degree murder in the killing of Kitty Pappas and sentenced to die in the electric chair at Sing Sing.

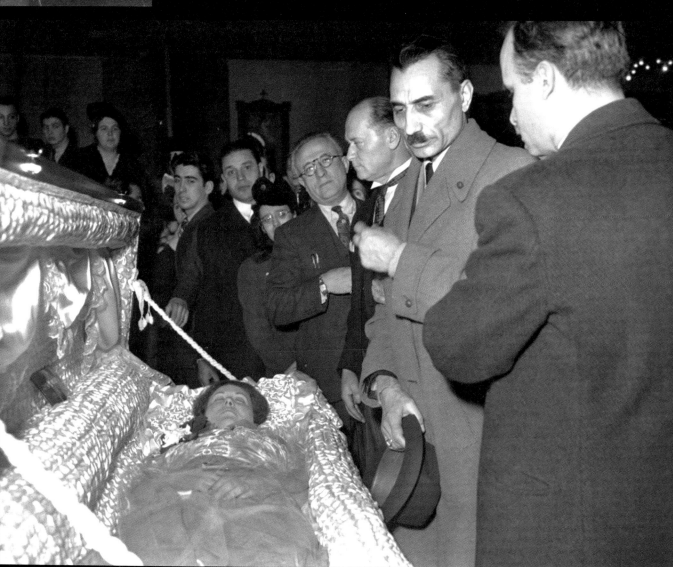

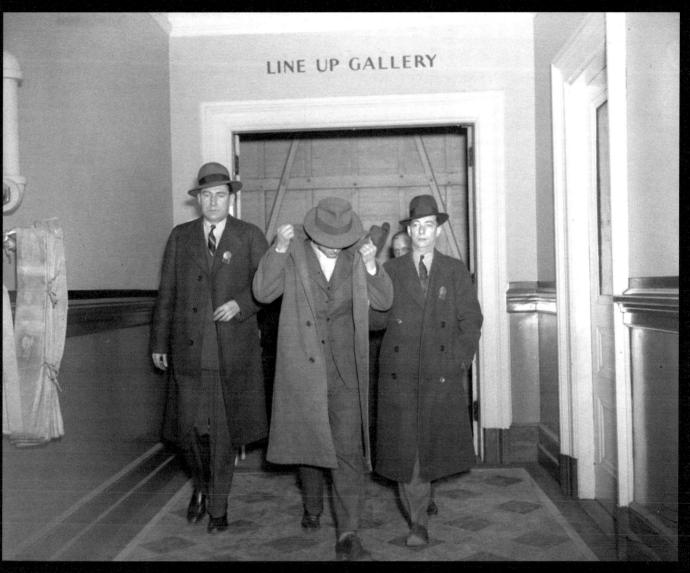

LINE UP GALLERY

Left: George Cvek. At end of hitch-hike trail.

Below left: Cvek in the Bronx District Attorney's office.

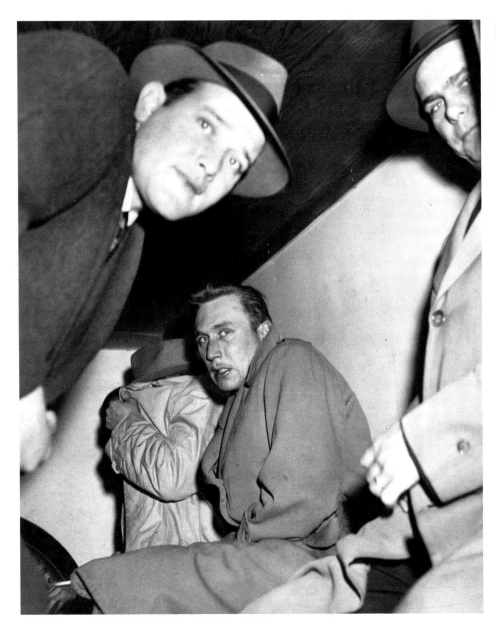

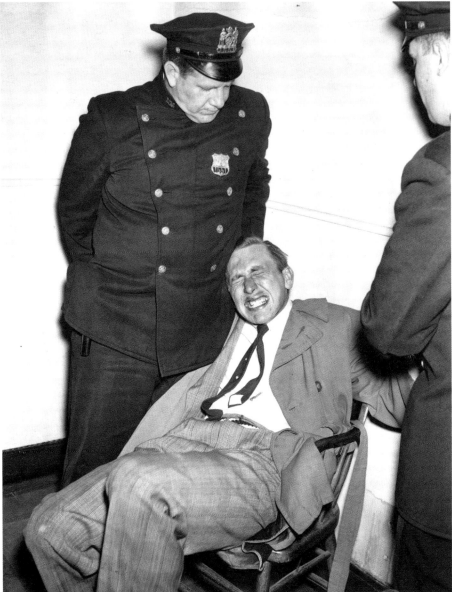

SHOT POKER PLAYER

Far left: JANUARY 11, 1956
Photographer: Al Amy

Shoots poker player
Manhattan Police Hq.

Pix shows: Theodore Clement 24 yrs. old who shot
poker player in Glendale…before being removed
to Queens Felony Court.—photographer's caption

Left: JANUARY 11, 1956
Photographer: Jack Clarity

Seated in precinct after arrest.
—photographer's caption

BROOKLYN POLICY BOSS

MARCH 26, 1954
Photographer: Rynders

Policy Boss Pleads for Reduced Bail
Supreme Ct

Shows Oscar Cuevas alleged Bklyn Policy Boss
(handkerchief over face) as he was led from
N.Y. Supreme Ct. after seeking bail reduction.
—photographer's caption

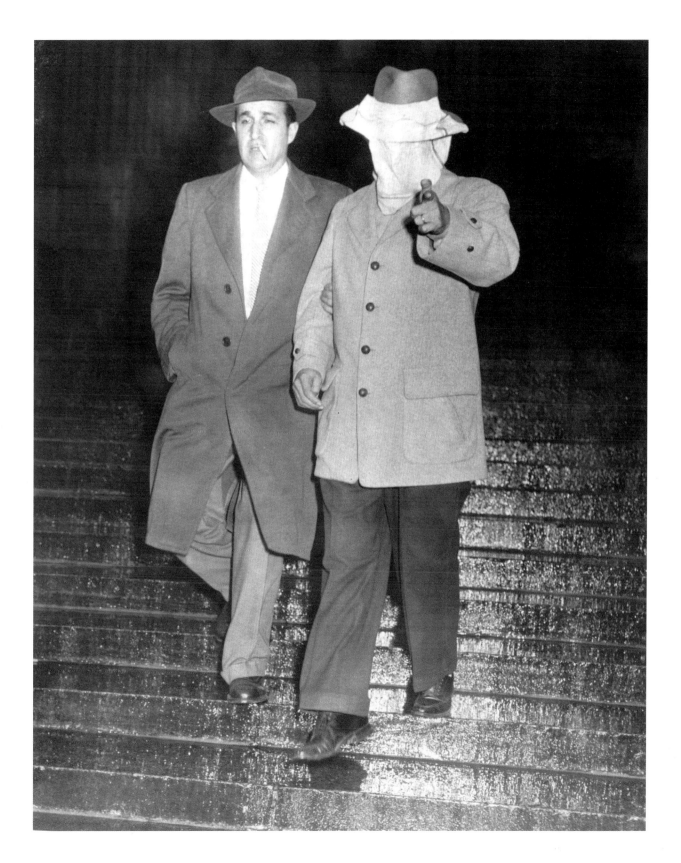

CP August 1 1943

 Payne es

Brooklyn stickup kids
Bergen St. Police Station

Photo shows Robert E. Maschak, left, 16 years old, of 682

 Chancellor Avenue, Irvington, New Jersey, who calls himself

"Curly Bill", and Ralph Yanicello, 20, of 703 Sackett St., with patrol-

man and gun in Bergen St. Station... they were picked up on Dean St.

between 3rd and 4th Ave., by Patrolm Irving Jampal of the 78th Pct.

as hold-up men.. "Curly Bill" enjoyed posing as toughie for photog...

 SEE JOE GEORGE STORY

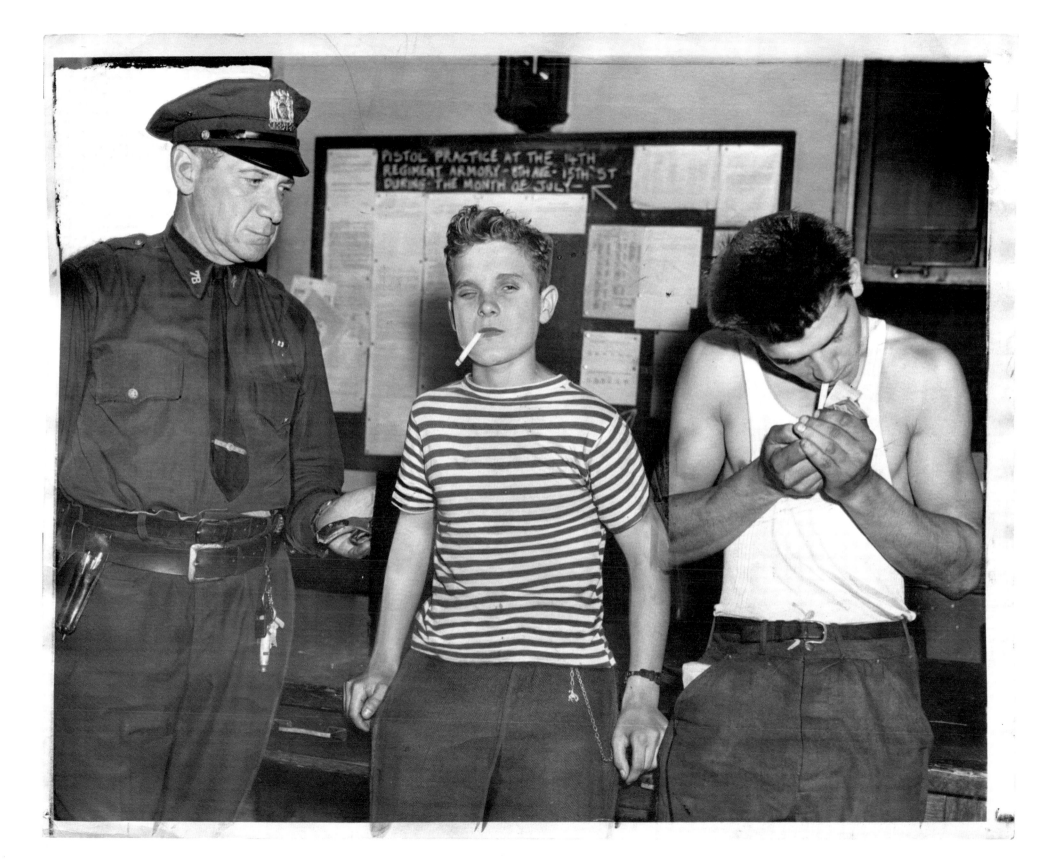

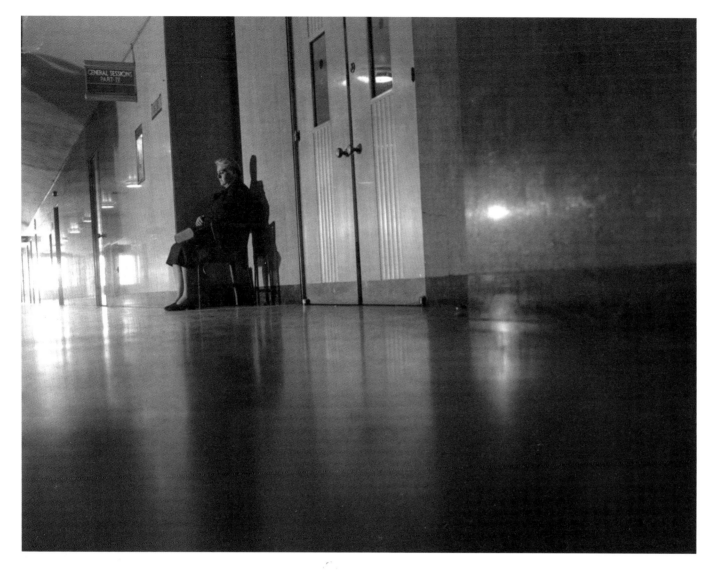

ALONE

May 11, 1956
Photographer: Rynders

Abortion Story
Criminal Cts., NYC

Shows: Mrs. Katherine Daniel[s], mother of
Thomas Daniel[s] sitting outside Courtroom.
Daniel[s] cut and hacked up Jaqueline Smith,
last Christmas, after an attempted abortion
failed—photographer's caption

PONDERING HIS FATE

February 15, 1953
Photographer: Tom Cunningham

In back seat of police car, the captured Donahue
closes his eyes as he ponders his fate. Seated along-
side of him is Maj. Leo F. Carroll of Connecticut
state police.

Previous spread:

POSING AS TOUGHIE

August 2, 1943
Photographer: Payne

Brooklyn stickup kids
Bergen St. Police Station

Photo shows Robert E. Maschak, left, 16 years
old, of...Irvington, New Jersey, who calls himself
"Curly Bill," and Ralph Yanicello, 20, of Sackett St.,
with patrolman and gun in Bergen St. Station...
they were picked up on Dean St. between 3rd and
4th Ave., by Patrolman Irving Jampal of the 78th
Pct. as hold-up men. "Curly Bill" enjoyed posing
as toughie for photog...—photographer's caption

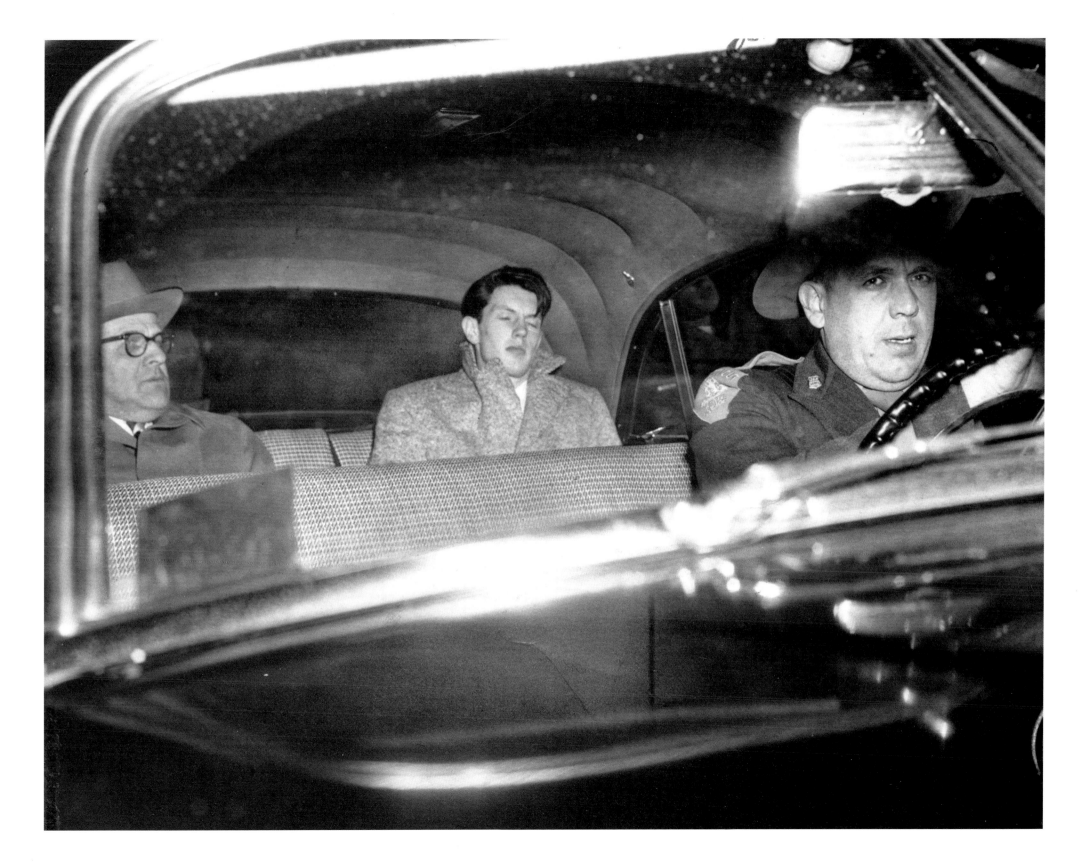

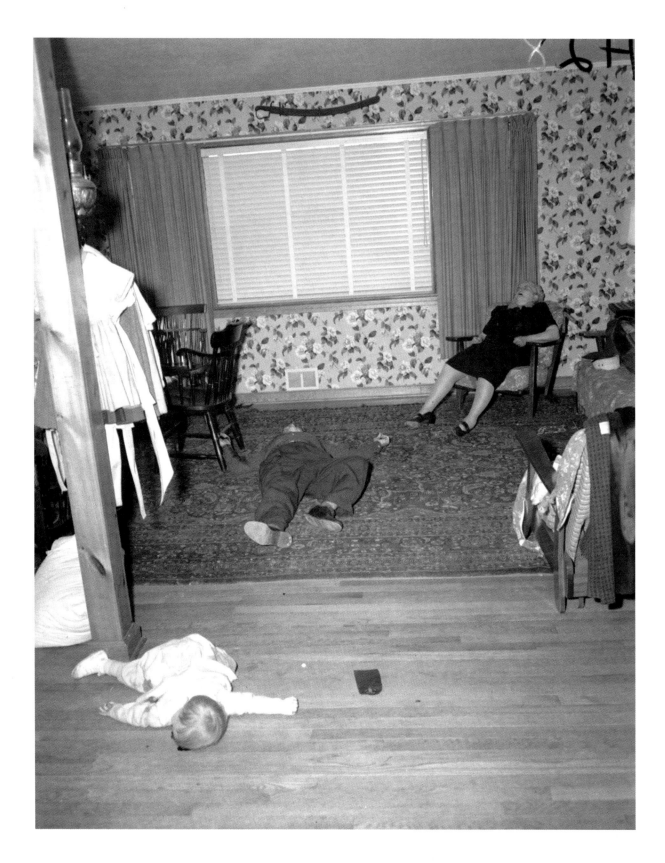

END OF A FAMILY

JANUARY 29, 1956
Photographer: Frank Hurley

Pathetic figure of Peter David, 19 months old, lies in the foyer after he was cut down by his father's [William Bauer's] shotgun blast. Bauer's mother-in-law looks as if she's sleeping but it's the sleep of death. Her husband lies on his back nearby. The Neubers, Bauer's wife's mother and father, had just dropped in to bid them good-by for their Florida vacation.

HOUSE OF DEATH

JANUARY 29, 1956
Photographer: Leonard Detrick

House of Death. Policeman looks over 12-gauge shotgun which William Bauer used to kill six members of his family before turning weapon on himself. Bauer's daughter, Elizabeth, 5, lies near cop and Bauer's 19-month-old son, Peter, lies sprawled in center of room of the Parsippany–Troy Hills (N.J.) ranch house. Police say Bauer also killed his father-in-law, whose legs can be seen in foreground, as well as his wife, his mother, and his wife's mother.

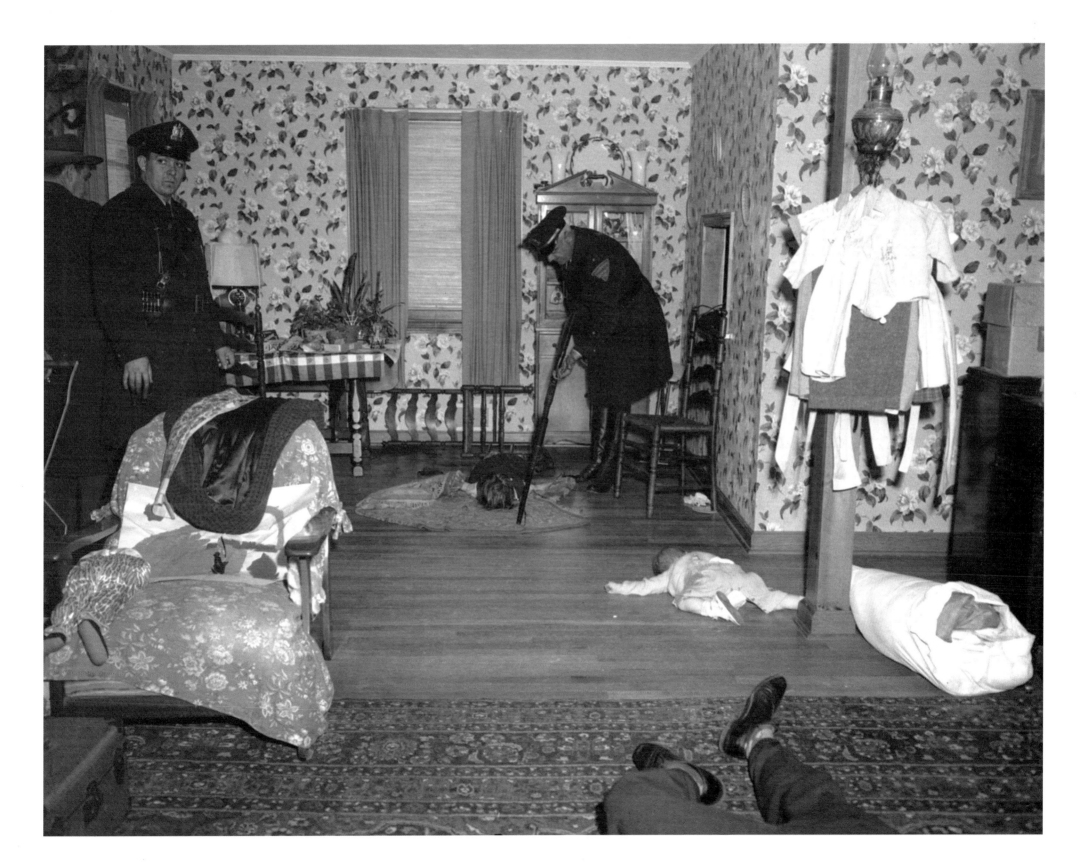

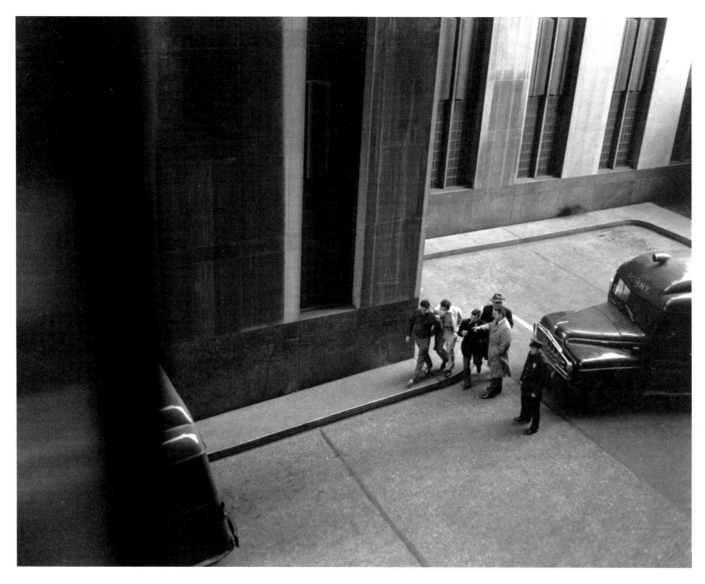

THE TRIGGER'S SQUEEZED

SEPTEMBER 2, 1955
Bill Meurer

A handkerchief to his face and handcuffed between two other prisoners, Trigger Burke is hustled from court to prison van by Capt. Frank Bruno (pointing).

SEPTEMBER 2, 1955
Daily News photo

Flanked by two detectives, Elmer (Trigger) Burke is escorted from train after being captured Saturday in Folly Beach, S. C., and returned to New York. After arraignment he was grilled about the 1952 barroom slaying of his crony, Ed Walsh, and five other murders.

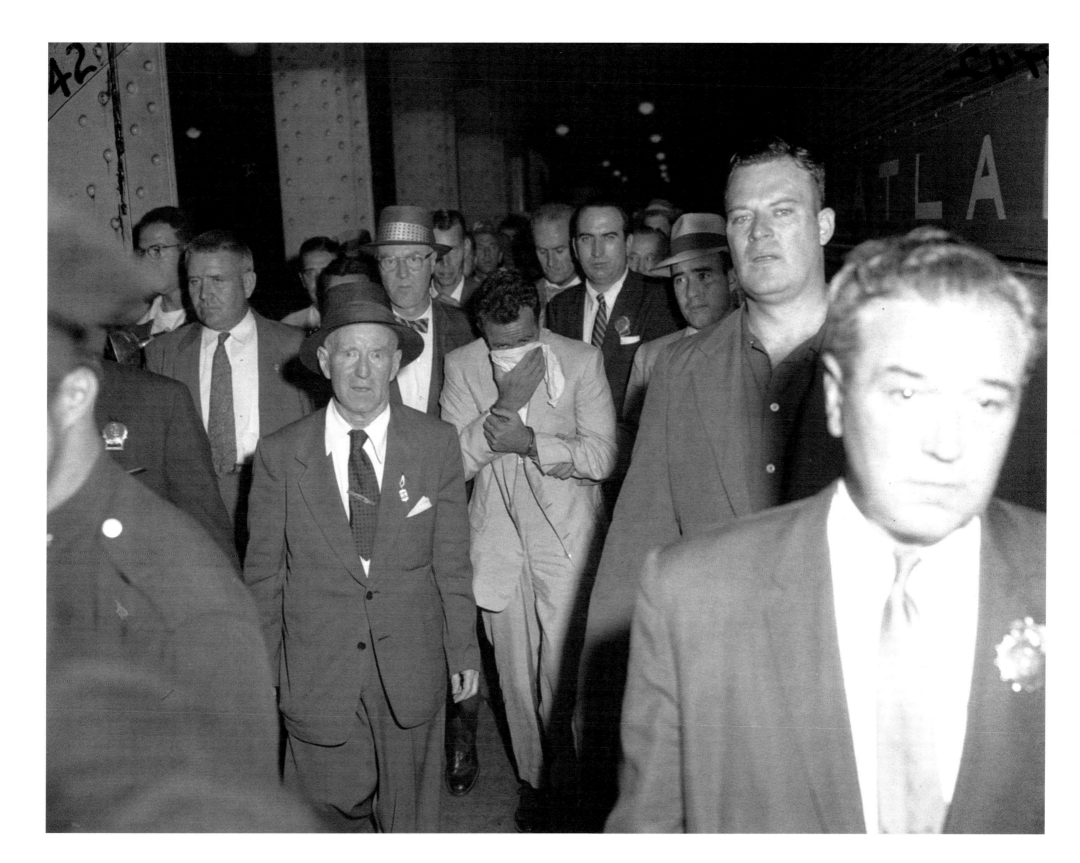

SHIELDING HIS DAUGHTER

May 14, 1952

Photographer: Twyman

Ernest Daigneault shields his daughter, Paula, from photographers as they leave Queens Felony Court.

KIDNAPPED HOUSEWIFE

August 12, 1956

Photographer: Mehlman

As kidnapped housewife Grace Drepperd leaves car under watchful eyes of police in North Branford, Conn., her abductor, Everett Cooley, sits sullenly in rear seat.

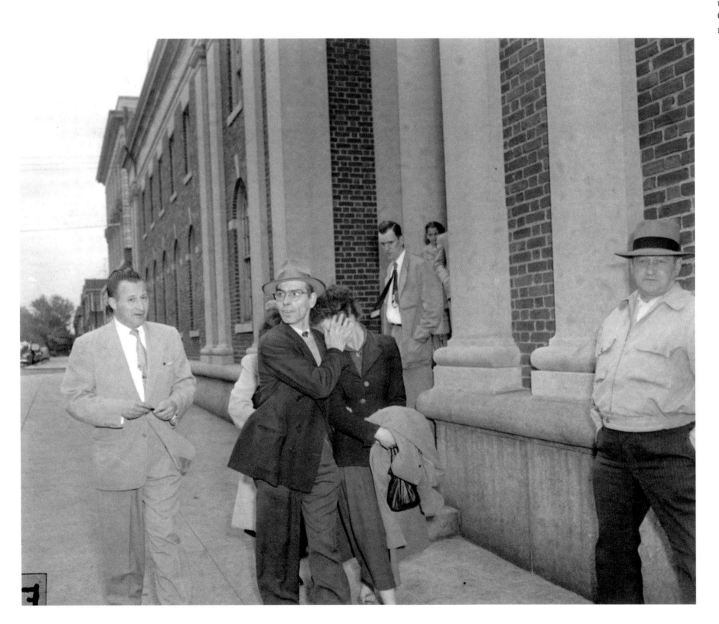

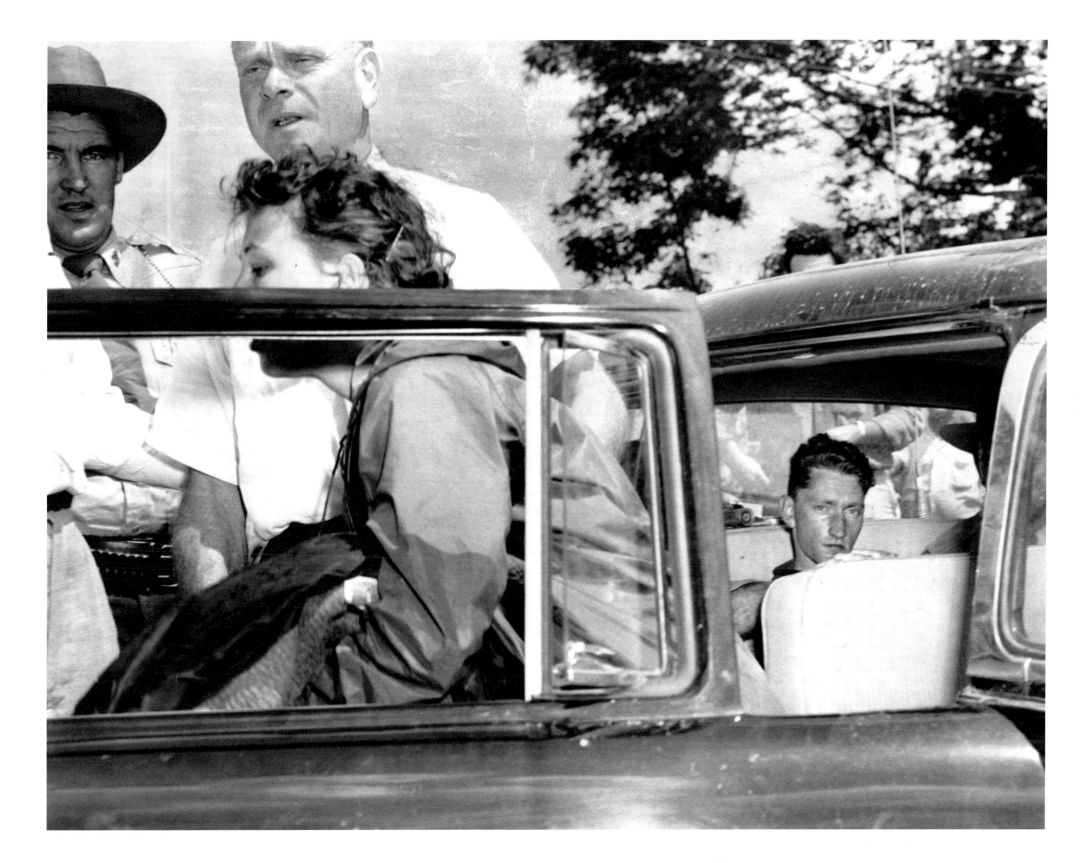

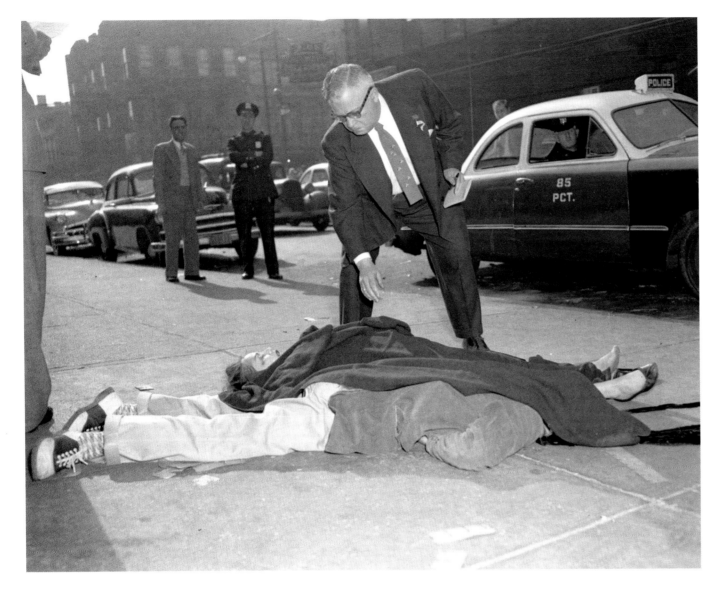

A MARRIAGE ENDS

MAY 17, 1951
Photographer: John Peodincuk

A Marriage Ends. Sam Gitlin, Brooklyn Asst. District Attorney, bends to examine bodies of Jack and Carmen Dietz lying on sidewalk on Moore St., Brooklyn. Dietz, 27, a liquor clerk, shot his estranged wife as she left home at 60 Moore St. for work and then turned gun on himself. Their 4-year-old son watched from window as mother was shot.

PAST HER LIFELESS DAUGHTER

JANUARY 25, 1958
Photographer: Alan Aaronson

Mrs. Lucy Canzoneri averts gaze from lifeless body of her daughter as she leaves house followed by detective.

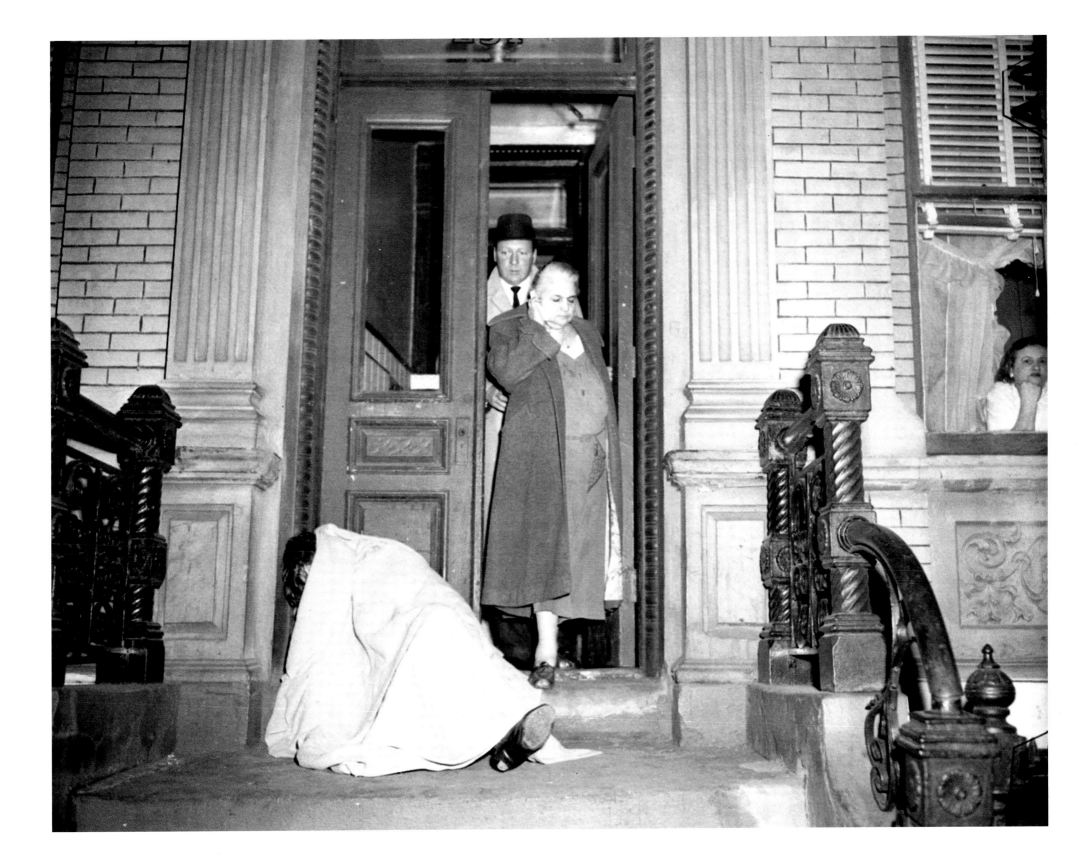

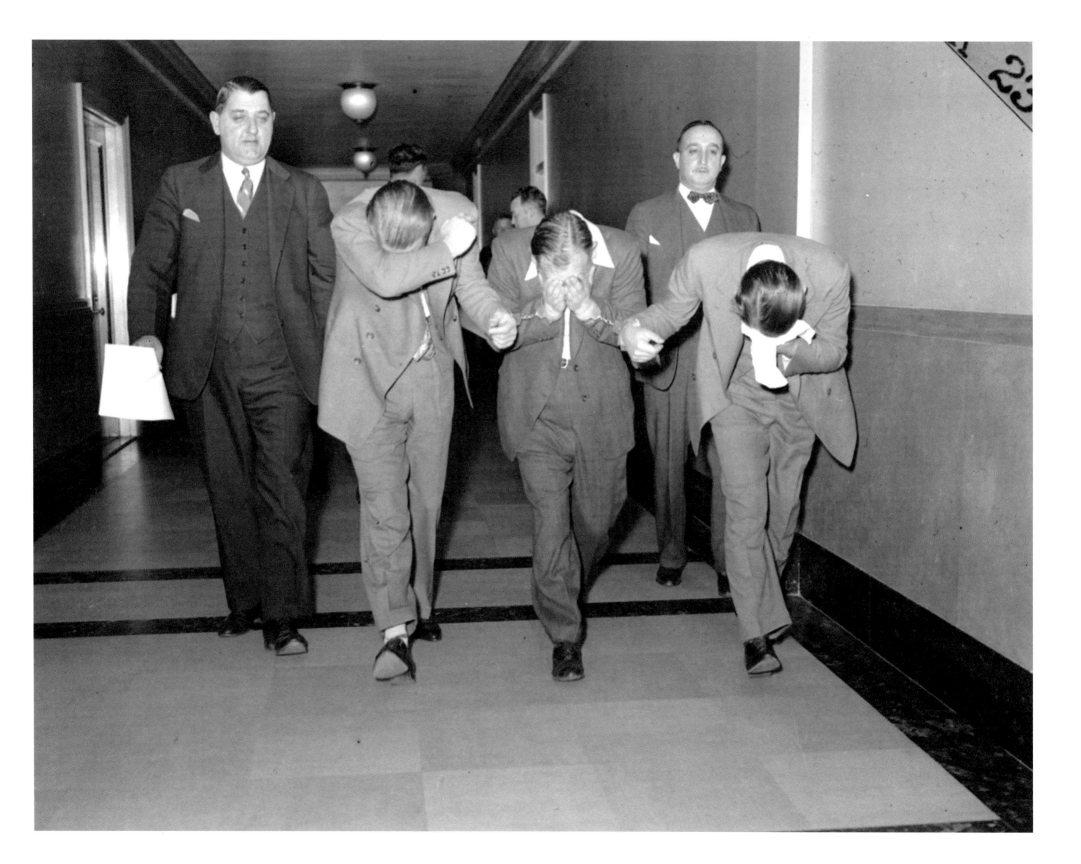

HELD IN BOGUS MONEY RAID

MAY 20, 1938
Daily News photo

Arraign 3 Held in Bogus Money Raid
Three men, described by Treasury Department agents as members of a large counterfeiting ring, were arraigned yesterday before United States Commissioner Joseph F. Holland in Newark, N.J., on charges of possessing bogus money.

BOTTLE CLUB

MAY 29, 1960
Photographer: George Lockhart

Raid! Happy Lads Social Club.

BLONDE BAD LUCK CHARMER

Janice Drake was no gun moll. In her youth, New Jersey picked her to represent the state in the Miss America contest and some time later she was voted to be in possession of "the most beautiful legs in the United States." She was the wife of nightclub comedian Alan Drake and, according to friends and neighbors, a good wife and mother. However, she kept some sinister company and had a penchant for dining with racketeers. Despite her unique dinner companions, Janice was described as "a nice, sweet, innocent kid." But things seemed to happen to those guys she ate out with: they seemed invariably to get "hit."

Born in Weehawken, N.J., in 1927, Janice

Left: Nat Nelson fêted Janice the night before he was killed.

Right: Little Augie Pisano, pictured here while being held on suspicion of murder in 1933, was once Al Capone's representative in the East. Pisano shared his final meal with Janice.

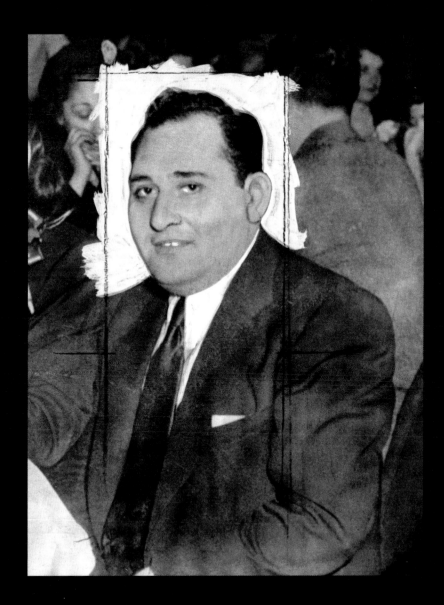

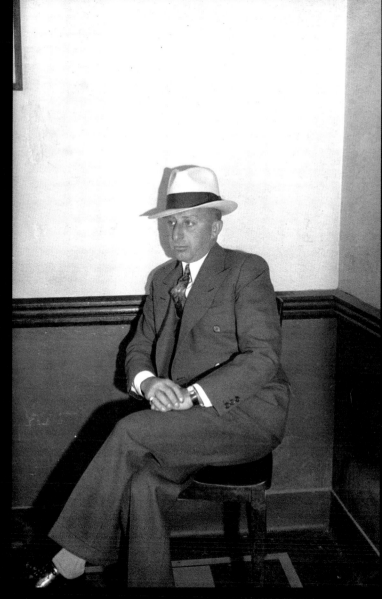

121

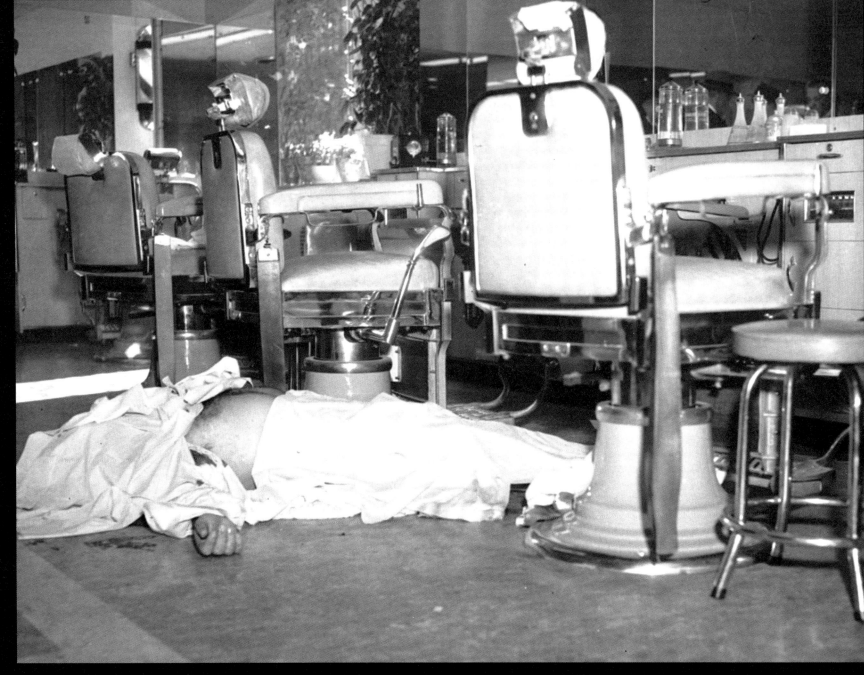

Above: Albert Anastasia, mob big shot, dined with
Janice, Augie; then met death.

liked Uncle Gus and you should hope Uncle Gus liked you. His real name was Anthony E. Carfano, but in underworld circles he was better known as Little Augie Pisano, and he was a dangerous man. With Louis "Lepke" Buchalter, he controlled the garment district and was suspected of having a hand in other rackets, slots, labor, and election fixing. He was arrested in connection with six different murder investigations and beat the rap every time.

Janice's reputation as a femme fatale was launched under the auspices of one Nat Nelson, wealthy dress manufacturer. Although Nat was a bit on the heavy side, he had a reputation as a ladies' man and nightly toured the hot clubs. It seems that Alan Drake took an open approach to marriage and didn't mind if his wife dined with other men. On the evening of February 9, 1952, Janice and Nelson did just that. The next afternoon he was found shot to death in his West Fifty-fifth Street apartment. Janice and Nelson's business associate, a Mr. Palmieri, were both brought in for questioning but could offer no assistance. The murder went unsolved.

On October 25, 1957, Janice accompanied sweet old Uncle Gus to dinner with the man who at one point was known as Lord High Executioner of Murder Inc.—Albert Anastasia. This name resonated throughout the mob kingdom, and although his power may have diminished some by the time of his introduction to Janice, there is no doubt that he still had a heavy hand in the policy game and other rackets. At 10:30 a.m. the next morning, Anastasia was shot in the barbershop of the Park Sheraton Hotel. Again Janice was questioned by police but could offer no clues.

By now you would think that word would have spread in the underworld that dinner with Mrs. Drake was a last supper, but apparently Little Augie was not a superstitious

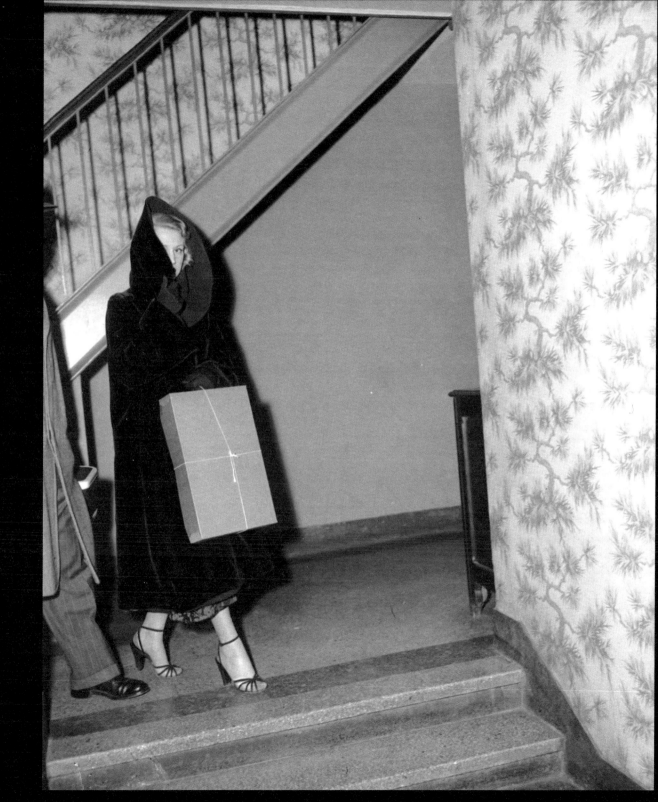

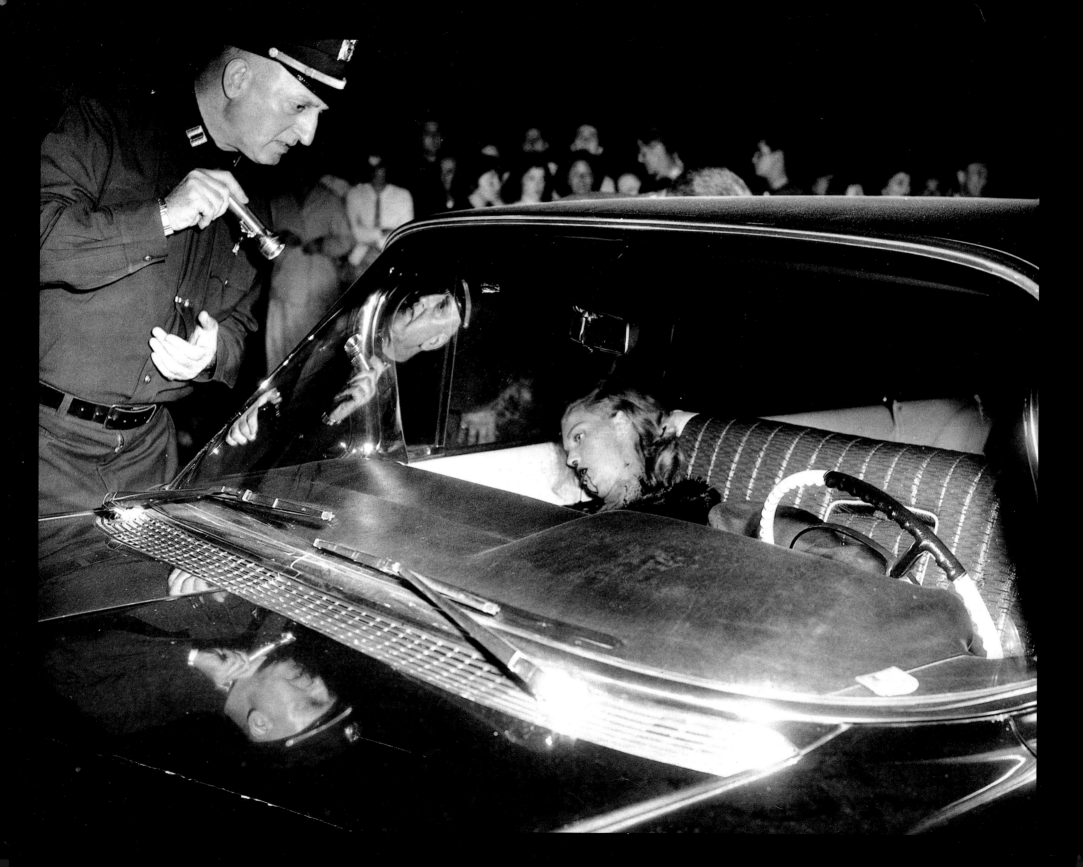

man. On the evening of September 29, 1959, Augie spotted Janice having cocktails with a friend and asked them to accompany him to dinner. During the meal Augie took a phone call at the bar. When he returned, he was in a highly agitated state, saying, "I got an appointment in Queens. I got to get there in a hurry." Augie sent an associate for his long black Cadillac, threw a wad of cash on the table to settle the bill, and said his good-byes. As he did so, Janice, dressed in an elegant black cocktail dress, marten stole, and white gloves, went out to the curb to wait. When the car arrived, Little Augie and Janice got in. It was 9:45pm.

Half an hour later a phone call came in to the police from Jamaica, Queens, where a witness had seen two men flee from a black Cadillac. Police rushed to the scene and found the Caddy, which had lurched up onto the curb. Inside were Little Augie and Janice—each with two bullets to the head and one through the neck. Janice's big blue eyes stared in silent wonderment out the front windshield. Augie was slumped in her lap. Judging by the path of the bullets, the killers sat in the back seat.

At first police were satisfied that indeed Janice was killed simply to silence a potential witness. But as Queens District Attorny Frank D. Connor's investigation dug deeper into Drake's life, it emerged that she had been consorting with the top figures of the crime world. Connor theorized that she was a courier, transporting both narcotics and money between high-ranking mobsters. When asked if she played a role in the upper echelon of mobdom, Connor replied, "She was considered to be top flight." That seems to have been the reaction from all that knew Janice, no matter what role she played for them.

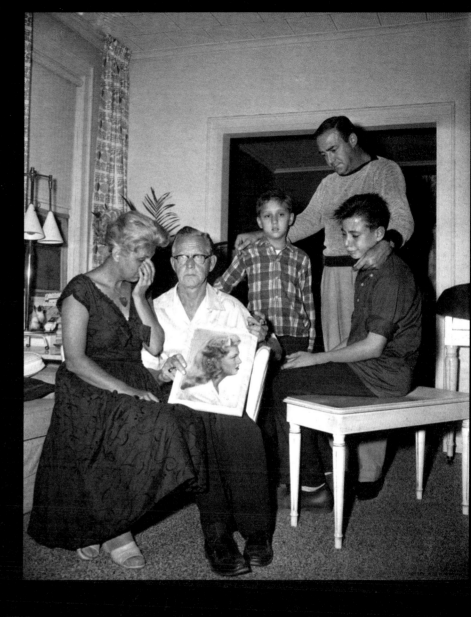

Opposite: Pix shows: Police Capt. looks at body of Janice Drake who was slain along with Mobster, "Little Augie" last nite...
—photographer's caption

Above: Janice Drake's family huddle together in grief after news of rubout, l. to r.: Mrs. June Hanson, her stepmother; her father, Harold Hansen, who holds her picture; her stepbrother, Harold Jr.; her husband, comedian Alan Drake, and their son, Michael.

BANK HOLDUP MISSES BY A SHADE

OCTOBER 8, 1954
Photographer: Jack Clarity

Bank Holdup Misses by a Shade. Policemen and detectives, guns drawn but exercising extreme caution, take up positions outside the bank. Inside the walls are one of the bandits, Joseph Ritter, 22, and five bank employees he is holding prisoner.

HER KILLER BOOKED

AUGUST 26, 1956
Photographer: Alan Aaronson

Her Killer Booked. The body of Rosemary Spezzo, 24-year-old parochial schoolteacher, missing since June 23, was found in Greenburgh, Westchester, after a coffee salesman confessed yesterday to killing her and led police to her body. The salesman, Edward F. Eckwerth, 29, stands handcuffed at Yonkers police headquarters while reporters look on. He was booked for murder. He had been brought back from Portland, Ore., last Wednesday.

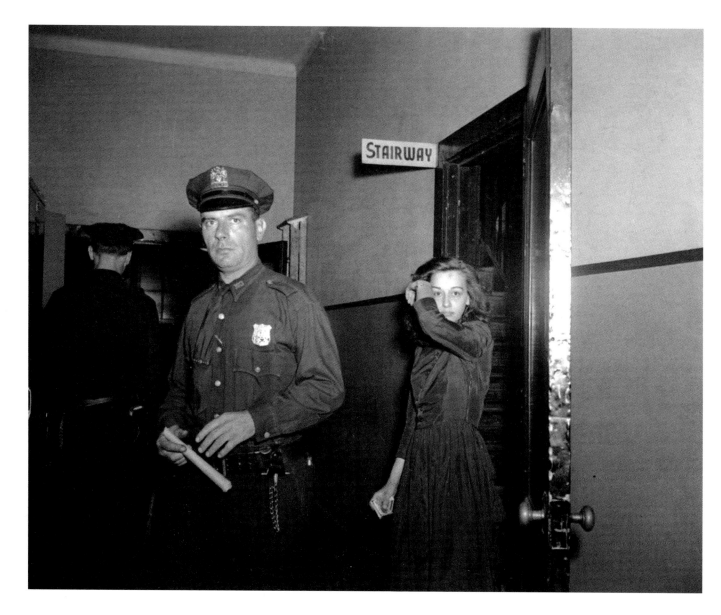

SCOLDED BY JUDGE
AUGUST 20, 1950
Daily News photo.

Mrs. Rita Collins, who was scolded by judge.

DEATH THREW A STRIKE
OCTOBER 9, 1956
Photographer: Jack Clarity

Death Threw a Strike. The body of Detective William F. Christman, 38-year-old father of five, is covered as it lies in street outside bar at 104-06 Liberty Ave., Ozone Park, Queens. He was shot to death by George Robert Thomson, 25, as an aftermath of argument over yesterday's Series game. Thomson said he got gun, fearing cop would follow him and awaken his wife, and fired after Christman threatened him.

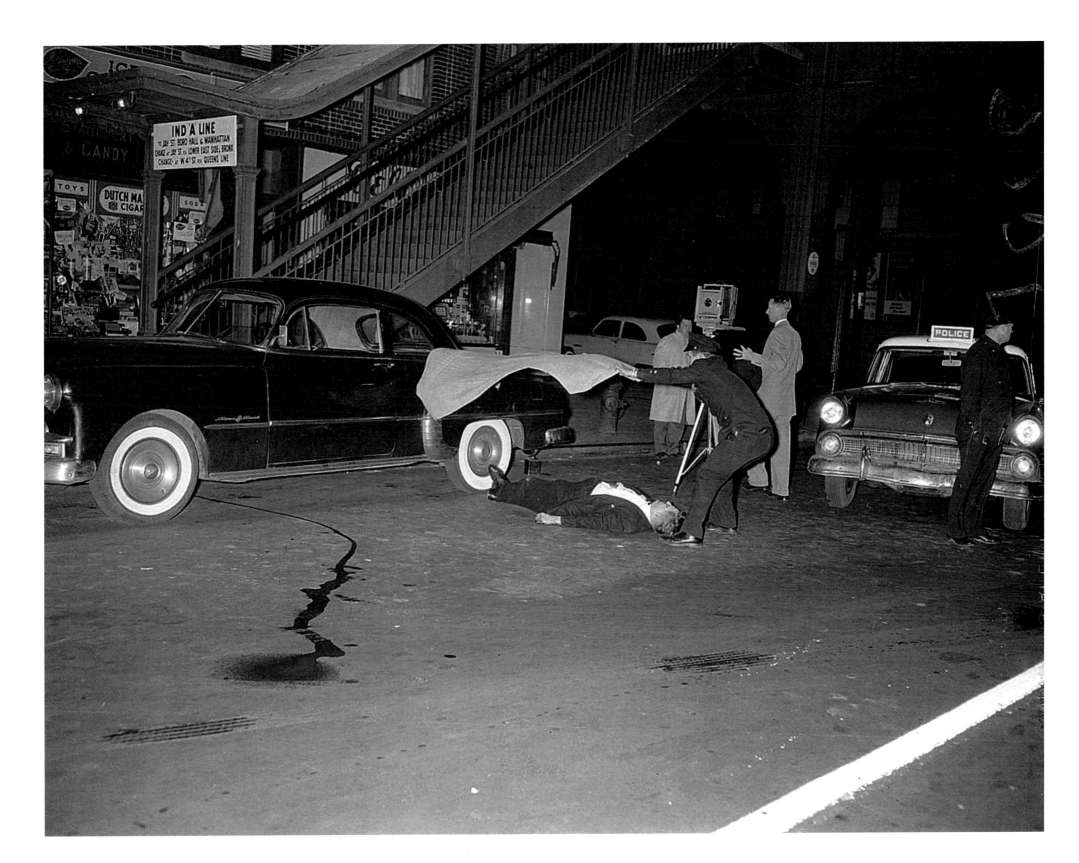

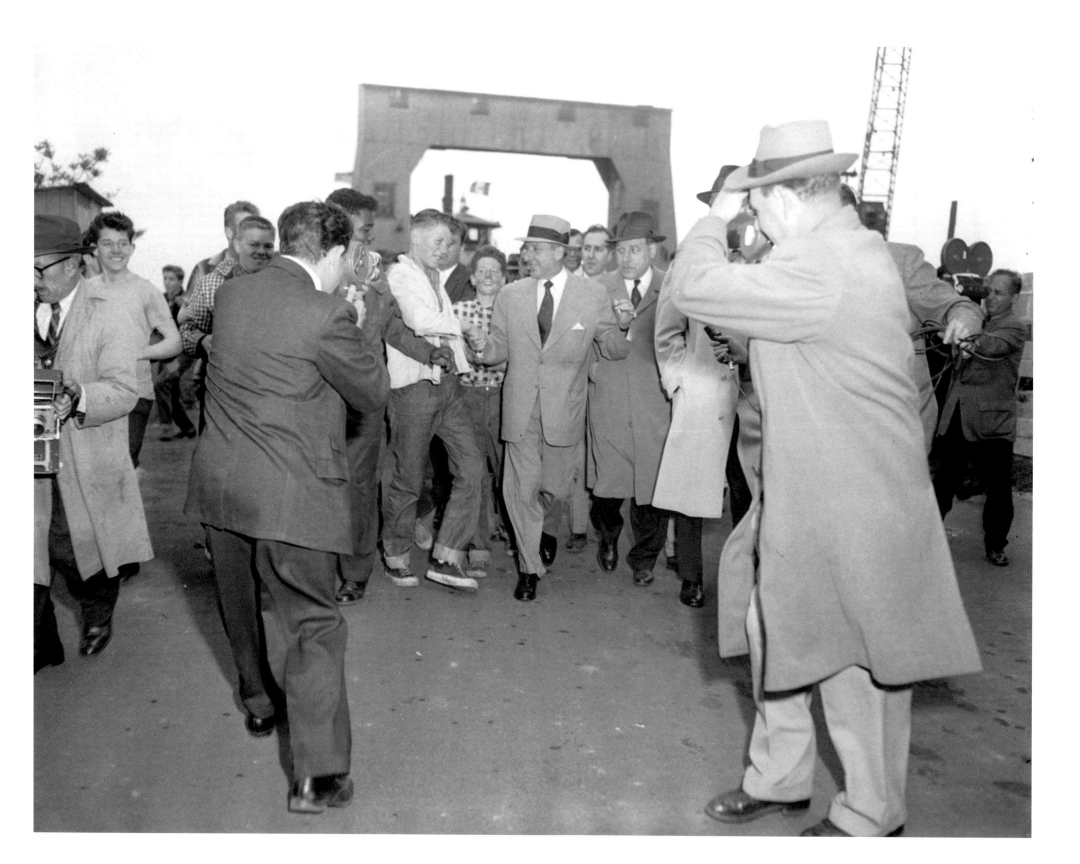

WELCOME BACK

MAY 23, 1957
Photographer: Bill Meurer

Teenagers mob Frank Costello as he leaves Rikers Island Ferry...They just mobbed him...here is one of them shaking him by the hand...one of his attorneys Morris Shilensky on his right... (moustache)—photographer's caption

GOLDILOCKS NABBED

MAY 2, 1957
Photographer: Ossie [Osmund] Leviness

Bellevue for Bednaper. A policeman escorts cigaret-smoking Marion Darmannin into Bronx Magistrates Court yesterday.

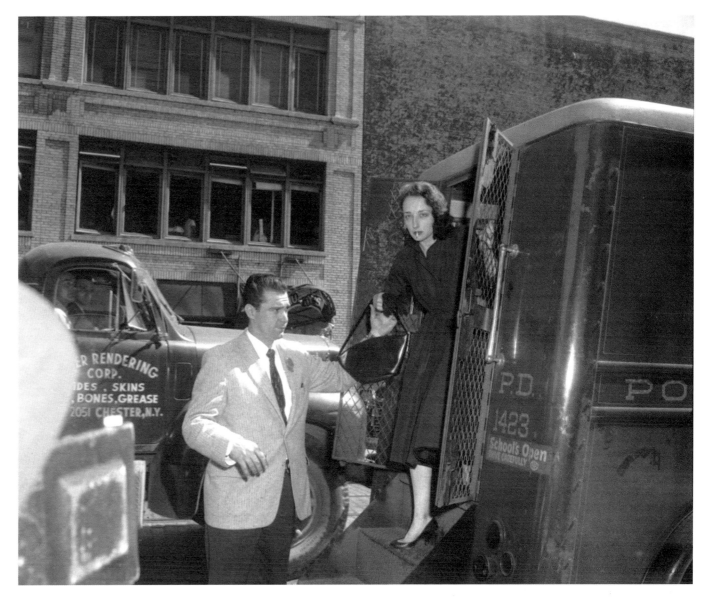

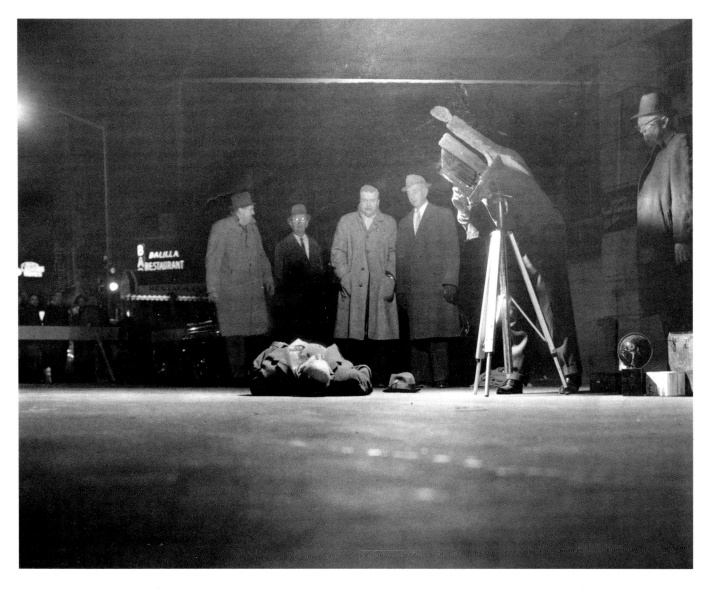

GREENWICH VILLAGE SHOOTING

FEBRUARY 8, 1962
Photographer: Bob Koller

Police photograph body of Louis J. D'Agostino, 42, found shot to death in a Greenwich Village street last night.

MARIE GAZZO MOURNED

NOVEMBER 20, 1955
Photographer: Ossie [Osmund] Leviness

Mother of Mae Gazzo, Mrs. Millie Gazzo, and relatives at grave.—photographer's caption

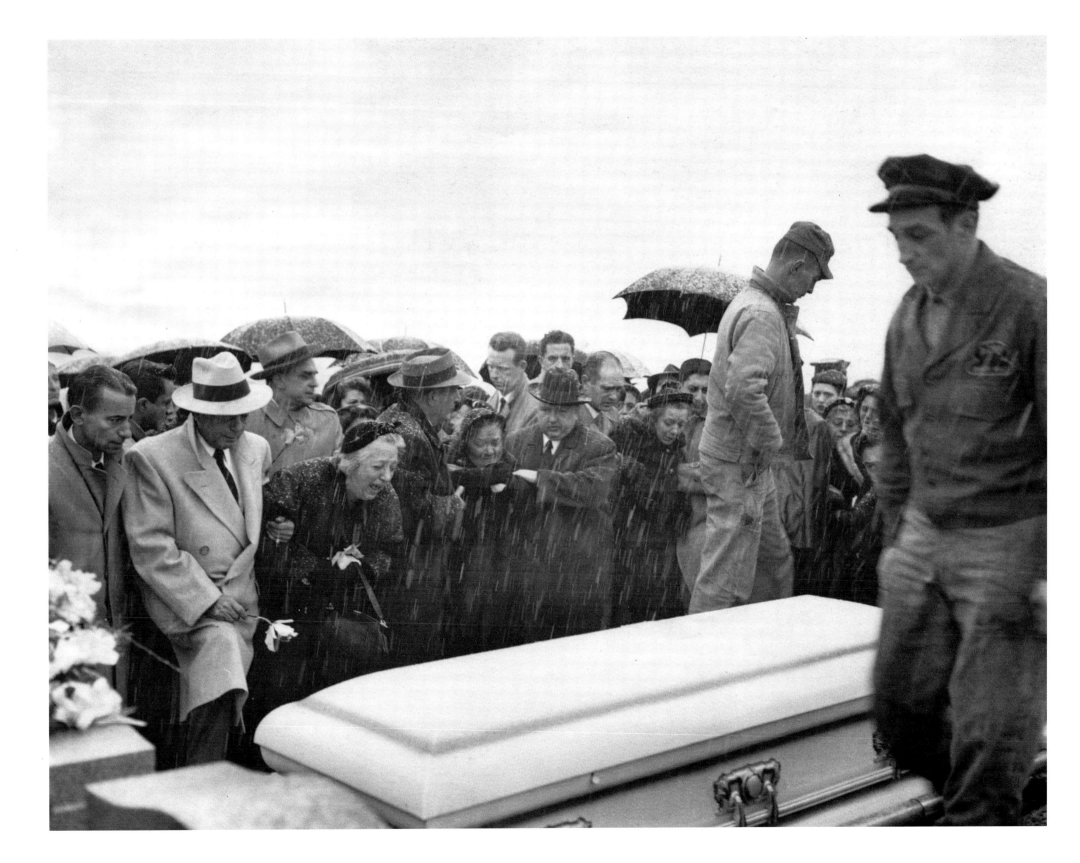

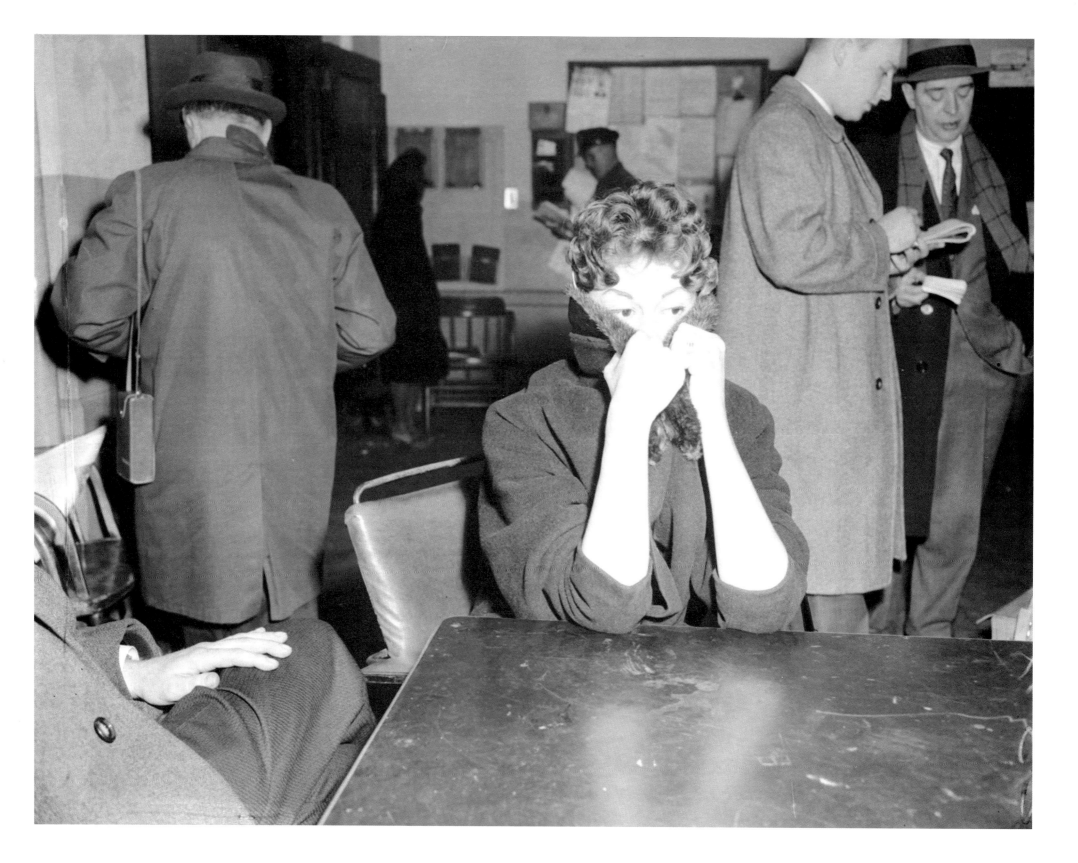

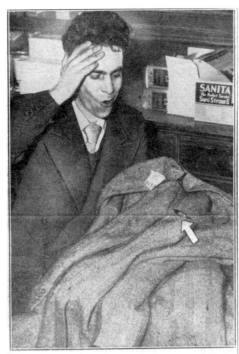

Cop Slays Thug. Patrolman John Christiansen, 29, examines bullet hole (arrow) in his coat, put there by gunman identified as Remigio Sanchez Crespo, 33, during duel at Fourth Ave. and Eighth St. The cop, off duty at time, killed Crespo, who'd just held up an Army & Navy store. —*Story p. 2*

DEC 27 1950

MOM WAS MADAM

MARCH 19, 1959
Photographer: Evelyn Straus

Say Mom Was Madam With Children Present
The slim, 20-year-old wife, a fugitive procurer, was arraigned yesterday in Adolescent Court on charges of allowing call girls to entertain Johns "while children were present."

COP SLAYS THUG

DECEMBER 27, 1950
Photographer: John Peodincuk

Cop Slays Thug. Patrolman John Christiansen, 29, after shooting Remigio Sanchez Crespo, 33, during duel at Fourth Ave. and Eighth St. The cop, off duty at the time, killed Crespo, who'd just held up an Army & Navy store.

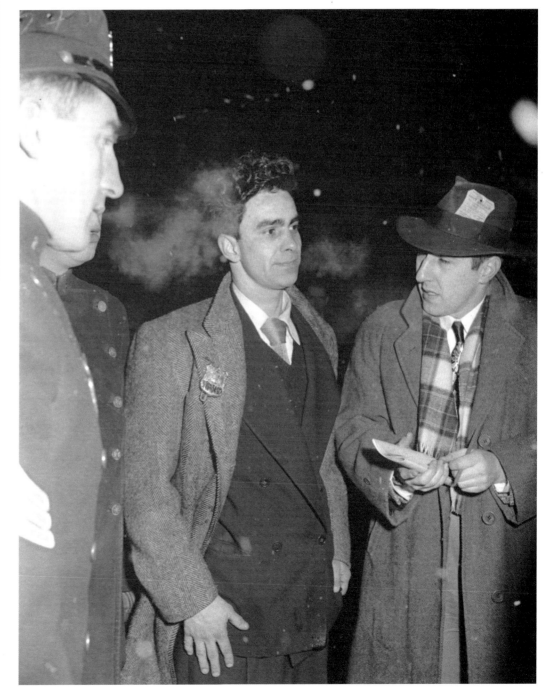

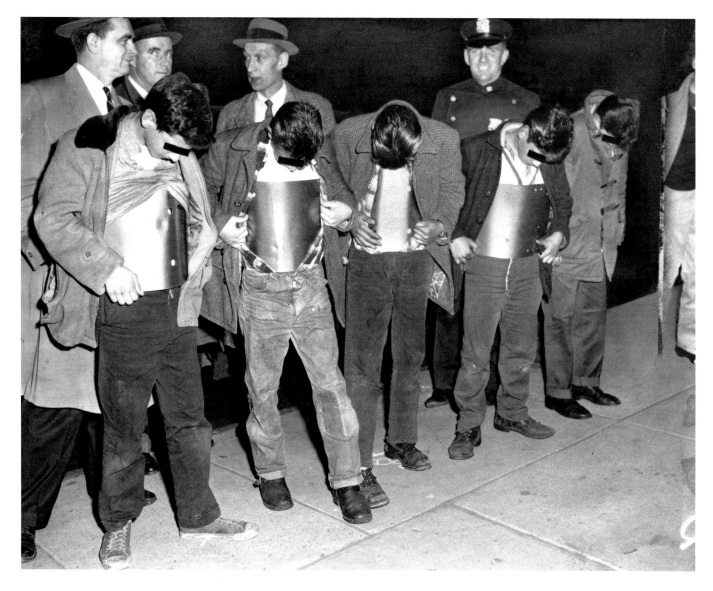

A VESTED INTEREST IN PROTECTION

APRIL 11, 1958
Photographer: Gallagher

A Vested Interest In Protection. Four of five boys arrested in Brooklyn last night to head off a gang fight exhibit aluminum vests, worn to protect themselves from heavy blows. The five were all two cops could grab of about 40 gathered for a rumble at Hancock St. and Irving Ave.

CAUGHT IN A POLICE TRAP

NOVEMBER 17, 1962
Photographer: Detrick

Body of gunman Kenneth Cavanaugh lies in W. Houston St. Bullet-riddled getaway car is behind him.

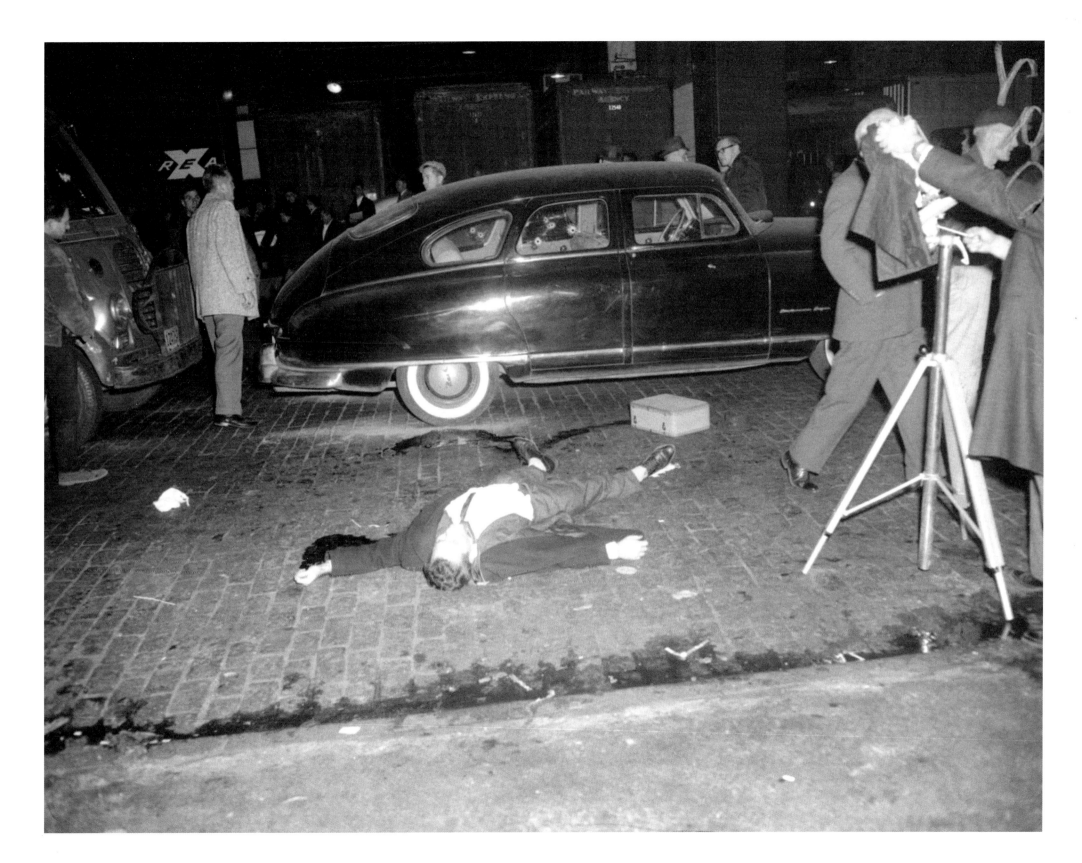

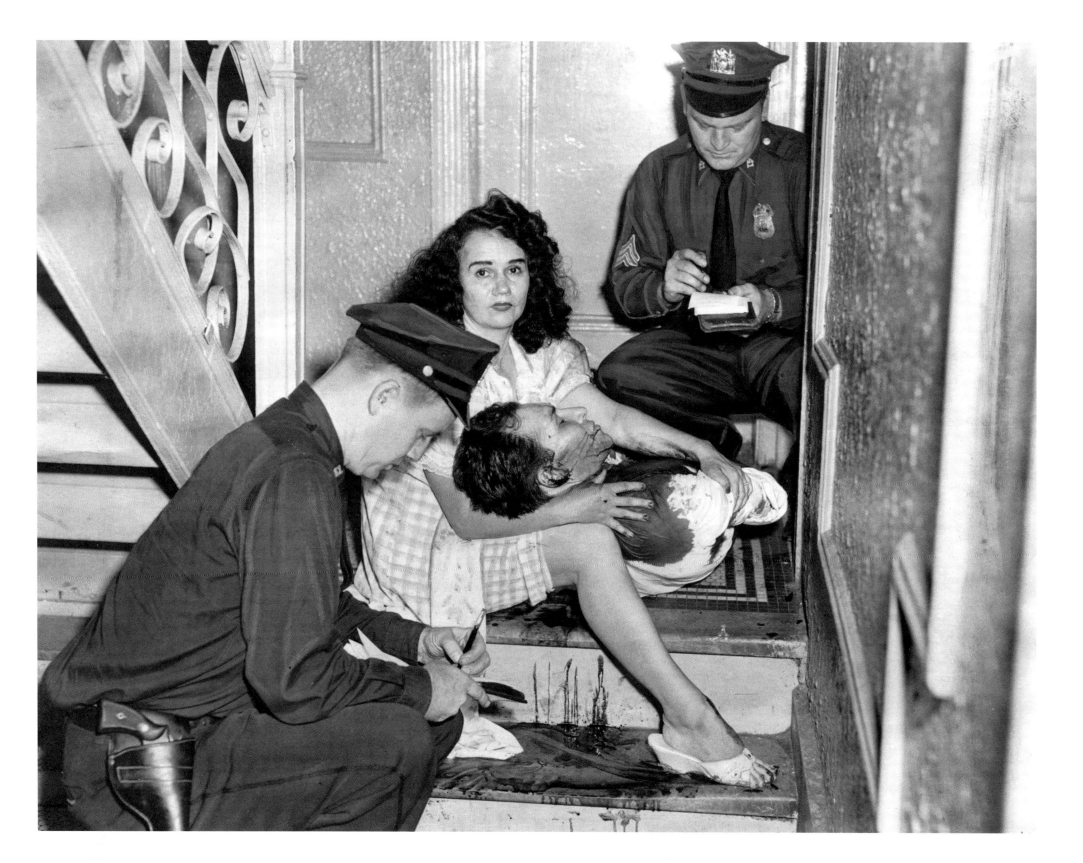

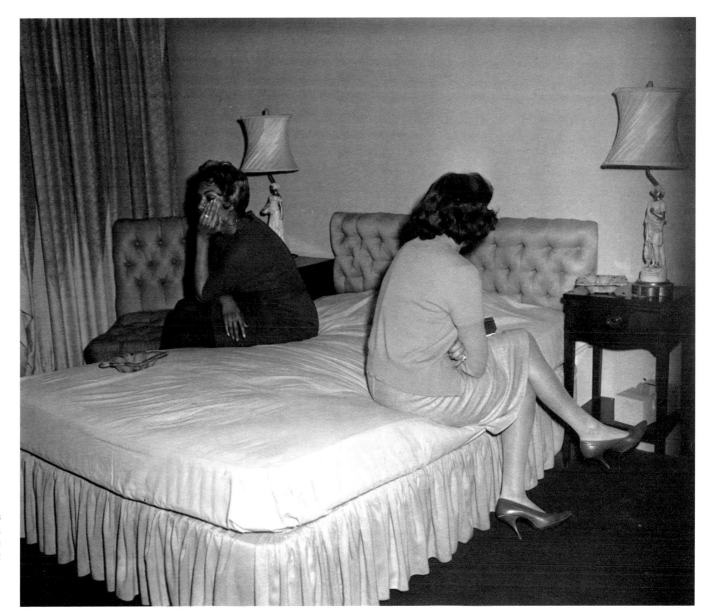

GUNNED DOWN BY RIVAL

SEPTEMBER 27, 1961

Photographer: Alan Aaronson

Gunned Down by Rival. Josephine Senquiz cradles the head of James Linares, 35, after he was shot in hall of building at 992 Southern Blvd., Bronx. The woman's husband, Henry Senquiz, admitted he shot Linares because of his friendship with his wife.

V GIRL RAID

FEBRUARY 4, 1961

Photographer: Mehlman

V Girl Raid
160 W. 85th St.

Shows: Seated on bed in raided apt are L. to R: Jackie Clark, 26, of 160 W. 85th and Ellen Robinson, 24, of 534 W. 159th St. who were caught in raided apt with 7 johns this PM by Vice Squad in a Love for Sale operation.—photographer's caption

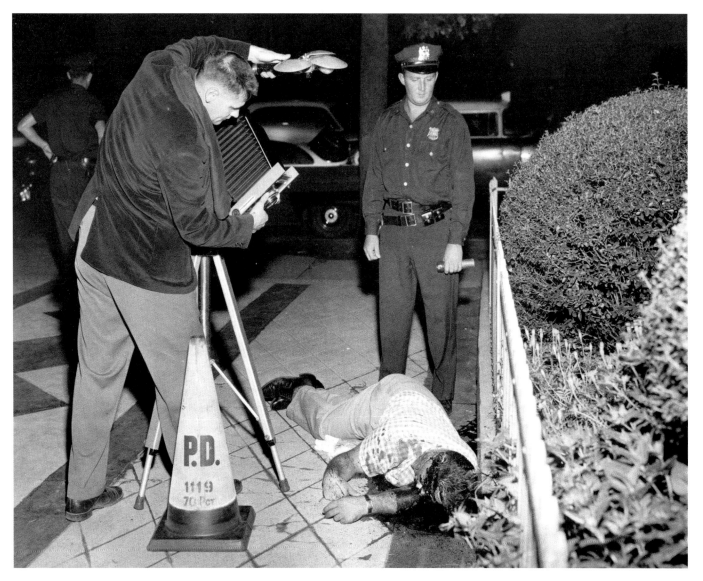

BENNY LATRIANO GETS THE MESSAGE

SEPTEMBER 14, 1958
Photographer: Jerry Kinstler

Benny [Biagio] Latriano lies dead at entrance to Brooklyn apartment house.

SLEEP HIGH, SLEEP LONG

JANUARY 1, 1956
Photographer: Hal Mathewson

Sleep High, Sleep Long. The man sprawled in the easy chair in the Empire State Building's 86th floor lounge seems to be snoozing. Actually, he's dead, a suicide.

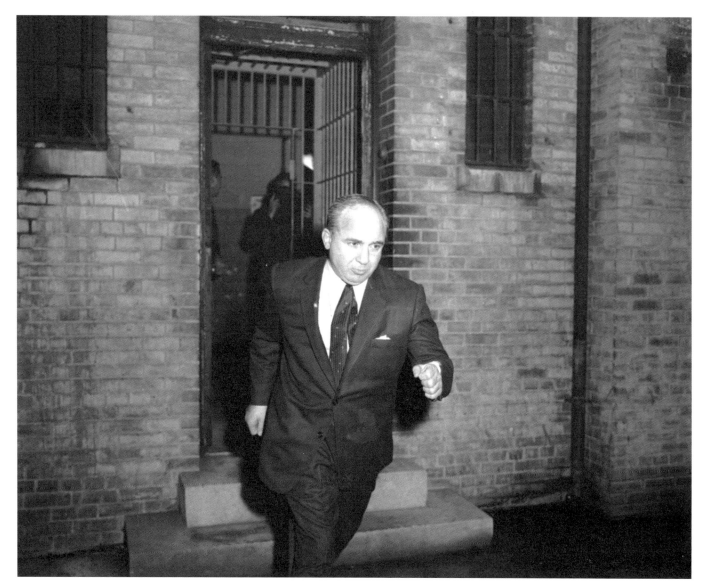

COHEN HASTENS FROM COURT

OCTOBER 2, 1960
Photographer: Bob Koller

[Mickey] Cohen hastens from court after posting bail.

RAPED AND ROBBED A MINISTER'S WIFE

MARCH 8, 1960
Photographer: Duprey

A slim six-footer, who was identified through a composite sketch by a Transit Authority detective, assertedly confessed early today that he raped and robbed a minister's wife last month in the 50th St. station of the Eighth Ave. IND subway.

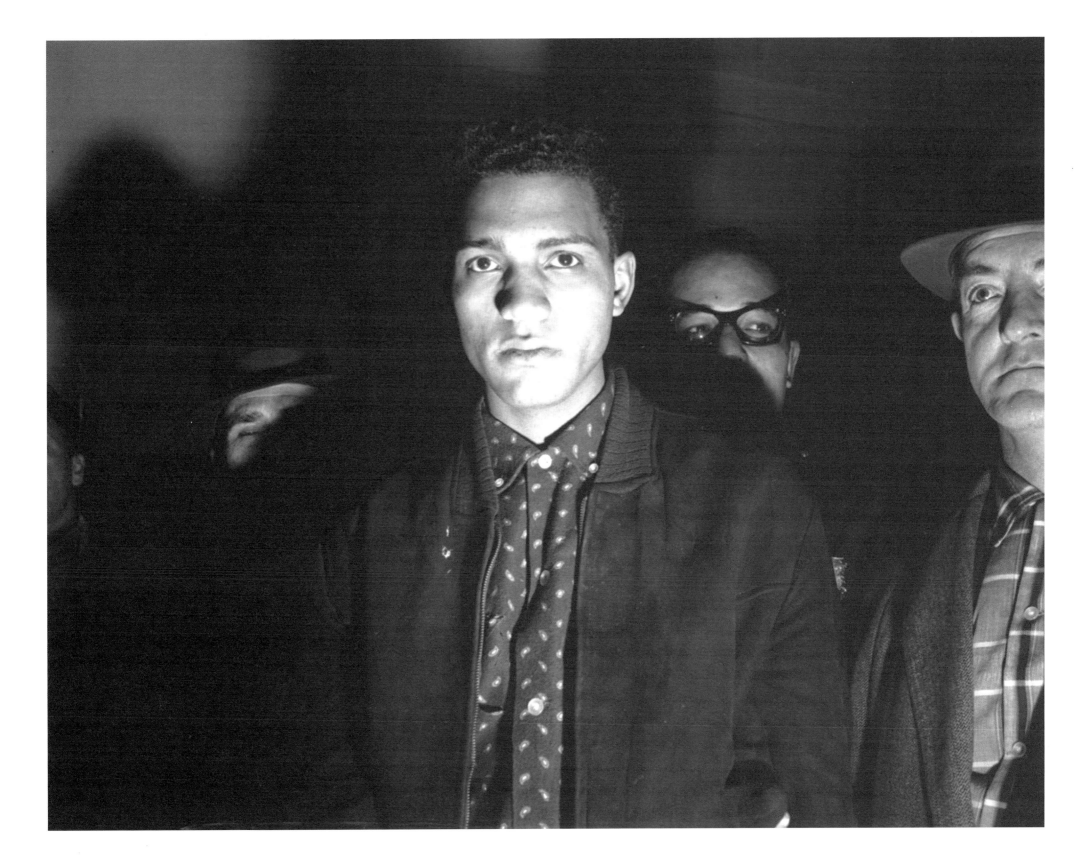

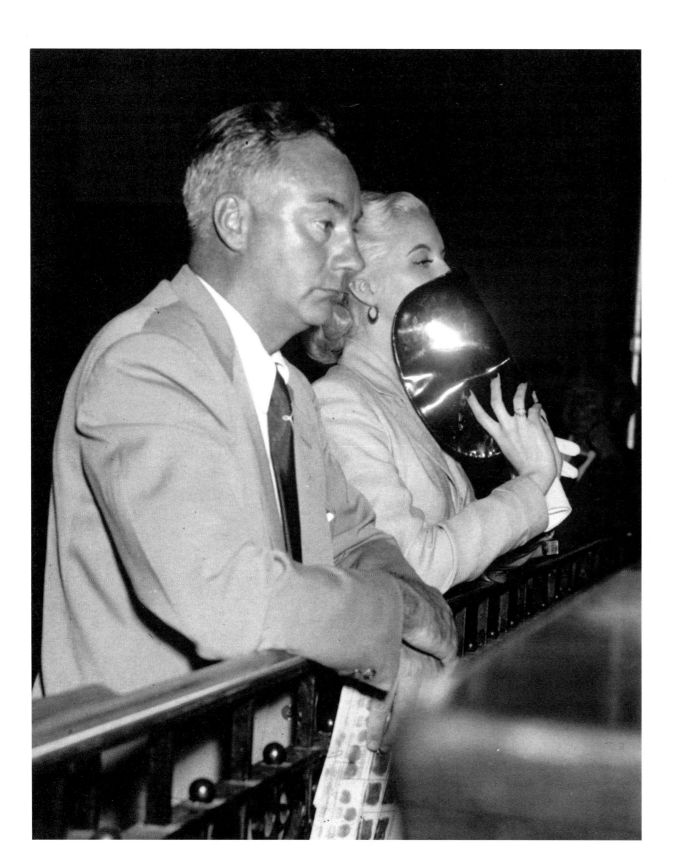

21-YEAR-OLD EXTORTIONIST

JULY 15, 1953
Photographer: Bob Costello

Alleged Extortion
23rd Pct, East 104th Street

Photo shows two close up's of Virginia Di Domenico (Dumont) 21 yr old extortionist while she is being booked. Other man is Det. Daniel Callahan of the 23rd Squad.
—photographer's caption

HOUSE OF ALL NATIONS

OCTOBER 19, 1956
Photographer: Al Amy

A "House of All Nations" call girl ring, which operated between New York and Chicago in hotels and apartments at rates of $25 to $125, was broken yesterday with the arraignment of its red-haired queen, described by a federal spokesman as "the heir apparent to Polly Adler."

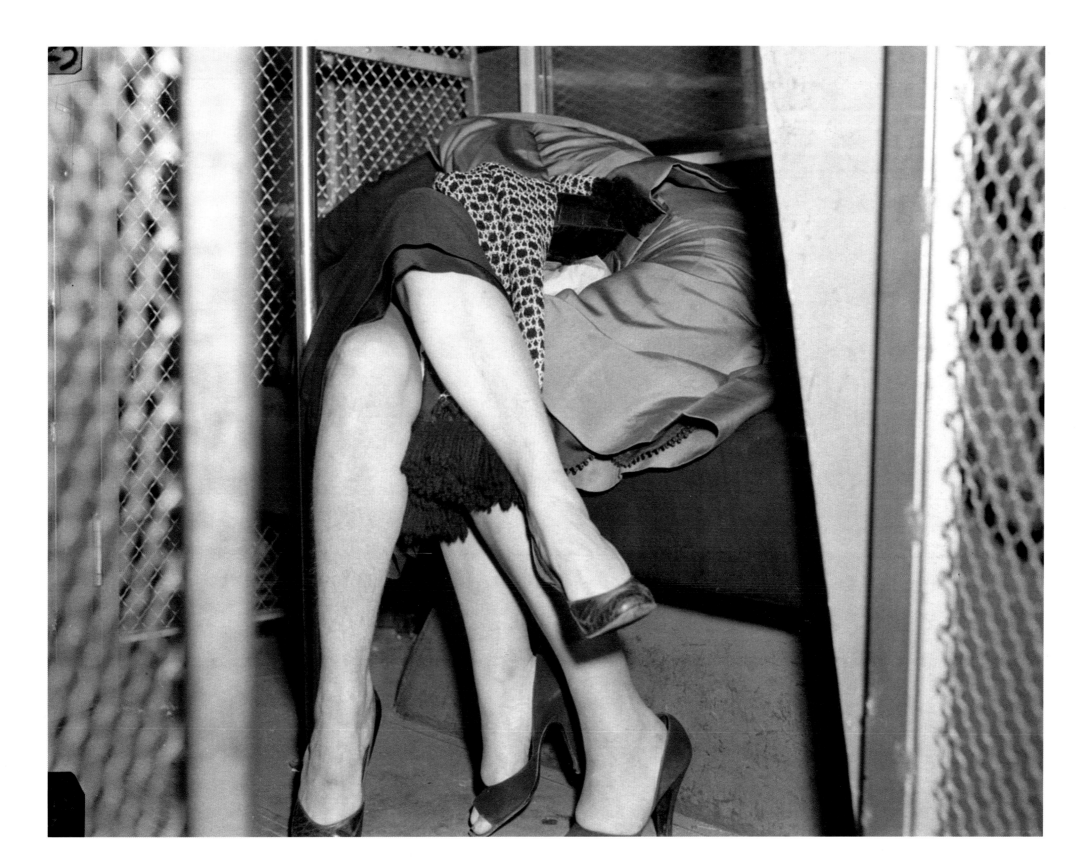

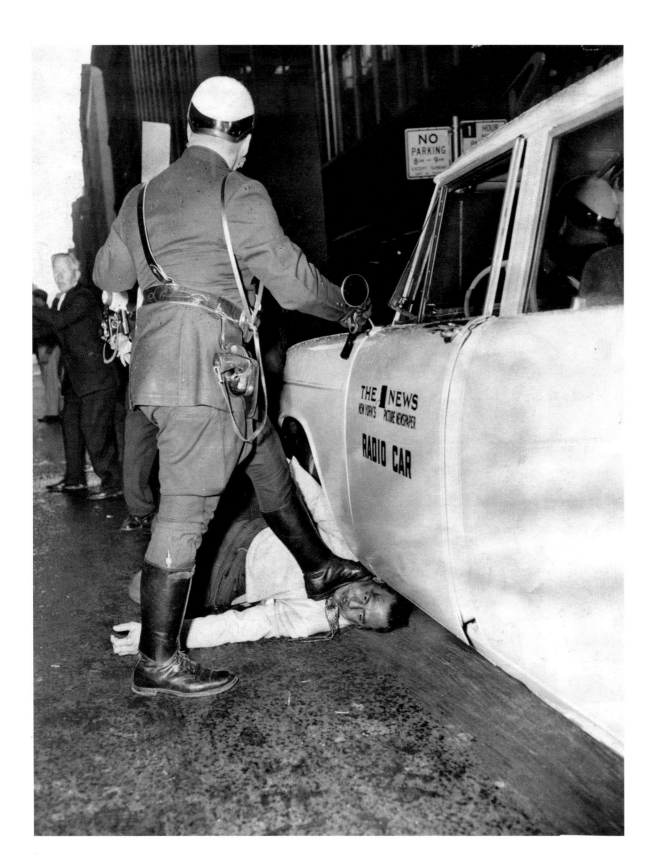

THE LAW STEPS IN

MAY 15, 1960
Photographer: Frank Russo

The Law Steps In. Jorge Orihuela, 42, census worker in the Cuban consulate, struggles as cop plants foot on his neck outside consulate at 625 Madison Ave. Orihuela was trapped under parked NEWS radio car which was covering brawl between pro- and anti-Castro factions.

HANDS DEALT DEATH

September 6, 1960
Photographer: Dan Farrell

Hands Dealt Death. Kenneth Leroy Brown, 15, displays his unusually large hands during reenactment of the strangling of Mrs. Wilma Tinsdale, 60, in her home at Clifton Place, Brooklyn. Police said that Brown admitted killing her in her bed when she awakened while he was rifling her purse. Theft netted youth $1 with which he bought cake and soda.

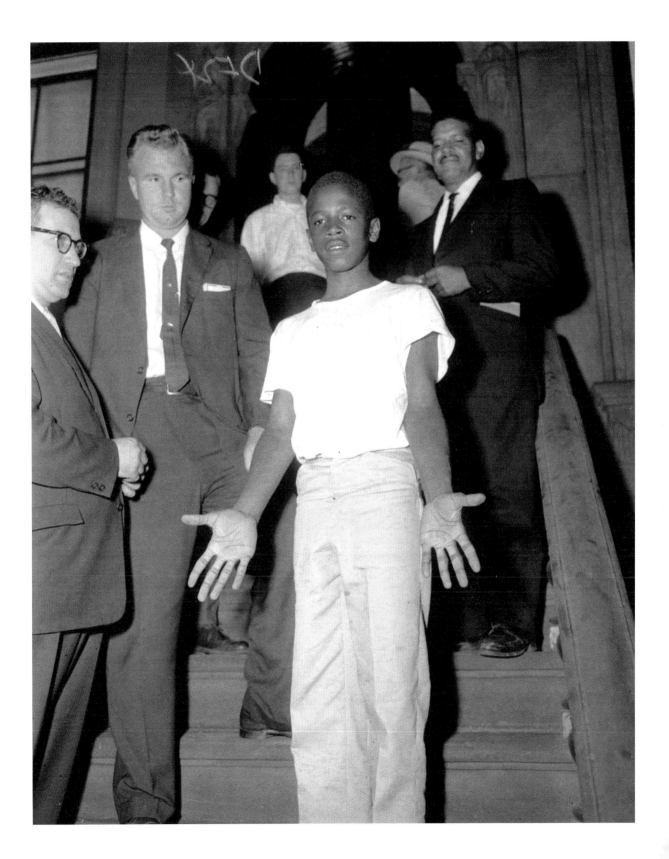

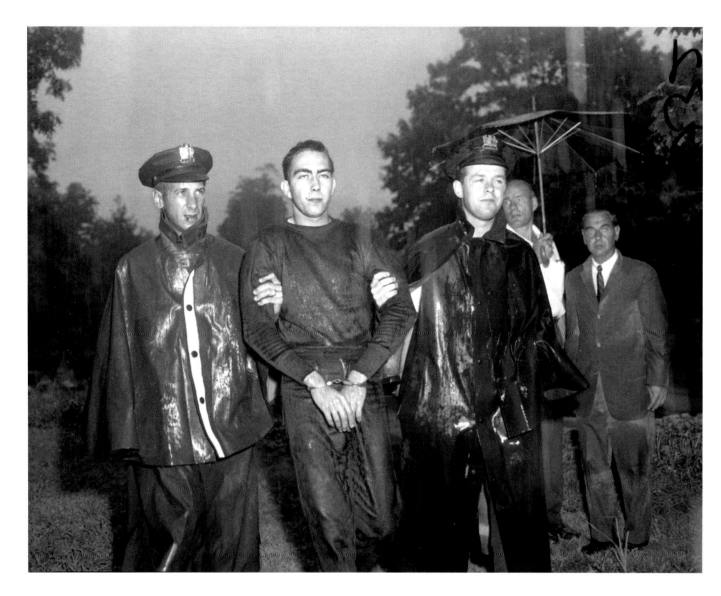

SHOT TEENAGER

August 22, 1961

Photographer: Detrick

Teenager shot
Evergreen Cemetery Elizabeth NJ

Pix shows: Boy who did shooting, Fred Baron, 19,
of 1018 Ilsyth Rd Elizabeth NJ is shown between
two detectives at scene of shooting. He shot
and killed John McKernan 14, of 830 Stanton Ave.
Elizabeth NJ—photographer's caption

SEIZED AS DOPE PEDDLERS

January 30, 1960

Photographer: Hurley

Seized As Dope Peddlers. John "Baps" Ross (right),
39, appears to be without a worry in the world in the
Old Slip police station. He was among seven men,
including Frank Carillo (center) playing peek-a-boo
behind braceleted hands, indicted under new law
making conspiracy to peddle narcotics a felony. D.A.
Hogan called "Baps" the biggest single distributor of
heroin in the U.S.

SYNOPSES

p. 6
GANG GETS REVENGE
JANUARY 29, 1939

Photographer: McCory

Louis Cohen (born Louis Kushner) was brought down by vengeance-seeking gangsters in a hail of gunfire as he exited a restaurant at the corner of Grand and Lewis Streets. It was the price he paid for the death of Kid Dropper, a.k.a. Jack the Drop, whom Cohen had bumped off in the early days of Prohibition.

p. 11
MASTER THIEF
MAY 8, 1955

Photographer: Ed Giorandino

Jack Bernstein, 49, was collared by police after his car was towed for being illegally parked and police discovered a loaded .38 caliber pistol, a kit containing various devices for picking locks, fur coats, and other stolen merchandise. A key found in his possession led police to another car and Bernstein's apartment, which also contained stolen property. Bernstein, who had been twelfth on the New York City Police Department's Most Wanted list, and one of the world's foremost practitioners of lock picking, possessed 129 different tools for picking locks, which he kept in a red jewelry case. These were later put on display at the New York City Crime Museum.

p. 14
RUTH SNYDER EXECUTED
JANUARY 12, 1928

Photographer: Tom Howard

See William Hannigan essay, p. 15.

p. 21
WAITING FOR A GRILLING
JANUARY 8, 1932

Photographer: Costa

William "Three-Gun" Turner was nabbed in the murder of John McGowan at his speakeasy on 57th Street in January 1932. Turner apparently gave himself that title to outshine the headline-grabbing Francis "Two-Gun" Crowley (see page 66). No mercy was shown to Turner, who claimed his only sorrow in murdering McGowan was that he got caught. He died in the electic chair at Sing Sing on February 2, 1933.

p. 25
D. A. ADDRESSES JURY
SEPTEMBER 28, 1929

Daily News photo

District Attorney Frank H. Coyne displays a photo of the key piece of evidence that convicted Earl Francis Peacox in the slaying of his wife Dorothy (see page 69).

p. 26
YOUNGEST MURDERESS
JUNE 22, 1925

Daily News photo

Dorothy "Dottie" Perkins was, at 17, the youngest woman to stand trial for first-degree murder in New York State. She was charged with the shooting murder of her suitor, a 28-year-old World War I hero, Thomas A. Templeton. Dottie's father had threatened her preferred suitor, Michael "Mickey" Connors, an ex-con twice her age. On February 14, 1925, her father's birthday, Dottie arrived at his party carrying a gun beneath her coat. A scuffle in the kitchen between Dottie and her father ended with Templeton being shot through the heart. She claimed that the weapon had gone off accidentally. Perkins was found guilty of first-degree manslaughter and sent to Auburn State Prison for a term of five to fifteen years but was released in 1929.

p. 27
YOUNG KILLER
FEBRUARY 24, 1930

Photographers: Twyman & Hoff

James Baker, who called himself "Texas Jim," shot his stepfather then fled his native Ohio at the age of 17 to join the Navy. After a crime spree of more than twenty murders, Baker was identified by a fingerprint as the killer of Henry S. Gaw, a lab technician in the Bronx. Baker's preferred murder method was poisoning his victims with cyanide, traces of which were found in Gaw's coffee cup. After a manhunt that lasted fourteen months, Baker was collared in Detroit and brought back to New York. He readily admitted to the Gaw murder and was sentenced to spend forty years to life in Sing Sing Prison. Once there, Baker pleaded with the warden to execute him on a national radio broadcast. Baker was remanded to the Clinton State Prison for the Criminally Insane where he served seventeen years.

p. 28
MASS MURDER EXECUTIONER
SEPTEMBER 19, 1935

Photographer: R. Morgan

In a macabre scenario, Charles Geery, a farmer and hunter from Pennsylvania, used a twenty-gauge shotgun to execute three relatives in a Newark, New Jersey, apartment in September 1935. Geery then called the Newark police to report the deaths, and after carefully removing his cigarettes and driver's license from his shirt, shot himself through the heart. Apparently the men had concocted a suicide pact in reaction to the recent death of Katherine Le Van, a wife of one of the victims.

p. 29
VICTIM OF GANG GUNS
DECEMBER 13, 1935

Photographer: Detrick

Samuel Mandel, the "Sugar King" of Paterson, New Jersey, was a prosperous supplier of bootleggers during Prohibition. Entering his apartment one night, he found his girlfriend, brother, and a booze-running acquaintance bound and gagged. Two gunmen lay in wait for him. Mandel made a break for it, was shot in the back, and died on the spot.

p. 30
KILLER'S END
FEBRUARY 12, 1932

Photographer: Osmund Leviness

As many as thirty-five slayings were attributed to Vincent "Mad Dog" Coll, a.k.a. "Irish" and "The Mick." First arrested at the age of 11, he was sent at 15 to Elmira Reformatory where he stabbed a fellow prisoner. During Prohibition Coll became a bodyguard for Dutch Schultz, but after a split hatred mounted between the two. After Coll's brother Peter was killed, Vincent suspected the Dutchman and vowed ven-

WHILE MOST OF THE CITY SLEEPS...
MAY 23, 1964

Photographer: Ken Korotkin

While most of the city sleeps, a police photographer takes foto of the body of Joan Wilson, shot to death in a lonely Times Square parking lot.

geance. Before he could make good on that threat, fifteen shots from a .45-caliber submachine gun felled the feared gangster while he talked on the phone inside the London Drug store on Twenty-third Street.

p. 31
MOTHER OF THE ACCUSED
AUGUST 21, 1931
Photographer: Boesser
The picture shows Hannah Cranmer, mother of Ruth Jayne Cranmer, in the West Side Court. Roy T. Yates, a successful young businessman, state senator, and bank vice-president, was married and the father of three daughters when he met Ruth, who was 23. She moved to New York City, where he put her up. Things soured: on August 13, 1931, a drunken argument broke out over Ruth taking a smaller, less expensive apartment. At 1 a.m. that night Ruth called Dr. R. L. Maier, a friend of the senator, telling him that Yates had been shot. Without notifying the police, Dr. Maier hired a private ambulance and hastened to the Cranmer apartment. Yates was removed to the hospital and the police were eventually called. When detectives arrived, they found Ruth in a hysterical state, claiming that she could recall nothing. When Yates recovered, he also stated he couldn't remember anything. Yates was forced to resign from the senate and Ruth was eventually cleared of felonious assault charges.

p. 32
SHOOTING AT A CHINESE THEATRE
JULY 10, 1930
Photographer: Condon
A barrage of fireworks masked the sound of five shots that slew state's witness Hang Wah Hung inside a Chinese theatre on the Bowery. The fall of the theatre curtain was the signal for the execution, which occurred as five hundred patrons began to exit after seeing *The Robber's Mistake.* The audience was jolted by the unexpected fireworks but cheered, believing it to be part of the show. In the cacophony the shots went unnoticed until Hung collapsed into his seat and pitched to the floor. The well-to-do merchant had pledged his aid in prosecuting the man charged with the murder of a fellow member of the tong that Hung led.

p. 33
AMUSED BY MURDER
SEPTEMBER 19, 1929
Daily News photo
Elvira Howard, friend of the slain Mrs. Dorothy Peacox, was called as a witness during the trial of her husband, Earle Francis Peacox, who was convicted of the killing (see page 69).

p. 34
"CHOWDERHEAD COHEN"
APRIL 9, 1931
Daily News photo
Two-hundred-sixty-six-pound Sam "Chowderhead Cohen" Harris was a professional strikebreaker and a not very successful criminal. After being arrested and released for vagrancy and then being picked up for his involvement in a melee with striking seamen, Chowderhead's work as a strike tough dried up. He then found work as a bodyguard for Vivian Gordon, but that was short-lived as she was murdered days before she was set to testify in the Seabury Committee investigation of police corruption.

p. 35
DAPPER ATTORNEY GENERAL
FEBRUARY 12, 1935
Daily News photo
In the 1930s, David T. Wilentz was the special prosecutor in the Bruno Hauptmann case in Flemington, New Jersey. Hauptmann was accused of kidnapping and murdering the son of the famous aviator Charles Lindbergh in 1932. Claiming that Hauptmann had written the ransom notes and that thousands of dollars found in his possession were part of Lindbergh's ransom payments, Wilentz pressed for a charge of first-degree murder and execution in the electric chair. While acting as the lead prosecutor in the case, Wilentz also served as the New Jersey State Attorney General. Despite apparent inconsistencies and perjury in witness accounts and prosecution statements, Wilentz won the case against the man he referred to as "Public enemy number one of this world."

pp. 36–37
RUTH SNYDER EXECUTED
JANUARY 13, 1928
Photographer: Tom Howard
Both sides of the original front page print depicting Ruth Snyder's execution, made from the negative famously acquired by the *News.* See William Hannigan essay, p. 15.

p. 38
THE GANGSTER'S TOAST
NOVEMBER 27, 1930
Daily News photo
Richie Boiardo's long criminal career started in the 1920s as a bootlegger running alcohol shipments between New Jersey and New York. From this time, he was known as "the Boot." A friend of Jack Diamond, Boiardo was by 1930 the overlord of Newark's First Ward racketeers. In the same year, he was severely wounded when a member of the rival Third Ward gang, run by Abe "Longey" Zwillman, shot Boiardo as he stepped out of his car. Despite Boiardo's boast, "a bullet ain't moulded that will get Richie," Boiardo was hit with eleven slugs, two of which ripped through his mouth, impairing his speech. After Prohibition, Boiardo's status in the underworld grew steadily with his involvement in unions and gambling. By the 1960s, Boiardo was reputedly a Cosa Nostra lieutenant and an elder statesman in the Vito Genovese gang.

p. 39
WHAT THE PHYSIOGNOMIST FOUND
APRIL 21, 1929
Daily News photo
Six months after an unsuccessful run for congress on the dry Republican ticket, bankruptcy lawyer David Steinhardt was found dead by his own hand at the Robert Morris Hotel in Philadelphia. It was believed that Steinhardt was the victim of a "mental murderer"—that he took his life under pressure from someone who might have been exposed by Steinhardt's expected testimony in a bankruptcy probe. It was estimated that Steinhardt had swindled more than $600,000 from unsuspecting investors before being exposed. In the company of his wife, and on the eve of his planned surrender, he swallowed poison and lay down to die. He was 42.

p. 40
BETRAYED BY MEAT CLEAVER
JUNE 10, 1935
Daily News photo
Police were originally convinced that a double murder in a Brooklyn laundry in 1935 was the result of a tong gang war. This story was fostered by the laundry owner, Chang Mon Dan, 78, who was found slashed and bruised at the scene where his nephew and nephew's son had been hacked to death. A bloody meat cleaver discovered in the laundry implicated Chang in the murders. The motive: an unresolved quarrel over a $1,000 loan.

p. 41
BUTCHER OF CLARKSBURG
SEPTEMBER 1, 1931
Daily News photo
Harry F. Powers, a modern Bluebeard, was indicted for the murder of Dorothy Lemke and hung for his crime in the Moundsville, West Virginia, State Prison in 1932. Called a mail-order Romeo, Powers corresponded through matrimonial agencies with dozens of middle-aged women throughout the country. Police found trunks at his home containing incriminating pictures, letters, and other evidence that helped to close the case on a man who, in addition to torturing and murdering Dorothy Lemke, had dispatched another would-be bride, Mrs. Asta Eicher, and her three children in a grim, windowless garage in Quiet Dell, West Virginia. In spite of claiming that he confessed under torture, Powers had to wait less than two hours for a jury to return a death sentence. The trial was so popular it had to be staged in the Clarksburg Opera House.

p. 42
DOUBLE MURDER IN THE BRONX
NOVEMBER 6, 1930
Photographer: Auerbach-Leviness
Stephen Ferrignio, 34, and Alfred Mineia, 37, were gunned down outside the apartment building in the Bronx where Ferrignio lived with his wife and four children. Both men were suspected of being involved in a Brooklyn lottery racket in connection with which several men had been slain in previous months. The three killers fired shotguns through closed windows of a first floor apartment. They had

rented the apartment two weeks prior to the shooting, moving in two chairs and a couch and hanging heavy curtains to conceal their activities.

p. 43
DROPPED ON THE SPOT
DECEMBER 9, 1939
Photographer: Willard
Known along the waterfront as "the man with a thousand enemies and few friends," David "The Beetle" Beadle was embroiled in a struggle for control of the docks when he was gunned down outside The Spot on Eleventh Avenue in 1939. Charges against Beadle at the time of his death ranged from disorderly conduct to homicide. His murder was never solved and at least two witnesses being questioned in relation to the Beadle case were also murdered.

p. 44
UNTIL DEATH DO US PART
DECEMBER 12, 1935
Daily News photo
Joseph Ashley Schwartz, alias John Collins, 27, was electrocuted in Sing Sing Prison in 1936 for the murder of Charles Therner. Refered to by the police as a cold-blooded trigger man, his list of crimes included assault, larceny, possession of a gun, and an escape from the Tombs prison in 1933. Despite allegations of bigamy by a woman in New Orleans, Collins was betrothed to 18-year-old Anna Downey on the day of his sentencing. Known as the "Bride of the Tombs," Downey appealed to the Governor of New York, but Collins was put to death after a final meal of candy, cigarettes, and veal.

p. 45
HOPE FLEES—AGAIN
AUGUST 10, 1939
Photographer: Pat Candido
"From B'Way Beauty to Gang Moll." Born Rosie Lutzinger, Hope Dare came to Broadway via the beauty contest route from the West Coast. After her promoter husband died, she found herself hopelessly attracted to Dutch Schultz's mouthpiece and legal counselor, J. Richard "Dixie" Davis. She and Dixie spent seven months on the lam after the Dutchman was gunned down and while D. A. Thomas E. Dewey was investigating Schultz's enterprises.

After being tracked down in Philadelphia, Dixie turned to his Tammany Hall connection, James J. Hines, who arranged for him to get off with a one-year slap on the wrist. Upon his release, Dixie wedded Hope and they tried to go straight, at one point opening a little ice-cream shop out west.

p. 46
CAREER OF JACK "LEGS" DIAMOND
DECEMBER 19, 1931
Daily News photodiagram

Jack "Legs" Diamond was murdered in Albany, New York in December 1931 at the age of 36, after having survived shooting attempts on his life in 1924, 1927, 1930, and April 1931. Police speculated that he was killed over a narcotics deal gone wrong. The son of Irish parents, Diamond grew up in the Hell's Kitchen section of New York City and started his criminal career in Owney Madden's Gopher gang. A petty thief and later a stick-up man, Diamond became an enforcer during Prohibition for the drug racketeers Charlie Cook and Oscar Hirshon, who imported millions of dollars of narcotics to the United States from Europe. During the Brooklyn painters strike in 1927, hit men from Hymie Curly's gang shot Diamond and East Side gang leader Jacob "Little Augie" Orgen, who was killed on the spot. When Diamond recovered, his gang waged war for two years against Curly, sometimes dressing in police uniforms to fool Curly's cohorts. Many died. At the height of Prohibition, Diamond moved to Greene County, New York, in an attempt to control bootlegging in the Hudson Valley. While living in upstate New York, Diamond was accused of kidnapping a truck driver and torturing a local farmer. As with his previous twenty-two arrests, he was acquitted of these crimes. In 1931 Diamond was finally indicted for conspiracy and violating Prohibition laws and was sentenced to four years in prison, a term he never served because of his murder. The man who boasted of killing more than twenty-five men during his career was buried on December 22, 1931, in the Mt. Olive Cemetery in New York.

p. 47
MYSTERIOUS ATTACK
JUNE 10, 1941
Daily News photodiagram

At approximately 3 p.m. on March 4, 1937, a man claiming to have a package for Mrs. Bernard Vinissky, better known as Jenny Dolly, came to the front door of her Lake Shore Drive home in Chicago. She opened the door, leaving the safety chain on, and looked out. The man bent down as if to pick up a package but when he straightened he blinded the woman with a handful of white pepper. The mysterious attack left Mrs. Vinissky with severe pain but with no permanent damage to her eyes. Dolly, a dancer who first came into public view in 1909 when she performed with her sister at Keith's Union Square Theatre, was born in Hungary and raised on the Lower East Side of Manhattan. This "photodiagram," which relocates the event to a kitchen, was prepared for an obituary published following Dolly's suicide at her Hollywood home in June 1941.

p. 48
JAILBREAK MASTERMIND
JANUARY 26, 1938
Photographer: Pat Candido

While serving time for the abduction of John J. O'Connell in the 1930s, Percy "Angel Face" Geary masterminded a daring escape from Onandaga Penitentiary. After a brief taste of freedom, Geary was captured and sent to Alcatraz. There he was implicated in the infamous $427,000 Rubel Armored Car robbery, which had remained unsolved for years. After serving more than twenty years of a seventy-seven-year sentence, a despondent Geary committed suicide in the Atlanta Federal Penitentiary.

p. 49
GRIM ROOM
APRIL 26, 1943
Photographer: Robert S. Wyer

Angry because his wife had left him and their three children over his affection for another woman, Leroy Luscomb, 32, confronted his wife at her parents' home with a loaded deer rifle. When she refused to return to him, he shot her through the neck, killing her instantly. Arrested for first-degree murder, Luscomb claimed that he meant only to threaten his wife and was unaware that the gun was loaded. This testimony was refuted by Luscomb's son, who told police that he had seen his father load the rifle the day of the killing.

p. 50
SEIZED AFTER 60-MILE-AN-HOUR CHASE
DECEMBER 27, 1932
Daily News photo

The five gang members were arrested after a high-speed chase in Brooklyn and indicted for assault, robbery, and grand larceny. They had stolen the car of Edward Gluckin after beating him horribly. Gluckin identified the license plate of the car that had been used in the robbery.

p. 51
SHOOTOUT
SEPTEMBER 12, 1923
Daily News photodiagram

This photodiagram interprets the murder of Clarence M. Peters on May 19, 1922. Walter Ward, son of a millionaire bread manufacturer, turned himself in as the killer just three days after Peters's body was discovered near Kenisco Reservoir in Westchester. Ward declared he had killed the 19-year-old former sailor in self-defense after balking at Peters's blackmail demand of $75,000. After the indictment for first-degree murder was dismissed, Mrs. Inez O. Peters, Clarence's mother, pleaded to Governor Al Smith to have the case reopened. A special grand jury reindicted Ward on first-degree murder charges, but on September 28, 1923, he was acquitted. Three years later a car owned by Ward was found abandoned outside Trenton, New Jersey. When he did not reappear, there was speculation that he had been murdered. He turned up in Havana, where he eventually died at the age of 54.

p. 52
WOMAN GOES TO CHAIR!
DECEMBER 30, 1931
Daily News photo

At the age of 24, Ruth Brown was sentenced to die in the electric chair at Sing Sing Prison for the stabbing murder of Eli Huston in a Harlem speakeasy in May 1931. She was only the second woman in New York State history to be condemned to die in the chair, the first being Ruth Snyder. Governor Franklin D. Roosevelt later commuted her sentence to life without parole. Brown was paroled and released from prison in the 1950s by Governor Dewey, but returned voluntarily, refusing ever to go before a parole board again. Brown died of a heart attack at the Bedford Hills Correctional Facility at the age of 77. She had spent forty-nine years in prison, the longest term of any female inmate in a New York State prison.

p. 53
COP KILLER
FEBRUARY 19, 1935
Photographer: Fred Morgan

During a high-speed chase on November 9, 1935, Edward Metelski fired a shotgun at a state trooper vehicle, virtually decapitating officer Warren G. Yenser. Escaping after his arrest, he was sought in of one of the largest manhunts in New Jersey history. Once captured, he was tried and sentenced to the electric chair. Among those witnessing his execution on August 4, 1936, was officer Earl Wright of Camden. Upon arresting Metelski in 1931 for a series of robberies, Wright had warned Metelski that he would "wind up in the chair." "If I ever do," Metelski replied lightly, "come and see me off." And so he did.

p. 54
BIGAMIST MOURNED
OCTOBER 18, 1931
Photographer: John Tresilian

Serving time for perjury in a vice trial, Charles Franchini hung himself in his prison cell on Welfare Island in 1931. After his suicide, allegations against Franchini of bigamy were substantiated when the two women he had married attended his funeral together. The first wife, the penniless Helen Vidal Franchini, and the second, Henrietta Franchini, who paid for the funeral, were reconciled and grieved for their former husband together.

p. 55
HOTEL OF HAPPINESS
MARCH 19, 1940
Photographer: Wallace

Th picture shows the scene of a murder near Hurleyville, N.Y., summer 1936. The victim, Irving Ashkenas, a one-time strong-arm man for a faction in the garment union, served five years in Attica State Prison on manslaughter charges in connection with the bludgeoning death of a millionaire dress manufacturer in the New York City garment district in 1930. After his release, he started a taxi service between Brooklyn and Sullivan County, New York, a favored area for the execution of contracts by the Brooklyn murder syndicate. In September 1936 Ashkenas's body was found sprawled across the front seat of his taxi at the Paramount Hotel near Lake Sheldrake in Sullivan County. There were sixteen bullets in his body and ice pick wounds.

p. 56
"KID TWIST"
NOVEMBER 4, 1938
Daily News copy

Abe "Kid Twist" Reles, a member of Brooklyn's notorious Murder Inc., was implicated in the murders of thirteen men and boasted of killing at least eleven during the gang's bloody reign in the 1930s and 1940s. In November 1941 Reles fell six floors to his death while trying to escape from the Half Moon Hotel in Coney Island where he was being held as a material witness in a trial of his former associates. His testimony had resulted in the execution of at least six men, including Reles's former partners, Martin "Bugsy" Goldstein and Harry "Pittsburgh" Strauss. It was said that "the canary could sing but could not fly." According to police, the rope Reles used in his daring escape unraveled from the radiator to which he had tied it, and he fell to his death. Some contended that Reles had been killed to prevent him from turning state's evidence against Albert Anastasia, the head of the International Longshoremen's Association, who had been implicated in the murder of union activist Peter Panto. After Reles's death, according to Kings County District Attorney William O'Dwyer, the state's case against Anastasia was destroyed. In 1950 a grand jury in Kings County heard new evidence in the Reles case, and contradictions surrounding testimony were addressed at Senate Crime Investigation Committee hearings in Washington, but no evidence of foul play was found.

p. 57
STOOL PIGEON DE LUXE
JANUARY 4, 1931
Daily News photo

Named for his native country, Chile "Mapocha" Acuna came to New York City in 1919. After working in a number of restaurants, he became a police informer for the New York City vice squads before being sent to prison for a year in 1929 for extortion. He claimed that he was framed by police. In 1930, after his release, Acuna testified at the Seabury-Kresel inquiry that police vice squads were arresting innocent women on immorality charges. The stool pigeon's testimony threw a bombshell into the police department, resulting in the resignation of six magistrates and the dismissal and arrest of dozens of police and bondsmen.

p. 58
SNIPER'S BULLET SLAYS WOMAN
APRIL 9, 1934
Photographer: Levine

Mrs. Yetta Einhorn, mother of three, stood chatting with a neighbor in front of her basement bread shop at 198 Orchard St. It was noon and children and pushcarts jammed the Lower East Side street. Mrs. Einhorn's husband had just stepped down into the bakery to pick up some bread when he heard her cry: "I'm shot." Her heart had been pierced by a .22 caliber bullet. No one heard the shot.

p. 59
ANOTHER TRIANGLE CASE...
MAY 31, 1935
Photographer: Detrick

David Corley, 50, real estate operator in Hackensack, N.J., was slain by three bullets from the gun of a mystery assailant. Corley's body was found at the wheel of his car on Spring Valley Road with bullet wounds in the head, left leg, and right wrist. Police said that Corley had recently been convicted in a Hackensack court for shooting his wife during an argument.

p. 60
ABORTIONISTS
OCTOBER 12, 1936
Photographer: Fred Morgan

Dr. George E. Harley, 66, and his nurse Anna Green, 28, were arrested October 9, 1936, on charges of performing illegal operations. It was alleged that they ran Newark's "Anti-Stork Club," a sort of co-op for illegal abortions, and that as many as eight hundred young women had paid $1 to $2 a month for "membership." Records seized at their offices indicated that the doctor might have performed as many as 5,800 abortions.

p. 61
MURDERED A GOOD SAMARITAN
FEBRUARY 21, 1940
Daily News photo

Joseph Calloway paid for his life for playing the good Samaritan. Spotting a dreary woman and a male companion trudging wearily along the roadside outside Lake Charles, Louisiana, on Valentine's Day 1940, he stopped to offer a ride. The Houston salesman was led into a field, stripped of his clothes, and killed as he knelt begging for his life. Although her companion, Horace Finon Burks, was also indicted, Mrs. Annie Beatrice (Toni Jo) Henry confessed that she fired the shot that killed Calloway. She robbed him, she said, in an effort to get money to finance her murderer-husband's appeal. Instead, she landed herself on death row. After being found guilty twice in verdicts that were overturned, she was convicted a third time and became the second white woman to be executed in Louisiana, on November 28, 1942.

p. 62
POSING AS DUTCH SCHULTZ
OCTOBER 24, 1935
Photographer: Detrick

The picture shows a detective posing for photographers to show how police found Arthur "Dutch Schultz" Flegenheimer after he was murdered. Early in his career, Dutch Schultz was nothing but a two-bit thief, pool shark, and tough on the streets of the Mott Haven district of the Bronx. Prohibition changed all that. After arrests under numerous aliases, he became proprietor of a speakeasy on Willis Avenue in the Bronx. Soon Dutch had a whole chain, which spread out over the Bronx and Harlem, and he began to expand into the territories of rival racketeers in Yorkville and the Upper West Side. He had his own breweries, a fleet of trucks and drivers, the gunmen to protect them, and a bail bonds business to help them out of a jam. All the while he was taking larger pieces of policy rackets in Harlem and the Bronx. Territorial feuds ended fatally for the Dutchman on the evening of October 23, 1935, when rival gunmen entered the Park Grill in Newark and felled the beer giant as he dined. It was believed at the time that Lucky Luciano, Meyer Lansky, and Bugsy Siegel plotted to knock him off because he planned to eradicate the meddling D. A., Thomas E. Dewey. The motive was right but the order actually came from Louis "Lepke" Buchalter and was executed by Charles "The Bug" Workman, Emanual "Mendy" Weiss, and another thug known only as "Piggy."

p. 63
VIEWING DILLINGER
JULY 26, 1934
Daily News photo

John Herbert Dillinger's career was brief. He was a completely anonymous figure on May 22, 1933, when he was released from the Indiana State Prison after serving eight and a half years for the attempted robbery of a 65-year-old neighborhood grocer in Mooresville, Indiana. From September of that year until July 1934, he left a trail across the Midwest of ten men murdered, seven wounded, four banks robbed, three police arsenals raided, and three prison breaks, becoming Public Enemy Number One to many and a folk hero to some. Dillinger felt the heat and moved on to Chicago where he dyed his hair black, grew a moustache, etched his fingerprints with acid, and had a face lift. On July 22, Dillinger (now going as Jimmy Lawrence), his moll, Polly Hamilton, and a friend, Ana Sage (Ana Cumpanas), decided to go see *Manhattan Melodrama* at the air-conditioned Biograph Theatre in order to escape the 101-degree heat. Ana Sage, who would be known from that day forward as the "Woman in Red," sported a red dress, so she was easily recognizable to F.B.I. agent Melvin Purvis and his boys as she exited the theatre. Purvis, standing in a doorway, lit a cigar to signal his men he had recognized Dillinger. As Hamilton and Ana fell away and agents approached, Dillinger realized he had been set up and broke for the alley, struggling to pull a gun from his pants pocket. He never reached it—he was shot four times. There were twenty-one federal agents present. The dimensions of the Dillinger legend are best illustrated by events that took place after the shooting. It was said that women ran to the alley and dipped the hems of their skirts in his blood. The head of Chicago's "Dillinger Squad" made a special trip to the morgue to shake hands with the corpse, and morgue officials arranged for a public viewing, resting the body at an incline to give people a better look. The Dillinger family eventually had to have three feet of concrete poured over the grave in order to prevent the body from being stolen.

p. 64
STICK-UPS
JANUARY 8, 1931
Photographer: Edger

Nine men and one woman were rounded up as a result of a police trap set up in Brooklyn. Six of the ten were captured after robbing a store where police from the Grand Avenue station were staked out. After intense questioning by police detectives they offered up the rest. The gang, whose ages ranged from 19 to 26, were held on charges that they committed more than seventy robberies in Brooklyn and Queens.

p. 65
THE TOMBS
NOVEMBER 7, 1941
Photographer: Charles Payne

In the 1830s a building officially known as the City Prison and Halls of Justice was built in an Egyptian style with enormous pillars that loomed ominously over passersby. It came to be called "The Tombs." This building was replaced in the 1890s by a new one on the same site. Although it did not resemble the former one, it was also called the Tombs. In this building was the "Bridge of Sighs," depicted in this photograph, a covered walkway over Franklin St. connecting the prison to the Criminal Courts Building. Prisoners were led across it to hear their sentences and returned the same way to be clapped back in their cells for their "stretch." If the sentence imposed was "life" or "the chair," the convict was then sent, via train, "up the river"—i.e., the Hudson—to Sing Sing Prison in Ossining. The Tombs housed New York's most notorious criminals until November of 1941, when they were transferred to the new City Prison, which stands adjacent to the Criminal Courts Building on White St.

p. 66
"TWO-GUN" CROWLEY
DECEMBER 3, 1931
Daily News photo

In February 1931 Francis Crowley was arrested for grand larceny. The detective patted him down and removed a pistol, but as he moved to cuff Crowley, the gunman pulled a second pistol and critically wounded the detective. From then on he was known as "Two Gun" Crowley. On April 27, 1931, an all-points bulletin was put out for Crowley, who was sought for the murder of Virginia Brannen. Police determined that the bullet that killed her was from the same gun that had been used on the detective. Ten days later, he killed a policeman who recognized him in a car parked in a lover's lane in North Merrick. Crowley's former girlfriend, Irene (Billie) Dunn, gave him up. Approximately 150 policemen surrounded an apartment at West Ninetieth and West End Avenue and shot it out with Crowley and his cohort Rudolph (Tough Red) Duringer. They were finally brought down when, during a heavy barrage, police chopped down the door and legendary cop Johnny (The Boffer) Broderick rushed in and took out Crowley with a blow to the jaw. On the following January 21, "Two-Gun" was executed. "Tell my mother I love her, I appreciate everything she did for me" were his last words as guards strapped him into the electric chair at Sing Sing.

p. 67
SPOT MURDER
AUGUST 7, 1936
Photographer: Arthur Fellig (Weegee)

Dominick Didato, alias Terry Burns, was murdered outside the Sciacca restaurant in August 1936 on New York City's Lower East Side, in the neighborhood where he had grown up with Charles "Lucky" Luciano. Didato became wealthy during Prohibition, operating a chain of warehouses and a fleet of rum-runners. He also joined Luciano in the early 1930s on a visit to Al Capone in Chicago to discuss an

underworld alliance between the two cities. In 1932 Didato had a falling out over Luciano's plan to liquidate rum smuggling boss Vinnie Higgins in Brooklyn. After Luciano went to prison, Didato reappeared in the Lower East Side. There was a suggestion that Didato was murdered for welching on a bookmaker's bet, but his was the fifth murder in a month resulting from a turf war raging between the remnants of Luciano's gang and Dutch Schultz's gang.

p. 68
FOUR HELD IN DEATH OF CITY MARSHAL
August 9, 1936
Photographer: Osmund Leviness
Believing Arthur Jackson to be a wealthy City Marshal, for that is how he presented himself while courting their friend Alice Smith, Frank Coleman and Neal Hamilton trailed Jackson back to his office. It turned out that Jackson was the caretaker. Coleman and Hamilton held Jackson until the real marshall, Morris Florea, arrived some time before 7 a.m. It was then that Coleman proceeded to bludgeon the 60-year-old to death with a lead pipe, making off with $800.

p. 69
JAZZ-AGE SLAYER
September 17, 1929
Daily News photo
"A jazz-mad, unstable youth of 21" was how one reporter described Earl Francis Peacox. "Psychopathic Peacox" and "Jazz-Age Slayer" were other headlines that described him after he celebrated his first anniversary by killing his wife, Dorothy, on April 22, 1929. The estranged couple had not planned to spend the special day together until Peacox showed up at the apartment where she was staying in Manhattan. They traveled together to their Mount Vernon home where Earl was still staying. A fight ensued when Dorothy supposedly commented, "It looks like the same old dump."

p. 70
CAUGHT IN CRIME NET
January 21, 1935
Photographer: Levine
One of 166 hoodlums picked up by New York City police in a city-wide sweep to cut crime in January of 1935, Isidor Strauss

was arrested in a Bronx gambling dive when a policeman saw him push a revolver under the cloth of a gambling table. After he was collared and fingerprinted, police identified Strauss, alias Samuel Harris, as the right-hand man of Richard Reese Whittemore, who had masterminded the $93,000 robbery of a Bank of Buffalo armored car in October 1925, in which two security guards were killed. According to police involved in the January 1935 sweep, Strauss was "a big fish among small fry."

p. 71
BANDIT
January 17, 1941
Photographer: Charles Hoff
No further information is available.

p. 72
MURDER ON THE WASTELANDS
May 31, 1931
Daily News photo
No further information is available.

p. 73
COSTUMED A HIT MAN
April 23, 1940
Photographer: Petersen
Gertrude Gurino, redheaded wife of fugitive gunman Vito Gurino, was held on $150,000 bail as a material witness in the Brooklyn murder syndicate killing of Antonio Siciliano and Cesare Lattaro. The two were gunned down by Harry "Happy" Malone at 1977 Bergen Street on February 6, 1939. It was charged that Malone was able to execute the hit by masquerading in feminine garb provided by Mrs. Gurino—a red-feathered hat and white blouse and skirt to be exact, which reportedly continued to be one of Mrs. Gurino's favorite ensembles.

p. 74
PUSHED GIRL IN FRONT OF TRAIN
May 10, 1947
Photographer: Twyman
In May 1947 Jack Didia pushed a New York University student in front of a train at the Canal Street Subway Station in New York City. He had recently been released from the Central Islip State Hospital, to which he had been committed twice previously, and he was thought to pose no danger. Didia later told police that he was "nervous and

felt like doing something." Miraculously, the student was saved by a trackman. Didia was savagely beaten by a crowd of onlookers, arrested by police, charged with felonious assault, and sent to the Bellevue Hospital Psychiatric prison ward.

p. 75
THE COBRA EYE
January 1, 1931
Photographer: Phil Levine
Jack "Legs" Diamond. See synopsis above for p. 46.

p. 76
SWEETHEART SHOT
June 24, 1945
Photographer: Bob Costello
Patrolman Paul Rickli, a recently discharged soldier, fatally shot his sweetheart—a pregnant mother of six children whose husband was a POW in Japan—then sent a bullet into his own head near the Jersey entrance to the Holland Tunnel.

p. 77
VICE PROBE WITNESS MURDERED
March 2, 1931
Photographer: Auerbach
"She wore a chic cocktail hat, a Paris-made black velvet dress, silk undies and sheer stockings and the only jarring note in her modish ensemble was the cheap choker someone had put around her neck. It consisted of six feet of dirty clothesline yanked so tight it strangled her." So opened one *News* account of the murder of Vivian Gordon. The former Benita Franklin Bischoff, a supplier of girls to the indiscreet parties of the rich and powerful in the gay 1920s, used her web of women to gather blackmail information. Described as an expert racketeer, she was found murdered on the morning of February 26, 1931, in a ravine near Van Cortlandt Park in the Bronx. Police were not surprised.

p. 78
EN ROUTE TO THE CHAIR
December 4, 1941
Photographer: Candido-Costa
Louis Capone and Emmanuel "Mendy" Weiss were sent to the electric chair with the only top crime syndicate executive ever executed, Louis "Lepke" Buchalter, boss of Murder Inc., the underworld's killing

unit. On September 13, 1936, Joseph Rosen, a former trucking contractor, who had been muscled out of the garment trade when Lepke moved in, was shot dead in his candy store at 725 Sutter Ave., Brooklyn. Rosen was taken out when it became known that he might describe Lepke's activities to District Attorney Thomas E. Dewey. Lepke ordered the shooting, his lieutenant Capone plotted it, and Weiss delivered the lethal shot.

p. 79
DEATH OF AN ANARCHIST
January 12, 1943
Photographer: Amy
Carlos Tresca was an Italian immigrant radical, an advocate of syndicalism, a form of anarchism. He edited a biweekly newspaper called Il Martello, "The Hammer," and was at one point a suspect in the Wall Street bombing of 1920. On the night of January 11, 1943, Tresca left his office on West Fifteenth Street and as he rounded the corner of Fifth Avenue, which was dimmed due to wartime regulations, a man came up from behind him and fired a shot into his back, spinning him around to face his assailant, who then fired a second shot, which entered under his left eye and killed him. Police theorized that Tresca's murder was political, but that the killing was performed by a professional gunman, who fled in a waiting getaway car. The case went unsolved.

p. 80
IT HURTS TO BE SO HAPPY!
November 24, 1942
Photographer: Osmund Leviness
Twenty-one-year-old mother of four Anna Harrington was accused of killing her 23-year-old husband, Alman, with one shot in the back. According to Anna, she shot him after trying to wrest a gun from him during an argument over money. Alman died months after the incident and Anna was put on trial for first-degree murder. After standing strong during the trail, she broke down and wept uncontrollably when the jury returned a verdict of "Not guilty."

p. 81
EMPIRE STATE SUICIDE
June 8, 1946
Photographer: Simon Nathan
Clark Tunison, 51, leapt to his death from the seventy-first floor of the Empire State Building in June 1946 after leaving a note for his wife alluding to financial problems related to gambling. He landed on a thirtieth-floor terrace, which prevented him from falling among the noonday crowd on Fifth Avenue. According to people working on the thirtieth floor, a strange whirring sound preceded the crash of Tunison's body on the terrace. Before his death jump from the offices of the Chemical Construction Company, Tunison, a father of four, left a note for a colleague which read, "please call Mrs. T. I've gone out the window."

p. 82
BLACK LEGION
June 3, 1936
Photographer: Pat Candido
A young servant girl's zest for gossip inadvertently led to the death of a young WPA worker, Charles A. Poole. Ruby Lane, who worked for the sister of Poole's wife, claimed she told her "that the Pooles had gotten into an argument." When she relayed this story to her own sister she claimed, "Her husband and her was quarellin'. He'd been fussin' her and abusin' her and she a going to have a baby." Little did she know that an acquaintance of her sister, Harvey Davis, who was present to hear her tale, was a member of the feared Black Legion and that the story would be enough of a spark to lead to Poole's death. Thirteen members of the Ku Klux Klan–like group stood trial for executing Poole in a blaze of gunfire.

p. 83
A NEW ANGLE ON THE OLD TRIANGLE
January 12, 1945
Photographer: Petrella
Mrs. Colleen Kluck, 27, had her husband, Walter, and honey-blonde Truth Fyfar held on charges of lewdness and bigamy. If this were not enough for 50-year old Walter, Truth served him with annulment papers as he arranged for bail on these charges. According to Colleen, Kluck's first wife had divorced him because of his love for another woman, just before Colleen

met him in 1937. Colleen had married him hoping for reform. For his part, Walter denied that he had ever married Colleen.

A PRISONER, BUT BLASÉ
JUNE 26, 1935
Daily News photo

Natalie Chadwick, ex-Follies and Earl Carroll showgirl, was sentenced to two to five years for grand larceny. It seems she took the opportunity of a Thanksgiving Day invitation to the Atlantic Beach, L.I., home of her friend Polly Lux, also an ex-Follies girl, to case the joint. Natalie, who knew that the home was closed for the winter season, posed as Miss Lux and sold the entire contents of the home to a Manhattan furniture company for $800. It was valued at $10,000. After being released, she was again arrested in June of 1935 for robbing the home of Mrs. Simone Brooks.

HELD IN KNIFE SLAYING
NOVEMBER 24, 1941
Photographer: S. O. Wally

After attending confession at St. Cecilia's Church, James M. O'Connell, 15, and his 18-year-old brother John were walking home on the Central Park side of Fifth Avenue when they were attacked by three black youths. As the O'Connell boys fled across the street, they were separated by a passing cab. John reached the curb and turned to see the youths slashing his brother. As he started back across the street, the youths fled. He was able to give a good description and they were apprehended the next day. They were Jerome Dore (pictured), 12, who confessed to wielding the knife, Norman Davis, 16, and Robert Allen, also 16.

PIERCING EYES OF LINDBERGH KIDNAPPER
JANUARY 30, 1935
Daily News photos

In what may truly have been the "Trial of the Century," Richard Bruno Hauptmann was charged with the kidnap and murder of Charles Lindbergh, Jr., the son of America's White Knight of the Air, Charles Lindbergh. To this day debate surrounds the question of Hauptmann's guilt. He main-

tained his innocence to the end—an end that came in the electric chair, April 3, 1936.

BABY BANDITS
JUNE 18, 1935
Photographer: Edger

"Baby Bandits"—that's what the *Daily News* called Frank Damato, 13, his brother Julius, 11, and Libson Lawrence, 13, who shot William Walsh, 35, in the head. The boys had no problem getting their hands on a gun; they were bootblacks at Motorcycle Squad No. 3, and as Patrolman Louis Churchvale showered, Frank lifted his pistol and strolled out the door. On the street they came upon two women. Frank brandished the gun and demanded their money. One of the women smacked him to the sidewalk and the other grabbed the revolver. Frank snatched it back and the women ran. A few hours later the trio came upon Walsh asleep in a vacant lot. After he tried to dismiss the juvenile assailants, Frank shot him in the head. Walsh remained there until discovered by the lot's superintendent and was taken to the hospital, where he died shortly after. The boys confessed that day. The grand jury refused to try them as adults and they were sent to reformatories.

STOLEN CAR LEADS TO MURDERER
APRIL 2, 1941
Photographer: Edger

April Fools Day, 1941: Following up a tip, Detectives Franklin Williams and Joseph Kenny visited a house at 53-39 65th Place, Maspeth. In the driveway they found a 1941 sedan that had been reported stolen. In an upstairs bedroom, they found two shotguns and six hundred rounds of ammunition. While they were gathering the arsenal, Carlo Barone appeared, accompanied by Leonard Alonge. When the detectives identified themselves, Barone drew a revolver and fired. He grazed the finger of Detective Williams before being overpowered. Detectives learned that Barone, known as Joseph La Sala, was being sought in connection with two murders. He was executed on April 21, 1942.

ACCUSED KILLERS LEAVING DEATH HOUSE
JANUARY 14, 1941
Photographer: Engels

These three accused killers are being taken from Ossining to Brooklyn to stand trial. One of them is Frank "Big Boy" Davino, twice tried and twice sentenced to the electric chair for the murder of fireman Thomas Hitter. He was identified as Hitter's killer by four eyewitnesses, all of whom said he was the one that robbed Hitter of the payroll he was delivering and then cold-bloodedly shot him down. The conviction was also twice reversed, however, and finally, as Davino awaited a third trial, the indictment was dropped.

FALL FROM BALCONY
MAY 10, 1938
Daily News photo

Driven literally over the edge by real or imagined persecution, Charles Costa, 23, scribbled on the wall at City Hall, "I was framed by the police—the reason I did not go home last night was that I wanted Mayor LaGuardia to know that District Attorney Dewey was the one that killed Margaret." Then he lit a cigarette and leaped over the balustrade. However, his attempt to end it all was in vain. With a broken back he was taken to Beekman Street Hospital in critical condition.

DEATH PLUNGE LINKED TO SPY QUIZ
DECEMBER 21, 1948
Photographer: Al Pucci

In December 1948, 43-year-old Laurence Duggan, Director of the Institute of International Education, plunged to his death from his sixteenth floor office. He had been mentioned as a communist sympathizer to the acting chairman of the House Un-American Activities Committee in Washington. A graduate of Harvard University, Duggan worked for the State Department from 1930 to 1944, advising Secretary of State Cordell Hull on Latin American affairs. A friend and colleague of Alger Hiss, Duggan was accused of being one of six men transmitting secret documents to Whittaker Chambers, ex-*Time* magazine editor and convicted spy.

STUNNED BY VERDICT
JULY 9, 1948
Photographer: Eddie Jackson

"Phone-Tap Cop Says Girl Told Nancy: Have Good Time For Pay" and "$100 Call Girl Suspect's Dad U.S. Diplomat" are how the headlines buzzed after the arrest of Nancy Fletcher Choremi in her Hotel St. Moritz apartment for "loitering for purposes of prostitution." Nancy and her two companions were given three-month suspended sentences and Nancy was whisked to her parents' home in Morocco.

KILLED THE THING HE LOVED
MAY 2, 1945
Photographer: McCory

No further information is available.

SON SAYS NO MORE
JULY 20, 1940
Photographer: Osmund Leviness

At 19, Herbert Crowson had grown used to the beatings that he and his mother bore at the hands of his drunken father. On the night of July 18, 1940, his father arrived home, drunk again, and began to beat Herbert's invalid mother, who suffered from tuberculosis, demanding that she go out and fetch him beer. Snatching a knife from the table, Herbert fatally stabbed his father. He was indicted for first-degree murder. While he awaited trial, his mother died at Bellevue hospital. Judge Lester W. Patterson took sympathy on young Herbert, who pleaded guilty to second-degree manslaughter and was given a suspended sentence.

HIDE AND SEEK
MARCH 29, 1949
Photographer: Watson

A few weeks after obtaining a marriage license to wed former Goldwyn actress Mira Stefan, Pastor Paul Buenaventura had a change of heart. That was in February 1948. Mira's son Michael was born in October of that year. Mira claimed that Pastor Paul was the father, a charge he adamantly denied. And so they found themselves in court.

COP SLAIN
JULY 18, 1942
Daily News photo

Returning home on an off night, Patrolman Thomas J. Casey halted at East Fifty-first Street and Lexington Avenue to question a suspicious-looking trio. His instincts were right; the men were planning to rob a neighborhood bar and grill. Casey, after searching one, turned to frisk the others; the first produced a .32 caliber pistol from his belt and fired four shots into Casey, who fell dead.

13-YEAR-OLD CHARGED WITH MURDER
OCTOBER 20, 1943
Photographer: S. O. Wally

At 13 years of age, Edwin Cordarre was convicted of second-degree murder in the rape-slaying of a 10-year-old girl in East Fishkill. He was sentenced to thirty years in prison. At 36, after serving twenty-three years, a Federal Court released Edwin from Green Haven Prison because he was not legally represented in the state court in 1943 when he pleaded guilty to the charge.

HINT BLONDE BEAT TWO WOMEN
JULY 9, 1943
Daily News photo

Robbery was apparently the motive behind a brutal assault on Betty Fitleson and Alice Clarfield in their ground-floor apartment in Park Slope, Brooklyn. Fitleson was already dead when police were called and Clarfield was barely conscious. It was dubbed the "Two-by-four Murder" for the killer's choice of weapon, a length of wood.

MURDERED FOR THRILLS
AUGUST 20, 1954
Photographer: Paul Bernius

The body of Willie Mentor, 61, is pulled from the East River. He had been savagely beaten, tortured, and thrown into the river by four teenagers whose only motive, police said, was pleasure. A crowd gathered when police brought the teenagers to identify the still wet body on the South Fifth Street pier. Upon seeing the body, each of the teenagers broke down and admitted his complicity in the grisly murder.

pp. 100–103
GEORGE CVEK STORY

p. 100
GEORGE CVEK
JULY 1940
Daily News photo

p. 101
GEORGE CVEK
NOVEMBER 1940
Photographer: Frank Novak

p. 102, above
Daily News studio copy

p. 102, below
MOURNS MURDERED WIFE
FEBRUARY 8, 1941
Daily News photo

p. 103, left
MARCH 8, 1941
Daily News photo

p. 103, below
MARCH 8, 1941
Daily News photo

Page 103, below right
JULY 1940
Photographer: Frank Novak

p. 104
SHOT POKER PLAYER
left–photographer: Al Amy
right–photographer: Jack Clarity
JANUARY 11, 1956

A 23-year-old auto mechanic with a history of insanity, standing dazed and distraught in Queens Felony Court, was accused of killing a man who took his life savings in a poker game the night before. On his way home from the game, contemplating the loss of his savings, he returned, convinced the game was crooked. After killing the poker player, he commandeered a bus and demanded that the driver head to Brooklyn. Police spotted Clement and took up the chase. The quick-thinking driver steered the bus into a tree and smothered Clement before he could regain his composure. When faced with the charges, Clement responded, "I know I drank an awful lot, but I'm sure I didn't kill anybody."

p. 105
BROOKLYN POLICY BOSS
MARCH 26, 1954
Photographer: Rynders

Though his attorney pointed out that Cuevas had lived in a small apartment in the Brownsville section of Brooklyn for twenty years with his wife and four children, New York police detained him as a suspected boss in a $3 million policy ring in Brooklyn. Evidence was minimal in Cuevas's case, and the judge repeatedly reduced the bail, contending that Cuevas was being detained by police solely for the purpose of gathering information from him that would lead to the conviction of others involved in the Brooklyn rackets. Cuevas offered them nothing.

pp. 106–7
POSING AS TOUGHIE (FRONT AND BACK SIDES OF ORIGINAL PHOTOGRAPH)
AUGUST 2, 1943
Photographer: Payne

Arrested first at the age of 10, Bobby "Baby Face" Naschak was already a career burglar at 16, when he first came before Judge Samuel S. Liebowitz. He was charged with armed robbery and given a mandatory sentence of twenty to forty years, to be served starting at the Elmira Reformatory. Upon hearing this news, Naschak spat on the judge and called him a rat.

p. 108
ALONE
MAY 11, 1956
Photographer: Rynders

In May 1956, Thomas Daniels, whose mother Katherine Daniels is pictured here, was convicted of manslaughter in connection with the death of his girlfriend, Jacqueline Smith. After she died during a botched abortion, he dismembered and disposed of her in garbage cans. Daniels, together with a hospital orderly acquaintance, committed the gruesome crime on Christmas Eve, 1954.

p. 109
PONDERING HIS FATE
FEBRUARY 15, 1953
Photographer: Tom Cunningham

Shortly before 9 p.m. on Valentine's Day, 1953, Connecticut State Trooper Ernest J. Morse spotted a black sedan speeding out of the tunnel on the Wilbur Cross Highway, bound for New York. When he stopped the vehicle, Morse was shot in the stomach as he approached the car. He was able to relay part of the license plate number to a group of sailors who came to his aid, and after an extensive manhunt, the 20-year-old car thief and gunman was captured just after midnight as he slept in the loft of an unlocked garage.

p. 110
END OF A FAMILY
JANUARY 29, 1956
Photographer: Frank Hurley

January 29th, 1956, William "Dill" Bauer killed five family members and himself at his home in Parsippany, New Jersey. A church trustee and a well-liked neighbor, Bauer went on a rampage just before the family was to leave for a vacation in Florida. All that police could surmise was that Bauer had broken down over the condition of his invalid mother, who, after two years in bed, was to be placed in a nursing home.

p. 111
HOUSE OF DEATH
JANUARY 29, 1956
Photographer: Leonard Detrick

See description above for p. 110.

pp. 112–13
THE TRIGGER'S SQUEEZED
SEPTEMBER 2, 1955
Photographer: Bill Meurer
SEPTEMBER 2, 1955
Daily News photo

Responsible for at least seven murders, and thought to have committed many more, Elmer "Trigger" Burke was electrocuted at Sing Sing Prison in January 1958 for the murder of ex-convict Edward "Poochy" Walsh in a tavern on New York City's Upper West Side in July 1952.

p. 114
SHIELDING HIS DAUGHTER
MAY 14, 1952
Photographer: Twyman

Using her little sister as a pawn, Paula Daigneault, and her partner in crime, Theodore Nowinski, robbed their unsuspecting neighbors one Sunday afternoon in the quiet neighborhood of Hollis, Queens. While the Pattersons were out that afternoon, Paula's 10-year-old sister crept into their apartment and stole a strongbox containing jewels and watches. She knew the strongbox was there because she played with the Pattersons' daughter Katherine, detectives explained. Paula and Theodore then pawned the goods and discarded the box. To his great shame, Paula's father, Ernest Daignault, could offer no explanation for his daughter's behavior to Magistrate David McKean, the man who had befriended him and his family after they had emigrated from Canada.

p. 115
KIDNAPPED HOUSEWIFE
AUGUST 12, 1956
Photographer: Mehlman

When Sherman Rimer saw a pair of feet sticking out from behind a tree, he thought he had discovered a body. After beckoning the others in the posse and moving in closer, he was presented with fugitive Everett Cooley, 24, and his kidnap victim, Mrs. Grace Dreppard, sitting quietly. Cooley did not attempt to use the .32 caliber pistol he held. It had been a long night for Mrs. Dreppard as she wondered about her wounded husband and infant son, whom she had last seen the night before, when Cooley arrived at their doorstep.

p. 116
A MARRIAGE ENDS
MAY 17, 1951
Photographer: John Peodincuk

Liquor store clerk Jack Dietz shot and killed his estranged wife outside of her Brooklyn home in May, 1951. Using a .32 caliber revolver, Dietz approached his wife, firing two shots at point blank range before turning the pistol on himself and taking his own life. Their 4-year-old son witnessed the double killing from the window of Mrs. Dietz's apartment.

p. 117
PAST HER LIFELESS DAUGHTER
JANUARY 25, 1958
Photographer: Alan Aaronson

Alternating between bread knife, hatchet, and .38 Colt pistol, Paul Canzoneri, 63, ran amok in his Upper East Side home, stabbing his daughter to death, killing a neighbor, and striking his wife with a hatchet. The explosion was apparently set off by Canzoneri's unfounded suspicion that his daughter, Mrs. Caroline Calabria, separated from her husband, was having an affair with the building superintendent.

p. 118
HELD IN BOGUS MONEY RAID
MAY 20, 1938
Daily News photo

Thirty-year-old Charles Blum was arrested along with accomplices for possession and distribution of counterfeit money. Posing as purchasers of the bogus currency, federal agents nabbed Blum and his companions in May 1938.

p. 119
BOTTLE CLUB
MAY 29, 1960
Photographer: George Lockhart

New York police raided the Happy Lads Social Club in Manhattan and arrested twenty-seven men and thirteen women for drinking illegally after hours and creating excessive and boisterous noise. Among those arrested, all piled into paddy wagons and taken to the police station, was the former middleweight boxing champion, Jake LaMotta.

pp. 120–25
JANICE DRAKE STORY

p. 120
Photo taken during WW II bond drive
SEPTEMBER 27, 1959
Daily News photo

p. 121, left
NAT NELSON
APRIL 4, 1933
Daily News studio copy

p. 121, right
Daily News photo

p. 122
ALBERT ANASTASIA
OCTOBER 26, 1957
Photographer: Tom Baffer

p. 123
MYSTERY BLOND IN MURDER
FEBRUARY 11, 1952
Photographer: Rothman

p. 124
SLAIN
SEPTEMBER 27, 1959
Photographer: Summers

p. 125
SEPTEMBER 28(?), 1959
Photographer: Phil Greitzer

p. 126
BANK HOLDUP MISSES BY A SHADE
OCTOBER 8, 1954
Photographer: Jack Clarity

The Ridgewood Savings Bank in the borough of Queens was the scene of a bungled robbery attempt in October 1954 when three armed men dressed as window washers forced their way into the bank through a side door and took as hostages a guard, the bank manager, and three women. The guard managed to set off a silent alarm and convinced the three robbers to draw a certain window shade in the bank, which was a pre-arranged danger signal to other bank officers and security personnel. As a result, a "flurry of brass" descended on the scene.

p. 127
HER KILLER BOOKED
AUGUST 26, 1956
Photographer: Alan Aaronson

Already on indefinite probation for beating and robbing an elderly woman, Edward Eckwerth was returned under guard from the West Coast as a suspect in the slaying of a 24-year-old parochial school teacher. He had disappeared from his home, abandoning his wife and young daughter, the day after Rosemary Spezzo was reported missing. After heavy grilling, Eckwerth admitted to killing Spezzo and led police to where he had dumped her body, about seventy-five feet off a private road near the Saw Mill Parkway.

p. 128
SCOLDED BY JUDGE
AUGUST 20, 1950
Daily News photo.

A Bayside, Queens, couple was arrested at 4 a.m. after their three small children had been found unattended. Police were called by neighbors who heard the children crying and found no adults in the home. Police removed the children and left a note telling the parents to report to the Bayside police station. George Collins, 32, and his wife Rita, 29, were each charged with endangering the health of their children.

p. 129
DEATH THREW A STRIKE
OCTOBER 9, 1956
Photographer: Jack Clarity

A 38-year-old city detective was killed outside Carmichael's Bar & Grill in Queens after an argument over the relative merits of the New York Yankees and the Brooklyn Dodgers. Detective William Christman and Robert Thomson, both supposedly Yankee fans, got into a heated dispute over a bet. In the aftermath Christman bought Thomson a drink to lower tensions but when Thomson offered to return the gesture, Christman replied, "I don't drink with the likes of you!" Thomson then threw a punch that staggered Christman and was promptly ejected by the bartender. Thomson went across the street to his home, which had a commanding view of the bar, and fetched his .30-.30 deer rifle. Christman was found dead next to his car.

p. 130
WELCOME BACK
MAY 23, 1957
Photographer: Bill Meurer

Frank Costello, a major figure in the New York underworld since the 1920s, is seen here when he was released after serving three and a half years for income tax evasion. In a matter of days, he would be shot inside the front door of his apartment building by a Vito Genovese hitman, Vincent "the Chin" Gigante. He survived, however, refused to testify against Gigante, and lived until 1973, when he died of cancer.

p. 131
GOLDILOCKS NABBED
MAY 2, 1957
Photographer: Ossie [Osmund] Leviness

Upon returning home to their apartment at 130 West 195th Street in the Bronx, Edward Hennessey and his wife, Betty, discovered a 23-year-old Goldilocks in their bed. Marion Darmanin, jobless barmaid, was found in their bedroom and committed to Bellevue for assessment. Miss Darmanin said she got tired and entered through the dumb-waiter. She was arrested for burglary.

p. 132
GREENWICH VILLAGE SHOOTING
FEBRUARY 8, 1962
Photographer: Bob Koller

Hearing cries from outside, two altar boys from St. Anthony of Padua Church ran out to discover Louis D'Agostino dying in the middle of W. Houston St. near Thompson. They summoned Rev. Archangel M. Sica from the church and he administered last rites. D'Agostino, owner of a struggling New Jersey construction company, had been shot twice in the abdomen—he had not been robbed.

p. 133
MARIE GAZZO MOURNED
NOVEMBER 20, 1955
Photographer: Ossie [Osmund] Leviness

Kathleen Egan had taken the day off to run errands in preparation for her upcoming wedding to a N.Y.C. fire lieutenant. One of these stops was the electrolysis shop of Marie Gazzo. After partially disrobing for her appointment, Egan emerged just before an armed intruder burst into the store. He calmly walked up to Gazzo, who was scrambling to get out a rear window of the store, and shot her through the heart. What happened next is not exactly clear. Witnesses who heard the shots, and rosary beads found on the scene, established that Egan had time to take out her beads to pray and that she had at least ten minutes to plead for her life. The killer finally chose to execute her with one shot to the back of the head. This case was never solved.

p. 134
MOM WAS MADAM
MARCH 19, 1959
Photographer: Evelyn Straus

The slim, 20-year-old wife of fugitive George Diblin (wanted at the time on vice and prostitution charges) was arraigned for allowing call girls to entertain johns while children were present. Mrs. Eleanor Diblin—mother of a five-month-old boy by her missing husband—allegedly helped her husband, also known as Ronald Stevens, to operate a house of prostitution in an apartment at 400 W. Fifty-eighth Street. Here they purportedly staged orgies with five boys and five girls—including two nieces—aged 10 to 15. The children were picked up and arraigned separately on charges of juvenile delinquency.

p. 135
COP SLAYS THUG
DECEMBER 27, 1950
Photographer: John Peodincuk

Hundreds of rush-hour pedestrians watched as off-duty patrolman John Christiansen, 29, fought a wild gun battle with a man who had just stuck up an Army & Navy store on Third Avenue, killing the owner as his wife looked on helplessly. Her brother shouted "stick-up" as the duo ran off in different directions. One ran right into Patrolman Christiansen, who pulled his gun and yelled that he was a policeman. The reply was a gunshot. Through the late afternoon crowds, Christiansen and the fugitive zig-zagged as they exchanged fire. The young cop finally downed the robber on Fourth Avenue.

p. 136
A VESTED INTEREST IN PROTECTION
APRIL 11, 1958
Photographer: Gallagher

Shortly before 8 p.m. on the night of April 10, 1953, five youths were arrested just as they were about to start warring with a rival gang in the Ridgewood section of Brooklyn. Clad in homemade aluminum body armor, these boys were all police could grab in a crowd of about forty that had gathered for the fray. The boys claimed they had no name for their gang but that they had gathered to fight it out with the Chaplains, who, three days earlier, beat up one of their members.

p. 137
CAUGHT IN A POLICE TRAP
NOVEMBER 17, 1962
Photographer: Detrick

Kenneth Cavanaugh, Albert Taylor, and Patrick J. Huston, all veteran thieves, attempted to rob a courier transporting deposits for the Franklin Simon stores on November 16, 1962. The police had trailed them for seven months and now had a chance to spring a trap. As the thieves emerged from the store's headquarters, the pouch containing the deposit emitted a cloud of smoke. It was a Tracealarm bag, which contained a smoke bomb triggered by a wire. The trio and cops exchanged more than thirty shots in broad daylight while truck drivers and passersby looked on. Cavanaugh and Taylor were gunned down and Huston was critically wounded. Detective Jeremiah J. Howard, eight times cited for bravery, was also severely wounded.

p. 138
GUNNED DOWN BY RIVAL
SEPTEMBER 27, 1961
Photographer: Alan Aaronson

No further information is available.

p. 139
V GIRL RAID
FEBRUARY 4, 1961
Photographer: Mehlman

No further information is available.

p. 140
BENNY LATRIANO GETS THE MESSAGE
SEPTEMBER 14, 1958
Photographer: Jerry Kinstler

"His head looked like as sieve. He's the worst sight I've seen since I've been in the department." This was the reaction of Captain Madden of the N.Y.P.D. upon seeing the bullet-riddled body of Biagio (Benny) Latriano. Returning home from the Court-Dean Bar and Grill in the early hours of August 28, 1959, Benny was gunned down outside his apartment at 349 Ocean Parkway, Brooklyn. Although on record as owner of the tavern, he was only the front man—but apparently not an obedient one. Only a month earlier he was the victim of an attack in which thugs sent their message with the butts of their guns and not the barrels. The message appears to have fallen on deaf ears.

p. 141
SLEEP HIGH, SLEEP LONG
JANUARY 1, 1956
Photographer: Hal Mathewson

Paul Edward Jones spent a dollar for an elevator ride to the observation tower, then sat down and waited. Darkness came. The last sightseer left. He drew a pistol and fired a bullet into his head. To avert identification, he had gotten rid of all credentials, but near him police found a torn-to-bits Army discharge. Pieced together, it identified him as Paul Edward Jones, 28, of Dorset, Ohio. The bag beside him contained a second gun, a black-jack, cord,

and other gear indicating he was a holdup man. His mother, Mrs. Myrtle Jones Smock, of Ashtabula, Ohio, said he had just served a California jail term for holdup. In his last letter to her, he said he was breaking parole. That meant he faced jail again. His letter added: "I'll fight arrest to the death."

p. 142
COHEN HASTENS FROM COURT
OCTOBER 2, 1960
Photographer: Bob Koller

At 13, Mickey Cohen dropped out of school to become a boxer. After an unsuccessful boxing career, he became involved with racketeering. In the 1930s Cohen moved to Los Angeles to work for Benjamin "Bugsy" Siegel as a bookie. After Siegel's murder in Beverly Hills in 1947, Cohen steadily rose through Southern California gangland ranks to become a racket kingpin in the late 1940s. The 5' 3" broken-nosed gangster, who wore built-up shoes to increase his height, lived in a $200,000 mansion, frequented Sunset Strip nightclubs, and always traveled in a Cadillac with an armed escort. In 1950 he was summoned to appear before the Senate Crime Investigating Committee in Washington. Cohen was subsequently sentenced to ten to fifteen years in prison for tax evasion. While in the Atlanta Federal Penitentiary, another inmate crippled Cohen by striking him in the head with a lead pipe. Cohen successfully sued the government for damages over the state's negligence in the incident. The one-time gangland big shot, who had survived at least ten attempts on his life, died of cancer at the age of 62 in 1976.

p. 143
RAPED AND ROBBED A MINISTER'S WIFE
MARCH 8, 1960
Photographer: Duprey

Anthony Durant was arrested for robbing and raping a 46-year-old minister's wife on the lower level platform of the Madison Square Garden subway station. He confessed, "I didn't intend to rape her. I wanted to steal her pocket book. I needed money. We were struggling around on the floor of the platform. Then I lost my head. I got an overpowering impulse. I got so excited that I can't remember exactly what happened." Durant, who was also wanted on a number of token booth robberies, was sentenced to 10 to 20 years in Sing Sing.

p. 144
21-YEAR-OLD EXTORTIONIST
JULY 15, 1953
Photographer: Bob Costello

Virginia Di Domenico, 21-year-old platinum blond, and her pretzel baker boyfriend, Daniel Enoch, 31, were arraigned on charges of extortion after attempting to pry $600 from shipping heir Edgar F. Luckenbach. It seems that someone named Luckenbach twice "entertained" Miss Di Domenico—who listed her profession as model—in his Manhattan apartment, and she claimed that the money she received represented her winnings at gin rummy. But, although the apartment she visited was indeed Luckenbach's, he no longer lived there. Lewis Steinman, 26-year-old Philadelphian and professional forger, had taken up the residence and identity of Luckenbach. He skipped town after posting bail but was later arrested.

p. 145
HOUSE OF ALL NATIONS
OCTOBER 19, 1956
Photographer: Al Amy

A "House of All Nations" call girl ring, which operated between New York and Chicago, was broken up with the arrest of Nela Bogacki, alias Nelda Bogart, alias Nina Sandman, 32. Bogacki, a Polish displaced person, arrived in the United States in 1951 and began enlisting other aliens, from Cuba, Haiti, France, and Italy, in an internationally spiced bordello.

p. 146
THE LAW STEPS IN
MAY 15, 1960
Photographer: Frank Russo

Violence erupted in front of the Cuban Consulate in New York City in May 1960 when two hundred pro-Castro freedom fighters attacked anti-Castro picketers carrying signs that read "Cuba Suffers Red Dictatorship." Police quelled the riot, arresting eighteen and confiscating chains and knives.

p. 147
HANDS DEALT DEATH
SEPTEMBER 6, 1960
Photographer: Dan Farrell

Eighth grade student Kenneth Leary Brown, Jr., was arrested for the murder by strangulation of 60-year-old Wilhelmina Tinsdale in the Clinton Hill section of Brooklyn in 1960. Pickd up weeks earlier in a peeping tom case, the 15-year-old Brown eventually confessed to the Tinsdale crime. He told police that after crawling through a partially opened window, he surprised Tinsdale in her bedroom and choked her to death. A total of $1 was taken from the house. After spending six months in jail, Brown was set free after defense lawyers showed that the police had coerced a confession by holding a gun to the boy's head, and it was determined that fingerprints found at the scene of the crime did not match Brown's.

p. 148
SHOT TEENAGER
AUGUST 22, 1961
Photographer: Detrick

Fred Baron, 19, was indicted for the murder of 14-year-old John McKernan in the Evergreen Cemetery in Elizabeth, New Jersey. A witness to the killing, John Conry, claimed that Baron had accused McKernan of complicity in a stabbing attack on Baron in January 1961 and said McKernan was also refusing to give money to Baron that the two had amassed in a series of burglaries. When McKernan refused to answer Baron's questions, the 19-year-old shot him in the head and chest. McKernan's body was found leaning against a tombstone.

p. 149
SEIZED AS DOPE PEDDLERS
JANUARY 30, 1960
Photographer: Hurley

Under a new State law that made conspiracy to sell narcotics a felony, police rounded up seven men, calling them "the most important" dope peddlers in the metropolitan area. Once police broke the intricate code the ring used when discussing business, wire taps proved fruitful. According to D. A. Hogan, the police nabbed the "top echelon" of heroin wholesalers, who did a multimillion–dollar business annually. Brought in was Joseph "Fatty" Russo, who was, Hogan said, "as close to the top as possible, short of being the top." Also arrested were: John "Baps" Ross, 39, said to be the largest heroin distributor in the country; Anthony Russo, 23, brother of Joseph, Aniello "Danny" Carillo, his son Frank (pictured), Alphonse Mosca, and Anthony Savoca.

p. 150
WHILE MOST OF THE CITY SLEEPS . . .
MAY 23, 1964
Photographer: Ken Korotkin

Joan Wilson and her younger sister, Margaret, were crossing the True Parking lot in Times Square when they ran into a friend, Cathy Brazil, as she parked her car. As they stopped to chat, a single shot from a .38 caliber revolver silenced Joan forever. Police determined it to be a random shot, probably fired from the Holland Hotel, which was adjacent to the parking lot. It was not until the first of November that police had a lead. A clerk found a Smith & Wesson that matched the caliber of the murder weapon hidden under a radiator in one of the rooms. The weapon was traced through a series of owners to Roy Francis Nagle, who promptly confessed to the killing. It seems Nagle was in New York not for the World's Fair, as most were that summer, but to kill his ex-wife. He had traveled to Queens that evening to do the deed but could not go through with it when she emerged from the subway with their five-year-old son. As he sat back in Times Square simmering with hate, he spotted young Joan Wilson, content and happy in her youth, and because of her resemblance to his despised ex-wife, he fired a single shot, killing Joan in an instant. Nagle was tried, convicted, and received a sentence of forty years. Upon appeal it was reduced to twenty—he was released after nine.